VISUALIZATIONS
THE nature BOOK OF ART AND SCIENCE

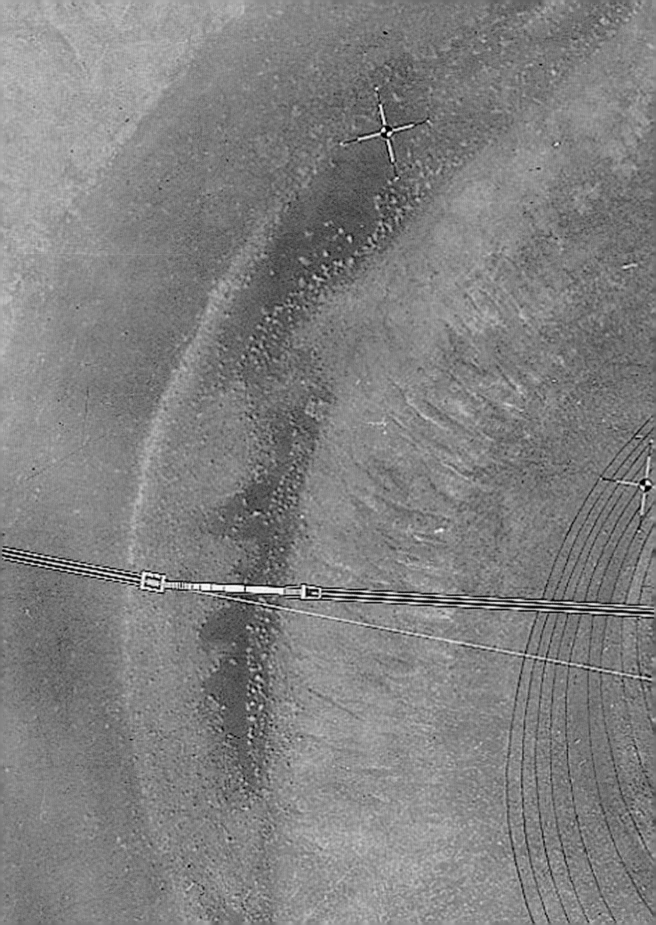

VISUALIZATIONS

THE nature BOOK OF ART AND SCIENCE

MARTIN KEMP

The
University
of California
Press

University of California Press, Berkeley and Los Angeles, California

Published by arrangement with Oxford University Press

© Martin Kemp 2000

The moral rights of the author have been asserted

Database right Oxford University Press (maker)

First published 2000

ISBN 0 520 22352 7

9 8 7 6 5 4 3 2 1

Typeset in Minion by Footnote Graphics, Warminster, Wilts
Printed in Great Britain on acid-free paper
by Butler & Tanner Ltd, Frome, Somerset

Preface

From idea to article

The origins of this book lie in an invitation from Philip Campbell, editor of *Nature* since 23 October 1997, to contribute a series of articles on art and science. Casting around for a possible author, he was 'put on' to me by Ken Arnold, curator of the gallery devoted to medicine, art, and imagery at the Wellcome Institute in London.

The journal was known to me through its high reputation as *the* place to publish scientific discoveries. I had also served it as an occasional reviewer and been a subscriber. When my daughter, Joanna, was studying Zoology at Glasgow University, I subscribed on her behalf and took advantage of the weekly arrival of the journal to gain some sense of what was happening in cutting-edge science, and above all to enjoy the visual feast that a number of issues presented. I was happy to tell my colleagues in the art world that the graphics of modern science, as represented in *Nature*, made much of the fare in art magazines look tame.

What Philip Campbell and I discussed was the possibility of a series of weekly pieces on the interaction of the visual arts and science, each of which would centre on a particular work of art. I explained that my interest was less in looking at the *influence* of science on art, or even vice versa, but at shared motifs in the imaginative worlds of artist and scientist. Too many of the increasingly fashionable art–science initiatives seemed to me to be operating at a surface level, in which obvious points of contact (e.g. artists using scientific imagery) were simply narrated or in which objects from art and science were juxtaposed without really interpenetrating. My interest, developed in discussion with the editor, was to look at some deeper structures which found mutual expression in some kinds of art and some kinds of science. These structures arose in relation to what I was beginning to call 'structural intuitions'—a term explored in the introduction.

We talked initially of about a dozen or so essays; I subsequently worked out an inflationary scheme for 25 articles covering Western art from the Renaissance to the present day. It was planned graphically, setting out a series of variables in a table of possible topics. The horizontal axis corresponded to broad periods—the arena of the 'old masters' (from the Renaissance to the mid-nineteenth century), the age of 'classic modernism' (roughly the first half of this century), and the present era of living artists. The vertical axis denoted the type of science, from abstractly mathematical to the illustrative modes of natural history and medicine. Looking back in my files, I see that the 'target' sciences were mathematics (three- and multidimensional geometry, topology, the golden section and the Fibonacci series, symmetries, and fractals), physics (light, statics, dynamics, materials, structures, and chaos), astronomy, chemistry, earth sciences, zoology, botany, and the human sciences —which, incomplete though it was, seemed enough of a list for the time being!

Within this basic scheme were plotted other variables, namely artistic content, the mode of art–science relationship, artistic medium, geographical spread, type of artist, and appropriate tone of voice. Not all the variables were respected as fully as others—unsurprisingly, given my own uneven knowledge and the personal factors involved in making choices including an obvious bias towards British artists in the essays on living practitioners, reflecting my own contacts. There need be no apology however for highlighting British practice at this time of notable vitality.

For reasons of competence, I dealt only with Western art—thus, no Islamic tile patterns or Chinese nature painting. For the most part I have selected artists to whom I feel a commitment, Salvador Dali being the most notable exception. Hence, no M.C. Escher—ingenious designer of tessellations and spatial conundrums and a favourite of mathematicians—whom I regard as heavy-handed and aesthetically laboured.

When it became clear that the response to the 'Art and science' series was gratifyingly enthusiastic, Philip Campbell asked me to think about its possible continuation. My proposal, accepted with a characteristic commitment, was for a second, complementary series on 'Science and image' that would look at the visual image in science. It would deal with the 'look' of scientific things, showing how the style of scientific artefacts is no less integral to the communication of content and meaning than style in a work of art. The items were to be discussed less in terms of their place in the technical history of science than as communicative objects within various communities—the narrowly professional, the broader worlds of science and learning, the influential audiences of patrons and founders, and various kinds of public from elite to so-called popular. The chronological cycle would mirror that of the earlier series: older historical, classic modern (c.1880–1960), and current. The other variables, such as type of science, would operate in a similar way to previously. A graphic mapping of the possibilities suggested that 27 articles should be the minimum.

By the winter of 1998, with the conclusion of my five-year British Academy Wolfson Research Professorship (which had been transferred to Oxford from St Andrews in 1995) and my resumption of more than full-time administrative and teaching duties (unfortunately in that order), the weekly commitment became unsustainable and we decided to move on to a monthly basis, with a freer agenda and a more opportunistic policy. The new series, 'Science in culture', has responded to items that attract my attention, including contemporary events such as exhibitions, while retaining the brief to cover a wide range of topics, chronologically and thematically.

From article to book

The present book contains all the pieces published under the banners of 'Art and science' and 'Science and image', together with those from the most recent 'Science and culture' series, up to August 1999. The only essay which does not appear in more or less its original form is 'Kemp's conclusions', written as the concluding article to the 'Art and science' set. A section of it has been incorporated into this introduction. The pieces on Brunelleschi's invention of perspective and Petrus Camper on 'facial angles' appeared as part of a separate series in *Nature* on events of the millennium commissioned from various authors, and seemed to sit naturally in the present collection.

The actual idea for the book arose quite early, not least in response to the encouragement of a number of readers who were kind enough to write or send e-mails. With the whole collection in mind, there has had to be some 'filling in the gaps', but this has never been an overriding priority in the choice of topics.

The question of order became the most decisive issue in putting the collection together between hard covers. Leaving the articles in the original published order seemed to miss an opportunity to explore greater thematic and visual unities. The obvious move would have been to arrange them in strictly chronological order beginning with Brunelleschi in the early fifteenth century, perhaps in two series, one on works of art and the other on images in science. The latter separation was not, for me, an attractive proposition. I did consider an entirely thematic arrangement, grouping together all the items dealing with such topics as space or pattern, regardless of historical period or other content. In the event, I resorted to my instincts as a historian and decided that I would broadly respect my three-part scheme of old master, classic modern, and contemporary. However, I did want to exploit some of the conjunctions, above all the striking visual resonances, that had arisen within and across different areas of activity in the arts and sciences.

The chronological arrangement was loosened sufficiently to let both obvious and unexpected juxtapositions occur. Inevitably, given the linear nature of the vehicle of the book, compromises had to be made, and some potentially telling dialogues became less apparent than I might wish. However, the essentially modular nature of the book allows an interactive freedom for the reader in a way that a more conventional narrative structure would not encourage.

Inevitably a certain amount of recasting of the original texts and illustrations was required, though I have resisted the temptation to rewrite or extend the essays substantially. The 500–600 word limit of the single-page articles in *Nature*, far from being irksome, came to represent a creative challenge. Drawing out a general point in each instance and making a specific analysis of the main image within the given space whilst sustaining thematic variety, varying the tone of voice, and finding different routes into each piece became a stimulus rather than a restriction.

The alliterative titles became a kind of personal game which I have continued into this volume. That it can be done without undue strain does seem to say something about the wonder of words—to set beside the power of pictures—but, at heart, the alliterations were sustained because I enjoyed them, and I can only hope that they do not become tiresome for the reader.

One catalyst for revisions has been communications from readers. It may be of interest, and it was certainly surprising to me, that the page on Vermeer was the most requested off-print (though I actually had none to distribute). Many correspondents have extended my knowledge and understanding, most notably the responses to 'Callan's canyons' by the astronomer, Adrian Webster, and the mathematician, Ian Stewart, which have resulted in the inclusion of a condensed version of Stewart's essay from *Scientific American*. Others were kind enough to point out shortcomings of fact or comprehension, and I have endeavoured to take their points on board.

The more critical responses have generally concerned 'priority disputes'—that is to say who first discovered and published what. I am not, however, intending to write a history of 'firsts', but rather to look at the power of images as tools for visualization and communication.

Originality is clearly of concern, above all in innovatory visualization, but it is not the major determining factor in my choice. When I have looked into the priority disputes, as, for example, with the symmetry of 'buckyballs' or the physiographic maps of the seabed, the issue is often less than clear-cut.

There is a long history of simultaneous, independent inventions, arising from the coming together of similar sets of intellectual and social imperatives in different places at the same time. A good example is the contemporaneous development of viable photographic processes by William Henry Fox Talbot in England and Jacques-Louis Mandé Daguerre in France, and the story of Talbot's scramble to respond effectively, courtesy of Michael Faraday, to the unexpected public announcement in Paris on 7 January 1839. Their techniques, one a negative–positive process on paper and the other involving the imprinting of a unique image on a silvered plate, proved to be distinctively different in their physical and optical bases.

In a comparable way, claims to have preceded much-trumpeted discoveries in science often deal with processes or results that are not quite the same and, not infrequently, the neglected results were published in a way or in a vehicle such that their implications were not fully apparent. In any event, I highlight the kind of visual entrepreneurship in science that has public impact, rather than the technical history of who was first into print.

Minor rewritings have involved eliminating some repetition and some cross-referencing (both necessary when the pieces were free-standing). The revised format has permitted the introduction of some supplementary illustrations, with some minor textual adjustments. I have not attempted to adjust the consciously different tones of writing, on the old principle of classical and Renaissance rhetoric that different topics benefit from different 'modes' (a term from ancient music) and from varied kinds of ornament. The pieces on the artworks of Goldsworthy and Parker probably stand at the ornamental extreme, while the more technical expositions of 'Lane's landscapes', 'Visible viruses', and 'Mammary models' are more akin to 'normal' science writing. I would guess that 'Parker's pieces' has received the most revision. Philip Campbell said that of my contributions it was the one that came closest to warranting inclusion in 'Pseud's corner'—the space allocated in *Private Eye* to pretentious and jargon-ridden passages of arts criticism—and he had a point, at least with respect to its use of 'art crit' language.

Other departures from the published articles are the addition of this introduction and the concluding observations, written specially for the book. ❧

Contents

Acknowledgements

This book is founded on the series of regular articles I have been publishing in *Nature* since 23 October 1997. The pivotal role of the editor, Philip Campbell, is described in the Preface and all the staff of the journal with whom I have enjoyed contact have assisted with a readiness beyond the call the duty. In particular, John Moore smoothed a speedy and efficient path into print, ably supported by Mary Sheehan; Barbara Izdebska undertook the picture research imaginatively and effectively; Majo Xeridat produced ingenious design solutions to the combining of images and text on the printed page; and, latterly, Harriet Coles has solicitously shepherded the monthly articles into the 'Reviews' section of the journal.

The research and the writing of so many pieces in such a relativley short time was made possible by the excellent research assistance of Rebecca Hodgson, who not only brought her training in the history of science to bear on the search for sources but also made creative judgements of a high order about which sources delivered the most telling material. She so rapidly developed an instinct for the nature of the essays, that she was able to work with the minimum of guidance. In the final assembly of the text during the processes of re-ordering and editing, Katerina Reed-Tsocha offered assistance at a high level, not least in the bringing of order to chaos, at a time when she was in the final stages of completing her doctoral thesis in Oxford. The dialogue with friends about the series as a whole and about particular topics provided both ideas and encouragement. Marina Wallace, as always, has been at the centre of that dialogue, and Pat Williams' enthusiastic discussion from her standpoint as a fellow 'columnist' was invariably uplifting.

The response of the scientific community to what began as an 'alien' intrusion into one of their most prestigious journals was hugely encouraging and welcoming. Living scientists into whose territories I trespassed were unfailingly helpful and patient, both in understanding my agenda and in softening the edges of my ignorance. Help in the preparation of specific essays was willingly provided by Astrid Bowron, Mike Brady, Jonathan Callan, Susan Derges, Ralph Highnam, Andy Goldsworthy, Michael Gross, David Hockney, Louise Johnson, David Juda, Jane Hamlyn, Sir Harry Kroto, Nancy Lane, William Latham, Joan Lederman, Gustav Metzger, Jonathan Miller, Tom Mullin, Paul Nesbitt, Glen Onwin, Cornelia Parker, Nicholas Stanier and Pat Armstrong of Initial Transport Services, Anna Radjzun, Willie Rusell, and Philip Steadman.

It is not practical to thank all those who wrote either directly to me or via *Nature*, but I would like specifically to mention Wilf Arnold, Hugh Bagley, Mark Bergmans, J. Best, Maurice van den Bosch, Eric Buffetant, Werner Burkhart, Robert Burn, J. Coleman, Nigel Constam, Steven Crockett, John Dalton, David DeRosier, Dan Danielopol, Avigdor Ben

Dov, Ernst Fischer, Sandy Geiss, Timothy Gorski, Stephen Jay Gould, Rita Greer, Patrick Gunkel, Lars-Olof Hjalmar, Robert Horne, Nooshin Ismail-Beig, Julian Jocelyn, Magnus Johnson, Dave Kaiser, Jonathan Katz, Jean-Claude Kieffer, Djuro Koruga, Ma Lianxi, Alan Mackay, Charles McCutchen, Ralph Martel, Alison Newton, Julia Nikolic, Max Perutz, Herman Prossinger, Michael Richardson, Douglas Rogers, Maggie Schold, Cameron Shelley, Ian Smith, Alastair Steven, Ian Stewart, Ted Sweeney, Chris Taylor, Ivan Tolstoy, Donald Voet, Adrian Webster, Elizabeth Whitcombe, Jo Wildy, Sue Wilsmore, Erika Wolfmeyer, Lewis Wolpert (who provided a critique that was characteristically pointed and generous in the *Independent on Sunday*, 31 May 1998), and Fredrick Zimmoch.

The support of staff in the Department of the History of Art in Oxford has made my programme more manageable than it otherwise would have been. Sheila Ballard, and her successor, Pamela Romano, have been models of commitment and patience, and Naomi Collyer and Catherine Hilliard always provided rapid answers about books. My graduate students have been cheerfully understanding of disruptions in their schedules.

Susan Harrison has been a vital source of editorial support, and Jonathan Coleclough, Beth Knight, Carole Sunderland, Debbie Sutcliffe, and Gill Watts have worked patiently with the overly busy author to bring the book into print. The index has been skilfully compiled by Liza Weinkove. Caroline Dawnay has exercised her characteristic tenacity in looking after my interests, both in the establishing of the initial project with *Nature* and in negotiating subsequent arrangements. And, last but not least, it has been a joy to share the pleasure of a '*Nature* columnist' with my children, to whom the book is dedicated.

April 2000 Martin Kemp ꙮ

List of contributions

The chapters in this book are based on the following articles in *Nature*:

Dedicated to
Joanna and Jonathan
as they enter the worlds of science

Introduction

Looking across the wide range of images in this book, the immediate impression is diversity. But underneath the varied surface run some constant currents in our human quest for visual understanding. The most enduring of these currents is our propensity to articulate acts of seeing through what I am calling 'structural intuitions'. There is always a danger in offering a compact phrase as a summary of a complex concept, but its deliberately double reading retains an openness that works against its becoming too formulaic. It is double in the sense that the 'structures' are both those of inner intuitive processes themselves and those of external features whose structures are being intuited. In case this sounds dangerously circular, I should look at each aspect in turn.

Every act of perception is necessarily a highly directed and selective affair, whether the guiding principles are conscious or inadvertent. Our view of the realities outside us is structured in relation to existing deposits of perceptual experience, pre-established criteria of interpretation, new and old acts of naming and classification, the physical parameters of our sensory apparatus, and, above all (or underlying all), deep structures operating at a pre- or subverbal level. I subscribe to the view that the general potentialities and parameters of those deep structures (i.e. their rules of engagement with experience) are genetically established, while the precise manner in which they are realized, in terms of the laying down of 'hard wiring', is shaped by sensory and other experiences. Some of these sensory experiences, such as our early visual and tactile engagement with the physical world, are shared by most human beings, while others are more specific to particular cultures or even individuals.

It is my conviction that the shared elements exceed the divergent ones, though it is inevitably the differences that most strike us, particularly as historians of culture. We may, for example, be very conscious of deep-seated differences in the way that the Italians and the English have played football (soccer) over the years—the former full of flair and sometimes exaggerated 'style', and the latter characterized by athletic vigour and stoic belligerence—and we can point to the fact that the rules are decreed by a cultural organization (the Federation of International Football Associations), but it is actually far more extraordinary that any able-bodied and sighted person from diverse cultures can readily judge the speed and position of an approaching ball and kick it back with interest.

I believe (as will already be apparent) that the deep structures of intuition with which we have been endowed by nature and nurture stand in a non-arbitrary relationship to definable elements in the structure and behaviour of the physical world. The increasing apparent size of the football as it speeds towards us, and its relationship with foreground and background objects, all tell us something 'real'. The laws that govern the inertia of the ball and the coefficient of its elasticity may be unknown to most professional footballers,

but they have instinctively acquired a precise sense of how fast it is arriving and what force is needed to propel it back in the right direction at the desired speed. The structures of the external world within which we need to operate (in matters more urgent than kicking a football) are those with which the internal structure of intuition has been designed to resonate, continuously reinforcing and retuning themselves in a ceaseless dialogue of matching and making.

The basic performance of the faculty of sight is functional, enabling us to navigate with apparent ease the incredibly complex and dynamic world in which we live. It will also become apparent, when we look at landscapes beyond normal vision—such as those disclosed by microscopy and X-rays—how our visual apparatus can remarkably adapt in unknown worlds to perceive levels of organization analogous to those with which we are familiar. We are clearly very good, astonishingly good, at picking up hints about form from angled views of objects illuminated by a source of light, and at immediately drawing out an underlying pattern from a chaotic medley of sense impressions. Not only can we instantaneously determine that the series of lines etched against the winter sky correspond to the complex, three-dimensional branching system of a tree, but we can also sense how an oak tree exhibits a different look in its branching from a beech—even if we could not begin to say what 'rules' distinguish the types of branching in each species of tree. Such discernment of order and the differentiation of one thing from another in a highly refined way are at root deeply functional attributes of our perceptual system.

But why do we gain *pleasure* from seeing a 'beautiful' tree and its surrogate in a painted landscape? My suspicion is that what we call the 'aesthetic impulse' is part of the feedback mechanism that reinforces our hugely demanding attempts to make coherent sense of those natural orders with which we can and must work if we are to survive. Our pleasure in pattern, in symmetry, in order and its judicious breaking, in minutely discriminatory acts of recognition, and so on, provides a system of gratification and reward. We have the ability to activate this system artificially; an ability that we have cultivated in science no less than in art.

If this is anywhere near the truth, it could help explain why the basic itch that triggers the procedures of scratching in all human acts of artificial making is fundamentally the same —whether we classify the acts as art or science or whatever. This is not to say that art and science are somehow the same thing. It is to state that they well up, in all their various forms, from the same inner necessities to gratify our systems of perception, cognition, and creation. These necessities and gratifications are not simple unitary impulses, but a complex tapestry of interwoven elements ranging from basic mathematical propensities to something as complicated as the recognition of hostile and friendly faces. Each element in this range can be accessed and expressed in a variety of ways.

It would be easy to say that from one or more of these ingredients the scientist sets out to explain *why*, according to logical analysis, and expresses the outcomes through systematic exposition, while the artist, on a wholly divergent course, plays imaginative visual music on the melodies and harmonies of structural intuitions without being accountable to the kind of logical scrutiny that decrees rightness and wrongness. However, this polar differentiation is much too simple and requires qualification for both science and art.

At every stage in the process of the undertaking and broadcasting of the most committed kinds of science lie deep structures of intuition which often operate according to

what can be described as aesthetic criteria. These may involve such things as the conducting of an 'elegant experiment', the formulation of a 'pretty explanation', the recognition of a 'beautiful proof'. It also involves the 'look' of any visual demonstrations, even if these, like the approved verbal modes, have in modern science become matters for abstinence from stylishness in the service of the rhetoric of absolute objectivity.

Recently, it has been interesting to see how computer graphics have served to unleash the aesthetic instincts of increasing numbers of research teams, presumably sanctioned by the fact that the 'arty' constructions are done by machine. Generally speaking, modern science has grown a tough carapace of 'hard' exposition which masks the 'softer' body parts and cerebral complexities that lie within and actually give life to the organism. There is a danger that we will take the *disinterest* avowed in much of the presentation of modern science as corresponding to *uninteresting* for non-specialists—using 'disinterested' in its proper sense of meaning without such personal engagement as would cause bias. The aim, rightly, is systematic presentation, such that the hypotheses, evidence, procedures, analyses, and conclusions are exposed to logical probing. But the deepest motivations are very much another matter.

Surface traces of these motivations—like the shadowy signs of archaeological structures in a flat field—can be discerned under the apparently even surface of the prose favoured in scientific exposition. If we look closely at the language, we find that it proves too rich in metaphor and analogy to an extent that its exponents would rarely acknowledge. The embedded metaphors range from visually descriptive to those that are suggestive of the kind of awe characteristic of science in the Romantic era. A telling disclosure of their potential is provided by the poem *The Crest of the East Pacific Rise* by Betty Roszak, the structure of which builds upon interwoven phrases drawn freely from oceanographic science. It is only possible to give a brief flavour here.

> . . . Farther yet the faults
> rise up
> like giant stairways.
> Lakes of solidified lava
> hundreds of meters long,
> in places
> collapsed and pitted,
>
> pillars and walls
> of basalt,
> banded, glassy,
> cooled lateral outflows.
>
> Mounds of minerals: sulfides of zinc, iron, copper, silver,
> vented as hot fluids . . .

What is revealed by setting the words in a different context of intellectual and emotional expectation, is an evocative richness that we are not normally invited to see. It is a richness that speaks eloquently of the imaginative intensity and wonder that are integral to the spirit of scientific enquiry.

In the realm of the visual arts, the post-Romantic myth of the fiery creator, driven only by passion and instinct, representing the antithesis of analytical sobriety, is in need of even more serious qualification than the passion-free image of the scientist. Many artists—I venture to suggest all the really compelling ones—think deeply about their work. Their thought may range from philosophical contemplation to the devising of technical experiments to enhance the performance of their media.

Many artists ask 'why?' as insistently as any scientist. For the artist, as for the scientist, every act of looking has the potential to become an act of analysis. The greatest of the

'nature artists'—that is to say those who aspire to represent nature in their works, whether figuratively or abstractly—are in the business of remaking on the basis of understanding. But their accountability is different. There is no demonstrable proof, although there is in the best art a sense of 'rightness', analogous to the sense of 'rightness' that a scientist may feel about a hypothesis long before it has been shored up with facts. What the artist presents as a final product is an open but not unstructured field for the exercise of the spectator's faculties, blatantly exploiting the subjective impulses that are apparently wrung out of the dry exposition of science.

If we look at their processes rather than their end products, science and art share so many ways of proceeding: observation, structured speculation, visualization, exploitation of analogy and metaphor, experimental testing, and the presentation of a remade experience in particular styles. In these shared features, the visual very often has a central role. These are themes that will be taken up in the concluding remarks at the end of this book.

Any visual product possesses the quality we call 'style'. The idea that art and artists exhibit 'styles' is unproblematic—at least in the sense that it is widely accepted to be the case. Perhaps we are ready to concede style to the visual legacy of older science—the pictures in natural history books and the de-luxe, decorated instruments of science made under aristocratic patronage. But what of modern science? Surely a table or a graph does not have a 'style', nor does an electron microscope? They are just what they are.

In reality, there are always choices in design and presentation—choices greatly extended by computer graphics—even if the chosen style is automatic and unconscious. The draining of obvious ornamentation, stylishness, and pictorial seductions from much institutionalized science from the mid-nineteenth century onwards, itself constitutes a style in its own right—what I have called, paradoxically, the 'non-style'.

Every age of science and technology has been committed to its own rhetorics for communication both within and beyond the profession. Style is one of the ways through which we can gain access to a remarkable range of questions about makers, materials, patronage, broadcasting, and reception. Style can key us into the nexus of cultural differences that historians necessarily exaggerate in the pursuance of their trade—and that we all automatically exaggerate when staring at the 'foreign country' of the past.

That there are radical cultural differences, even within the compass of 'Western' societies, from the Renaissance to the present day, is not to be contested. Kepler's laws of the elliptical orbits of the planets could not have been formulated by the makers of prehistoric stone circles, however sophisticated their astronomical observations. They were well served by the spiritual geometry which they discerned in the heavenly lights and had no recourse, intellectually or institutionally, to the kind of ideas that led Kepler to think about the movement of the planets in terms of the mechanical laws govering the motion of solid bodies. Behind Kepler's compound of resources lay not only his Platonic obsession with mathematical beauty but also new understandings in the science of ballistics occasioned by Renaissance artillery. The body of knowledge in any society is formulated in a manner relative to that society. But this does mean that the knowledge itself is arbitrary. Kepler's redefinition of the orbits has more 'rightness' to it than Galileo's clinging to the perfection of the circles, which seems to have been motivated not least by aesthetic criteria.

A scientific belief may be specific to a given society, but the explanatory power of that belief may possess a validity which is not simply a social expression, just as a spiritual

belief may provide an insight into the human place in nature that has its own value independent of the mechanics through which that belief is expressed in ritual. The visual demonstration in science—alongside the verbal formulation, the mathematical expression, the table, and the graph—has its own job to do in building the edifice of scientific understanding. The images that follow show how wonderfully varied that job has been in the hands of creative individuals in varied cultural contexts—no less varied than the artists who have been conveying their own kinds of structural intuitions.

The 'shuffle of things'

The phrase is from the great promoter of the empirical ideal in late sixteenth- and early seventeenth-century Britain, Francis Bacon. As part of the 'essential apparatus of the learned gentleman' Bacon recommends:

> a goodly huge cabinet, wherein whatsoever the hand of man by exquisite art or engine has made in stuff, form or motion, whatsoever singularity chance, and the shuffle of things hath produced; whatsoever nature has wrought in things that want life and may be kept, shall be sorted and included.

How we 'shuffle' things is clearly vital in structuring our intuitions or in responding to their already shaped structures.

Right from the first, from the title of the book itself, we already have two packs of cards in different coloured packets—one called art and the other science. I do not in this context intend to rail at length about the constraints imposed by these terms, but it is right as a historian that I register how the meanings we now have for these terms, with all their associations and exclusions, cannot be applied safely to earlier periods. Even the science conducted by *Nature* in its first issue on Thursday 4 November 1869, as we will see, embraced a different range of voices than our present enterprise of science. I should also say, without more extended analysis, that the range of pursuits currently classified as science, even in our relatively restrictive sense, is so varied as to render the shorthand term 'science' but a crude and undifferentiated descriptor. However, as convenient shorthands, 'science' and 'art' mean something to us, and do correspond in some rough measure to pursuits in the past. Above all, they do provide us with a starting point—with shared terms of reference which signal to the present-day reader what this book is about.

The more detailed shuffling that took place when I initially planned the series, according to three chronological categories and varied types of science, has not retained its primacy here, though traces of the original chronological divisions remain. In the rounding-up essay at the conclusion of the first 'Art and science' series, I suggested that there was a gross pattern or historical shape that might be identified in the three-part scheme. I repeat that analysis here.

The shared shape of the selected images may be described, telegraphically, as *analytical description*, *abstraction*, and *process*.

Analytical description refers to a form of representation in which aspects of appearance are remade—literally re-presented—on the basis of an intuitive or intellectual understanding of the nature of what is being seen, how it is seen, and how it may be depicted in such a way as to convey 'information' to an attuned viewer. The tools for such remaking

include the projective system of linear perspective, the rational description of light effects through shadow and the modulation of colour (i.e. manipulation of tone, hue, and saturation), and the structural bases of natural form (such as human anatomy or geology).

Leonardo worked with all these tools, and no masters of naturalism could afford to neglect any of the optical means, however selectively they might concentrate on other areas of interest. Given the prominence of empirical analysis in so many sciences during the 'Scientific Revolution', it is not surprising that some artists were able to play an active role in the dialogue between various types of seeing and knowing, not only in the obvious areas of illustration but also in the more searching evocation of the causes behind natural effects—whether the perceptual explorations of Vermeer or the fiery emissions from the inner earth in Wright's volcanoes.

High levels of remove and *abstraction* from the sensory parameters of our normal experience is a signal characteristic of modern science, using devices to see and often to generate emissions inaccessible to our eyes e.g. X-rays, infra-red, thermal radiation, sonar, electrons, other subatomic particles. Spectacular devices have enabled us to 'see' forms and forces at scales of minuteness and immensity unimaginable with conventional microscopes and telescopes. Particles have etched the febrile geometry of their kamikaze lives across the spaces of cloud and bubble chambers, bearing witness to a realm of existence in which the classical laws of physics are inapplicable. At the same time, modern artists have striven to forge a realm of artistic reality separate from that of the eyewitness and conventional naturalism, seeking an aesthetic autonomy which obeys its own set of unfathomable rules—whether these were seen as residing in the mind or in the greater forces of the universe, or both in concert.

It helps us not to become obsessed with the question of influence, seeking demonstrable ways in which ideas from the new physics percolated into educated consciousness (which they undoubtedly did), but rather to see art, in its own right, as exploring submerged worlds of mind and matter that had only been implied under the skin of older naturalisms, now that the burden of naturalism had shifted to the photographic media.

The desired autonomy of non-figurative art might be manifested in forms hostile to science or in conscious harmony with scientific explorations. In either case, the idea that truth (to whatever) was located in modes of representation that were not dependent upon and may even contradict our commonsense notions of realism places modern art in a reciprocal relationship to the counter-intuitive revelations of much modern science. How and why are questions that are best, for the moment, entered through the individual gateways of artists like Gabo, Bill, and Albers, who arrived in comparable zones of abstraction down quite different paths.

The characterization of present artistic production in terms of *process* is clearly dependent on my choice of artists. Given the plurality of current practice, a different selection might emphasize such tendencies as the need for instant media impact, a tiresomely incestuous self-reference to art and artiness, a resort to found objects, or a perpetual dissolving of the fixed boundaries inherent in any definition of 'art'. But, at this disadvantageously close viewpoint, it seems to me that one of the factors—perhaps *the* factor—that distinguishes the artistic cutting-edge in the last two decades has been process, not so much its description (in the manner of Wright's volcanoes) but rather its use to determine the final configuration of the work (if there is indeed any 'final configuration' other

than an animated image of Latham's type). A programme is initiated, with chosen para-meters, but the end result is not predetermined.

This lack of determinism, even when the means are apparently simple, as 'Callan's canyons' or Onwin's vats of brine, has clear affinities with non-deterministic chaos and self-organized criticality—those fashionable kinds of computer driven analysis computa-tion that have reclaimed the visual dimension for advanced mathematics. Chaos theory has shown the remarkable patterns behind unpredictable systems,while criticality deals with systems poised at the very edge of stability. It is also notable how the self-similar prop-erties of fractals stand in a suggestive relationship to the scaleless qualities that frequently characterize artworks that use process. But are the relationships more than suggestive?

Jonathan Callan was as surprised as I to be told by Andrian Webster that his 'dust-scapes' conformed to Voronoi cells and exhibited 'affinities with a recent model of the architecture of the Universe on very large scales'. Clearly, there is no influence here. Rather, I believe that one of the dominant tenors of an age which is obsessed with process—through computer programmes, notions of market forces, the remorseless march of 'selfish genes', 'big bangs', and black holes, the transmission of information through cyberspace, and so on—is being addressed by artists, in the same way that artists have always created images framed by the leading paradigms of their society.

The artist and scientist both live within and play active roles in constructing human mental and physical landscapes. That they should share structural intuitions is less sur-prising than inevitable. What is surprising and wonderful is how these intuitions have manifested themselves in the works of innovative artists and scientists in culturally apposite ways.

So much for the three-part scheme. In the event, my final reshuffling produced a more refined order that overlay but did not destroy the three big divisions. There are now ten thematic divisions that more or less 'emerged' naturally—though not without odd points of strain, when a particular piece could have fitted just as well elsewhere. The order is not some kind of absolute, given disinterestedly by the nature of things, since it mirrors my interests, but it is intended to correspond to definite features that can be discerned in the conjoined histories of images in art and science. Chronological succession remains a prominent characteristic but it does not hold sovereign sway. I think it will help to look briefly at the each of the ten thematic sections or parts.

The order of things

Microcosms, the first section, is concerned with the most compelling and widespread model in the Renaissance for the understanding of the human organism, the 'lesser world', in the broader context of the whole of God's creation. It was an ancient idea, liter-ally, but it was given renewed vitality by its expression in visual terms in the Renaissance, above all in Leonardo's remarkable representations. Microcosmic investigations range from the kinds of detailed physical explorations conducted by Leonardo and Vesalius, to the elaborate cosmological metaphysics of the *Four Seasons* print, which expounds doctrines that earlier underlay Dürer's *Four Apostles*. All of the examples can be dated to the sixteenth century, with the exception of Frederik Ruysch's preparations of bottled babies, which shows the continued vitality of the microcosm around 1700.

The earliest example in *Spatial visions*, Brunelleschi's invention of perspective before 1413, predates anything in the 'Microcosms' section, but it deals with a concept that is much newer and more radical. It is concerned with acts of seeing and representing in which the eye not only forms images geometrically, as had long been posited in the science of optics, but also provides a means to construct images according to precise rules of optical matching. Perspective is at the centre of this part, but it also extends to other acts of the 'measuring eye' by Galileo and Hooke, using the telescope and microscope respectively. There was a major conjunction of constellations of such acts in the first half of the seventeenth century in both art and science.

Nature on the move, beginning around 1700 with the first female subject of the book, Maria Merian, looks at the more dynamic, interactive vision of nature in flux that gained a hold in the eighteenth and early nineteenth centuries—modifying if not replacing the more compartmentalized and static assemblages exemplified in Bacon's proposed cabinet. It was a vision that laid essential groundwork for the Darwinian revolution. Were I now in the business of filling in gaps, perhaps the first I would rectify would be the omission of Alexander von Humboldt, whose holistic vision of natural environments found remarkable visual expression in his illustrations. Otherwise, Wright, Stubbs, Thornton, Audubon, and Turner cover a good range of the possibilities in what may be called 'romantic science'.

Systems of technical expression and representation in (mainly) nineteenth-century science lie behind the section on *Graphic precisions*. The dominant impression is the making of sober visual models, not least in the restrained medium of line illustration, that would speak of unadorned objectivity. The use of seeing devices, like the camera lucida in art or the photographic camera in science, and the more radical use of X-rays to see the previously unseeable, are characteristic of such enterprises. However, the 'aesthetic component' erupts more openly than it would in later modernist science, not least in Worthington's unabashed delight in the revelations of instantaneous photographs in 1908 and Boys' pleasure at the visual music of bubbles in his 1902 book.

Man and beast deals with the altogether more emotive business of the relationship between humans and animals, which had been reshaped by Darwin's theories of evolutionary descent (or 'ascent', as it became in the hands of the German Darwinian, Ernst Haeckel). It is a signal of the public moment of Darwin's ideas that four of the pieces are concerned with the popular culture of science in literature and film, even if one of the literary works, Mary Shelley's *Frankenstein*, was composed in the light of the earlier sensations about the nature of life occasioned by new experiments with electricity. The final piece, on Ernst's Freudian surrealism, signals the impact of another revolutionary theory about the nature of man as other than the Enlightenment paragon of reason.

Our move into thorough-going modernism is marked by the section on *Space and time*. The paradox is that the great new visualizations in physics, namely relativity and quantum mechanics, were stubbornly resistant to representation in visual terms, whilst artists strove to spin their own intractably three-dimensional media out into multidimensional space. Only Abbott, in her beautiful photographs, succeeded in representing physics directly, but she was dealing with classic phenomena. Even Feynman's famous 'diagrams' represent an encoding which serves as a powerful visual aid to intuition rather than directly representing the phenomena—in spite of obvious reference to the traces of atomic particles in cloud and bubble chambers. In one sense, the story in this part is one of artistic

delusion, yet the artwork as an 'open field' for the exercise of 'subject impulses', of which I have spoken, somehow allows more to be evoked than should be possible.

By contrast, *Making models* operates in domains where the visual means and the theoretical structures stand in a much more direct relationship. Some of the model making is of the most obvious kind e.g. the building of structures which represent on visible scales things which can only be seen through those devices that give access to ever more minute worlds, whilst other is concerned with the modelling of aspects of the visual process itself, whether it is the artist trying to control colour within the experimental field of a canvas or the psychologist of perception playing improbable games with the extraordinary properties of our visual apparatus.

Other ways of representing new worlds revealed through the instruments of science are explored in the eighth part, unsurprisingly entitled *New worlds revealed*. The worlds extend from the very distant bodies in our galaxies, which the artist James Turrell is drawing into our body on earth, to the tiny landscapes of cell walls made visible by electron microscopy. On our own planet, seemingly so familiar and well charted, large amounts of the great topographies of the underwater landscape disclosed in the second half of the twentieth century remain in the realms of *terra incognita*, at least by comparison with an area like Europe, which has been charted for centuries.

Much of the science in these later sections is concerned with process—that is to say the transitory action of physico-chemical forces that science encourages to leave behind some kind of trace. The penultimate part, *Process and pattern*, is dominated by artists who have reacted to this twentieth-century concern, either by recording traces of natural process indelibly in physical artefacts or by using process as artistic performance in a way that does not result in a fixed or settled artwork that can be purchased and housed in the customary manner. The very epitome of process is embodied in the computer—a tool which has insinuated its own kind of aesthetic into our visual lives through graphic programmes and not least through the strange world of chaos theory.

Finally, I have grouped three pieces on *People, places, and publications*, to remind us that the visual image of science does not just involve images generated to convey the content of science. How the scientist is envisaged, as an icon of intellect—or, as earlier with Frankenstein and Dr Jekyll, as a dangerous obsessive—has an effect on the very fabric of the scientific endeavour in its political contexts. That fabric is represented in more literal terms through contrasting laboratory buildings, a genre of architecture that is as extensive as it is overlooked. The examination of the styles of *Nature* itself, as a graphic product, exemplifies what I have earlier said about the eloquence of style as a register of cultural values.

I do not wish to pretend that this shuffle represents some grand scheme of things that was in my mind from the first, and I certainly do not wish to claim that it is, even in microcosm, an adequate representation of the two histories of art and science. But I hope the way I have shuffled my pack of visual cards will prove thought-provoking and stimulate critical ideas about the nature of the image at the interfaces of art and science, now and in the past. And, I would like to think that a few structural intuitions might have been surreptitiously induced. ❧

PART ONE

Microcosms

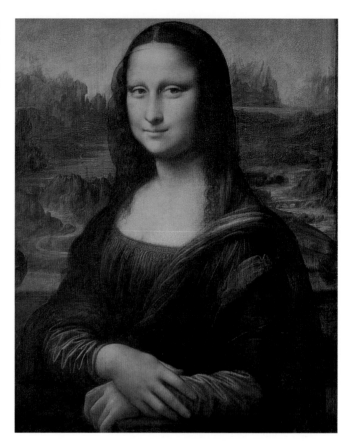

Leonardo da Vinci, *Mona Lisa* (Portrait of Lisa del Giocondo), *c.*1503–13, Paris, Louvre. Bridgeman Art Library, London

Lisa's laws

To begin our journey through the landscape of images with Leonardo's *Mona Lisa* may seem obvious and even banal. But even such a familiar work can be scrutinized through fresh eyes if we set aside our stock categories of art and science. For Leonardo the invention of a compelling image was not based on literal imitation of nature or un-licensed imagination but on the remaking of natural effects through the understanding of natural laws derived from 'experience'. The inventor's imaginative faculty or *fantasia* worked in concert with the intellect to recreate an infinity of plausible images.

Before looking at the way in which Leonardo's portrait of a lady embodies his philosophy of nature, we should try to discover her identity. If we strip away the myths of ages, it is now reasonably clear that she was indeed 'Madonna Lisa', the wife of a prominent Florentine citizen, Francesco del Giocondo—hence her nickname, 'La Gioconda', which can be trans-lated as 'the smiling one'. It is likely that Leonardo commenced her portrait in about 1503 and continued to work on it over a number of years, perhaps more than a dozen. In that time it became less of a portrait and more of a universal statement.

In this painting as in all others by Leonardo, every painted effect was, in theory, based on a natural law. For our present purposes I will highlight just four which are inherent in the *Mona Lisa*, restating in more compact form what Leonardo wrote about the phenom-ena of light on surfaces, the formation of spiral configurations, and the huge changes in the bones, flesh, and blood in the 'body of the earth'.

Law 1 'The intensity of light on a plane is proportional to the angle of impact of the light on that plane.'

Thus, on a human head, light from a point source will make its strongest impact when it strikes a surface perpendicularly. When it strikes a glancing blow, the intensity of light at that point will be proportionately weaker. The relative intensities of light on any solid body must be characterized according to this rule. Convex and concave surfaces will exhibit smooth transitions from proportionately lighter to proportionately darker.

In the eighteenth century Johann Heinrich Lambert established that the brightness was proportional to the cosine of the angle between the line of sight and that normal to the plane—the law now observed in computer rendering.

Law 2 'A helix arises from the combination of two components: a straight axis corresponding to a linear motion or a weight acting in a vertical direction; and a circular motion or shaping force in a plane perpendicular to that axis.'

Thus, a current of air or water will exhibit a desire to move forward, just as a weight desires to fall, but will be deflected by successive impacts to induce a revolving impetus, just as a substance that has an inherent desire to curl, such as hair, will be disposed to turn around the axis of its weight. Phenomena that involve direct and revolving impulses include vortices in water currents, ringlets of hair, gathered or compressed drapery, the growth of leaves in plants, shells of marine creatures, spiral staircases, and conical gears for clocks.

Law 3 'The relative positions of the sphere of water and the "body of the earth" are constantly in flux, such that different zones of solid earth are extruded from the sphere of water and become subject to erosion, while the inner caverns of the earth are also subject to periodic collapse.'

Thus mountains are eroded at their bases, eventually collapsing and damming rivers to form lakes at different levels, the higher of which will in time burst forth leaving stranded water creatures—as is witnessed by the deposits of ancient shells in high places.

Law 4 'The body of the human being as a microcosm or "lesser world" is vivified by the pulsing of the blood in its vessels just as the "body of the earth" is given life by the waters that ebb and flow across and within it.'

The woman and the landscape stand in profound harmony to each other and to the laws that govern the physical world. ✑

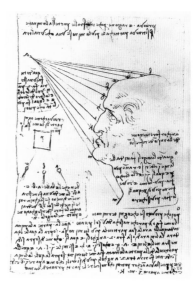

Leonardo da Vinci, *Demonstration of the Intensities of Light on a Human Face According to Angles of Impact*, Windsor, Royal Library, no. 12604r. The Royal Collection © 2000, Her Majesty Queen Elizabeth II

Leonardo da Vinci, *Comparison between Turbulent Water and the Curling of Hair*, Windsor, Royal Library, no. 12579. The Royal Collection © 2000, Her Majesty Queen Elizabeth II

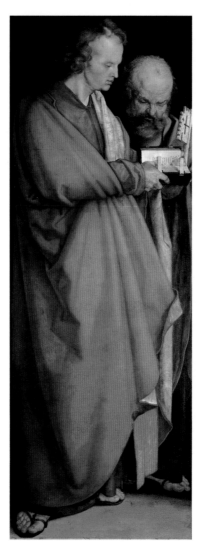
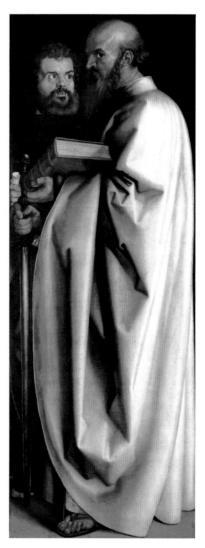

Albrecht Dürer, *Four Apostles*, 1526 (Saints John, Peter, Mark, and Paul). Artothek/Alte Pinakothek, Munich

Dürer's diagnoses

The great German painter, printmaker, and theorist, Albrecht Dürer, shared with Leonardo the quest for an art that would be 'universal'; that is to say, one that constructs representations of all forms in nature on the basis of a profound understanding of natural philosophy in all its relevant facets. Indeed, Dürer became acquainted with some of Leonardo's ideas and drawings on his second visit to Italy in 1505–6.

When portraying human beings, Dürer considered that the mental and physical constitutions of each individual were to be systematically expressed in terms of the Renaissance theories of psychology and physiology. The medical basis for characterization was the ancient and persistent doctrine of the four humours—sanguine, phlegmatic, choleric,

and melancholic—which were locked into the universal, four-fold scheme of the elements, times of day, seasons, winds, and ages of man.

The constitution of those who exhibited the sanguine temperament was composed from the predominance of the humour of blood, and was of the nature of air, morning, spring, Zephyr, and youth. The other equations were: phlegmatics with phlegm (inevitably), water, night, winter, Auster, and old age; cholerics with yellow gall, fire, midday, summer, Eurus, and maturity; and melancholics with black gall, earth, evening, autumn, Boreas, and later middle age. Each temperament manifested itself not only in behaviour but also in physical characteristics and 'complexions', not least in physiognomy and the nature of skin (colour and texture).

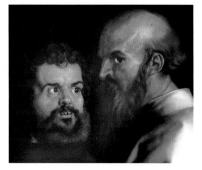

Albrecht Dürer, detail of heads of Mark and Paul

Dürer was fully conversant with such theories and embodied them in a number of his prints, but their most complete expression is in the two magnificent panels of the *Four Apostles* that the ageing artist presented as his own 'memorial' to his home city of Nuremberg in 1526—declaring that 'I have bestowed more trouble' on them 'than on any other painting'. Accompanied by Lutheran texts from the Bible, they testify in equal measure to Dürer's religious and intellectual allegiances.

The learned calligrapher, Johann Neudörffer, who wrote the inscriptions, later stated that each apostle embodied a specific temperament. There is no difficulty in identifying the sanguine

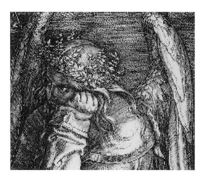

Albrecht Dürer, detail from *Melencolia I*, engraving, 1514, London. © The British Museum

St John the Evangelist, ruddy in garment and complexion; the phlegmatic St Peter, bald and stolid; the leonine St Mark, choleric in character and physiognomy; and the dusky-skinned St Paul, who exhibits the haunted look associated with melancholy 'genius', as characterized by Dürer in his famous engraving, *Melencolia I*. Like a doctor expected to observe the external 'signs' of humoral imbalance, the spectator is presented diagnostic clues through which Dürer invites us to discern their deepest natures in the context of the fourfold essence of God's creation.

Dürer's manner of characterizing individual temperaments in his published writings on human proportions exercised a long-lasting impact, not only on physiognomics but also on the nineteenth-century sciences of phrenology, craniology, and eugenics. Even now, after the refutation of humoral medicine, the insights (real or imagined) are far from dead. We all act as amateur physiognomists, however often our initial reaction to someone's 'look' is confounded. And Jerome Kagan, the Harvard developmental psychologist, in his book Galen's Prophecy, has recently advocated a return to four-part division of personality—timid, bold, upbeat, and melancholic—as corresponding to patterns of brain activity. ∾

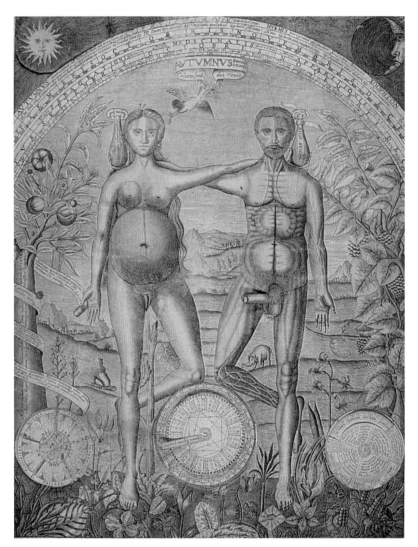

'Autumn' from the engravings of *The Four Seasons*, History of Medicine Collections at Duke University, North Carolina. © 2000 Duke University Medical Center Library

Cycling the cosmos

Any mature culture is sustained by intricate systems of belief in which each idea and practice is mutually self-reinforcing. For much of Western culture, from Greek antiquity to the Enlightenment, understanding of the nature of life in the greater scheme of things was founded upon the profoundly cyclical behaviour of the universe—the gyrations of the heavenly bodies, the phases of the moon, the passing of the seasons, the times of day. On this 'mortal coil' the 'four ages of man' acted out their endless succession. This elemental cycle of all natural things operated according to a periodic base of four.

A remarkable and apparently unique set of prints of *The Four Seasons* in the History of Medicine Collections at Duke University in North Carolina are unrivalled as a compact yet comprehensive visual encyclopaedia of the governance of human existence. Dating

from around 1600 and of northern European or British origin, they are of a complexity that defies brief summary—not least because each print is overlaid by strata of super-imposed flaps which progressively disclose deeper layers of knowledge, while rotating paper 'volvelles' can be used to plot temporal conjunctions of signs.

God's most divine creation, a progressively ageing 'Adam and Eve', are anatomized under an astrological arch, flanked by the vitalizing 'Tree of Life' and the dangerous 'Tree of Knowledge'. The busy microcosms of animals and plants within the 'body of the earth' provide the background against which the two archetypal humans pursue their life cycles, accompanied by the remorselessly ticking clock of cosmological time. In *Autumn*, the third in the series, the rich harvest of the implanting of man's seed by his alert penis is made manifest by the woman's swollen belly, which hinges open to reveal the homunculus with-in. In the fullness of time, the new birth re-initiates the cycle.

The Hippocratic mottoes on the ribbons locate the prints within the orbit of the physician's art, which was seen as founded on higher philosophical wisdom. All maladies were treated according to the doctrines of humoral medicine evinced in Dürer's *Four Apostles*, in which the body was governed by the four humours of blood, yellow bile, phlegm, and black bile. A seriously skewed imbalance would not only result in the manifestation of the corresponding temperament but would actually cause illness. The humours themselves obeyed the greater governance of the four elements of air, fire, water, and earth and their coupled qualities, moist–hot, hot–dry, cold–moist, and dry–cold.

Looking back, it may be difficult to comprehend how a system which now appears so erroneous held such sustained sway. However, once we understand how deeply the parts of the mutually supporting doctrines were embedded in institutional belief and practice, we can better appreciate how each part continued to bear witness to the validity of each other and to the essential rightness of the whole.

Faith in the rule of the planets over our lives, to take just one component, was not unreasonable, given the striking evidence of the moon's ability to shift great bodies of tidal water, and the cyclical governance evident in all aspects of the natural year. In societies that were still dominated by the vagaries of agrarian cycles, where the course of events was clearly determined by remote agencies, it was rational to believe that some hugely complex clock was at work. There was no reason why humans should prove an exception to the rule.

It seems to me that the breakdown in the com-plex machinery of the set of beliefs in the *Four Seasons* is profoundly associated with the grow-ing dominance in the eighteenth century of the urban environment, with its increasing reliance upon technology and the forging of a lifestyle based upon the conviction that scientific and technological progress will accord us mastery over nature. We are the heirs to this world-picture of human manipulative potential. But there is no guarantee that our systems of interlocking beliefs will not look as strange to later cultures as those in *The Four Seasons* now look to us. ❧

'Autumn' with the flaps of the man's body opened

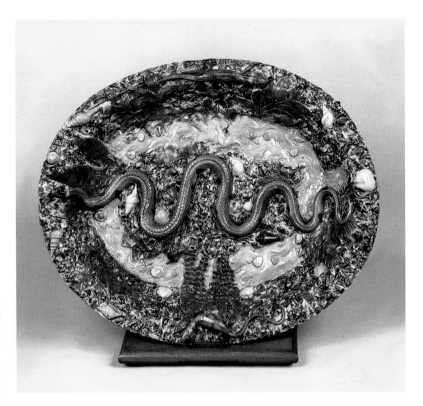

Palissy's philosophical pots

Nowadays we think of the so-called 'applied' or 'decorative arts' as just that—as combining functional application with decorative ornament—but not as conceptual vehicles for the kind of high seriousness that we associate with the 'fine arts' of painting and sculpture. But this is not a hierarchy that we can safely apply to the art of the past. It is salutary to realize that a Hellenistic chalcedony dish in the Medici collection in 1492 was valued at 10 000 florins, while the most expensive painting (by Fra Angelico) rated only 100.

The famed ceramic dishes by the eccentric Hugenot potter, Bernard Palissy, now survive as curious items in collections of ceramics, but for the artist and his royal patrons in France his creations were of great visual and philosophical moment. Palissy was named in 1563 as 'Inventeur des Rustiques Figulines du Roy' ('King's Inventor of Rustic Ceramics') and gained renown as the maker of elaborate, semi-subterranean grottoes, including one in the area of the Louvre for Queen Caterina de' Medici. After the death of the widowed Queen, he was finally imprisoned for his religious beliefs as a reforming Hugenot and met a melancholy end in the Bastille in 1590.

What distinguished Palissy's work as a grotto designer and potter was his extensive use of life casts of animals, brilliantly coloured with fused enamel glazes. Life casting of animals and plants became the expensive speciality of a number of goldsmiths in the sixteenth century, requiring prodigious skill, particularly for soft-bodied creatures. German craftsmen took the lead in metalwork. Palissy virtually scooped the field in ceramics, having driven himself to exhaustion in mastering the huge technical problems of modelling and firing. His *oeuvre*, most especially his marine creatures and amphibians, stands alongside the compelling images in the great contemporary picture books of natural history. But they are more than objects of supreme naturalism in which the maker collaborates with nature herself.

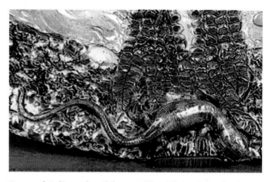

Bernard Palissy, detail from *Dish with Snake and other Life Casts*

Palissy was the author of two extraordinary dialogues on the sciences of the earth, published in 1563 and 1580. In the second of these, his *Admirable Discourse on the Nature of Waters*, he exploits his artisan's stance as 'a man without Latin' to debunk the elaborate metaphysics of the alchemists and abstruse philosophers. Like Leonardo, he proclaimed knowledge based in 'experience' as superior to the most sophisticated book learning. Probably independently of his great Italian predecessor, he advocates plain, straightforward explanations of age-old mysteries, such as the presence of springs on high mountains and the formation of fossils. Typically, he attributes fossils to a casting process:

> Just as all kinds of metals and other fusible materials take on the shape of the hollows or moulds in which they are placed or thrown, and even when thrown into the earth take the shape of the place where the material is thrown or poured, so the materials of all kinds of rocks take the shape of the place where the material has congealed.

Above all, he saw the fiery 'womb of the earth' as mirrored in his own infernal kilns, which served in his mind as microcosmic reflections of the great forces that have shaped the earth:

> The kilns in which I bake my work have taught me much concerning the violence of fire; but among other things they have made me know the strength of the elements which generate earthquakes.

Like a number of his aristocratic and learned contemporaries, he formed a 'cabinet of curiosities', but his was specifically designed to provide irrefutably empirical proofs of his geological theories:

> I have set up a cabinet in which I have placed many admirable and monstrous things which I have drawn from the womb of the earth, and which give evidence of what I say, and no one will be found who will not be forced to admit them to be true.

Palissy stands as a supreme representative of the way in which the intrusion of practical knowledge and empirical methods into the philosophical mainstream did so much to fire the revolutionary changes in science around 1600. ॐ

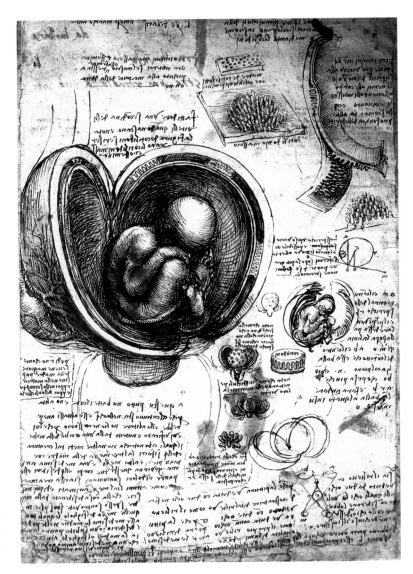

Vincian velcro

All the new graphic modes forged during the Renaissance were realized at the highest level in the drawings of Leonardo da Vinci. Indeed, he may be considered the inventor of key techniques, including the exploded view and solid section for the disclosing of natural structures.

His famous drawing of a foetus in the womb is a miracle of intense presentation, replete with visual analogies of a microcosmic kind. The womb, split open like a burst seed-case, reveals the coiled foetus, shaped into compelling roundness by the rhythmic curves of his pen. The botanical analogy, typical of Leonardo's search for explanantory parallels

between all created forms, is underscored by the ancillary sketches in the lower centre of the sheet, where the skins of the womb are peeled away to disclose its tender secrets.

The womb is clearly not that of a human mother. The cotyledonous placenta, composed from separate pads attached across the surface of the womb, has been adapted from the beautiful drawing he made of his dissection of the gravid uterus of a cow. The perfection of design that he found in that dissection could not, in his mind, be other than present in the human womb, complementing the innate sphericality of the chamber in which the new life germinates.

Alternative configurations for the interdigitations of the placenta and uterus are envisaged in two brilliantly innovatory drawings to the upper right. The peeling back of one of the cotyledons, separating reluctantly from the uterine wall like a velcro strip, is a graphic device of extraordinary eloquence.

On first glance, the two slight diagrams on the sheet, to the centre right and in the bottom right corner, appear to be unrelated—typical of the

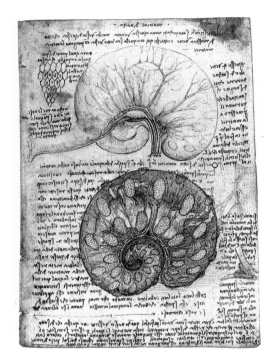

Leonardo da Vinci, *Foetus in the Womb of a Cow*, Windsor, Royal Library. The Royal Collection © 2000 Her Majesty Queen Elizabeth II

magpie restlessness of Leonardo's thought. However, the former, which demonstrates how a sphere may be stabilized on an inclined plane by an eccentric weight, probably arose during his meditations on the orientation of the foetus with its heavy head in its bath of fluid, while the latter, which demonstrates 'why a picture seen with one eye will not demonstrate such relief as the object seen with both eyes' serves as a characteristic reminder that even his skills cannot equal the effect of the actual form seen with binocular sight.

But we are still missing the core of Leonardo's vision. In his accompanying note to the *Foetus in the Womb* he speculates on a matter that we would not deem to be susceptible to 'anatomical' investigation:

> The same soul governs these two bodies, and the desires and fears and sorrows are common to this creature as to all the other animal parts, and from this it arises that something desired by the mother is often found imprinted on the limbs of the infant ... and a sudden terror kills the child.

Viewed in this light, the drawing is a study of what he calls the 'great mystery' of the foetus in the waters of the womb, a dreamer whose very thoughts and body are irresistibly shaped by an intimacy between two beings that can never be exceeded. There was no such thing as 'descriptive anatomy' for Leonardo, unless we extend description to embrace the profoundest instincts about human life in the greater scheme of things. ✑

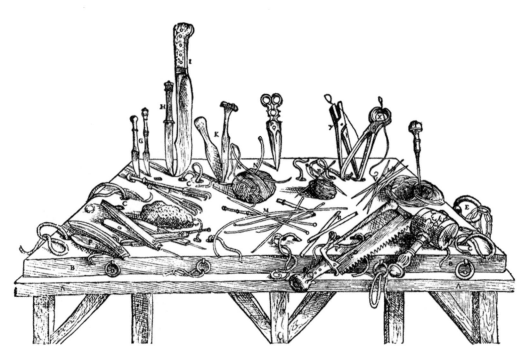

CHARACTERVM SEPTIMI CAPITIS FIGVRAE INDEX.

Andreas Vesalius, 'Tools for Dissection' from *De Humani Corporis Fabrica* (Book II, vii). Wellcome Institute Library, London

Vesalius' veracity

Showing the tools of the trade was a long-standing practice in the illustration of surgical texts, not least in the manuscript tradition that looked towards Islamic sources. With the rise of naturalistic illustration, particularly in the great picture books of the human and natural sciences in the sixteenth century, the equipment could be displayed with a new conviction. The instructional role of such representations seems obvious. But is their function and meaning as simple as this?

When Andreas Vesalius of Brussels displayed an array of dissecting instruments—many of which were common or garden in the literal sense—he was demonstrating to the reader 'everything that could be used in the conduct of dissections or an entire anatomy'. The implication is that the aspiring dissector would be fully kitted out if he could lay his hands on everything in the woodcut.

However, Vesalius' large and luxurious volume, *De Humani Corporis Fabrica*, dedicated in 1543 to the Holy Roman Emperor, Charles V, can hardly be considered as a stock handbook aimed at tiros or even the jobbing surgeon. It was an expensive production aimed at the wealthy and the learned.

The level of knowledge in the *Fabrica* went far beyond the rude empirical procedures

needed by a field surgeon or even the kind of court employee Vesalius was aspiring to become. The *Fabrica* was more in the nature of a philosophical treatise on the architectural magnificence of the human body, bearing witness to Vesalius' heroic excavation of the inner truths of its fabric. By revealing the miracles of bodily form and function through magnificent representations, he was paying open homage to God as the supreme artifex of the supreme edifice in the created world.

The illustration of the tools is just one move in a series of visual strategies to underline the veracity of Vesalius' representations. He is at pains to stress that his knowledge is literally firsthand; that is to say he had, as his frontispiece demonstrates, descended from the aloof heights of the professorial cathedra to undertake the cutting on his own account. This direct intervention extends beyond anatomies of the dead; he tells us that the board bearing the instruments is 'such as we employ in vivisections, resting on a table'.

This board, illustrated again on two occasions in the *Fabrica*—once with an unfortunate pig tethered to its rings and apertures, and also within an illuminated letter 'Q' with eager *putti* actually performing the vivisection—makes open reference to the experiments by Galen, the Alexandrian philosopher and doctor. Vesalius is at once aspiring to surpass Galen in firsthand knowledge and setting himself up as a second Galen—following his great predecessor's principles of deducing function rigorously from observed form.

In the famous series of muscle-men, heroically performing their myological striptease in grand landscapes, Vesalius repeatedly emphasizes the physical reality of his procedures, describing, for instance, precisely how the figures were suspended by ropes. Less well known is his innovative use of visual proof through mechanical analogies, as in his illustrations of the metal hinge of a window shutter and his neat demonstration of the restraining role of the transverse ligament in the ankle.

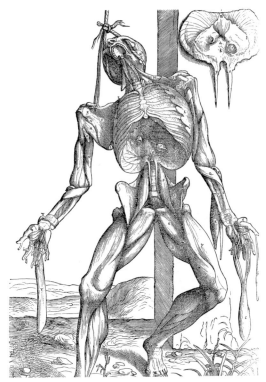

Andreas Vesalius, 'Seventh Plate of the Muscles' from *De Humani Corporis Fabrica*, Basel, 1543 (Book II, xxx). Wellcome Institute Library, London

Andreas Vesalius, 'Demonstration of the Need for a Transverse Ligament in the Ankle' from *De Humani Corporis Fabrica* (Book II, i). Wellcome Institute Library, London

Vesalius not only aspires to show us the physical realities in the most dramatic fashion, he also uses visual devices to convince the reader of the physical truth of his observations. ❧

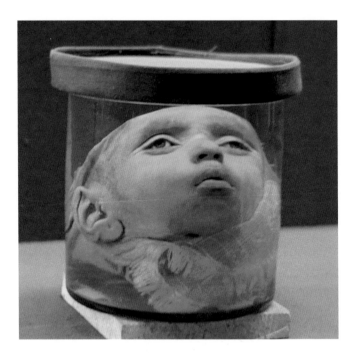

Frederik Ruysch, the head of an infant with dissected cranium and glass eyes, from the Kunstkammer of Peter the Great in the Museum of Anthropology and Ethnography in St Petersburg

Babes in bottles

The sight of pickled babies and their severed parts, floating in jars of balsamic liquor, adorned with lace cuffs, elaborate hats, and festoons of beads, is bound to make the modern spectator feel uneasy. Yet seventeenth-century visitors to the 'cabinet' of Frederik Ruysch in Amsterdam appear to have expressed no disgust. The science and aesthetics of anatomical preparations were clearly very different from those in a modern anatomical museum.

Dr Ruysch was Praelector Chirugiae et Anatomiae for the City of Amsterdam over a remarkable span of time—from 1667 until his death in 1731—as well as serving as the supervisor of its botanical garden (i.e. responsible for herbs). He was the subject in 1670 and 1683 of two paintings in the famous series of Dutch 'anatomy lessons', of which Rembrandt's recently restored *Anatomy of Dr Tulp* is the most celebrated. An acclaimed teacher and popular public dissector, Ruysch gained international fame for anatomical preparations made by his secret techniques of injection both of isolated systems such as blood vessels and of whole corpses prior to dissection.

One witness to Ruysch's collection delighted in 'groves of plants and designs of shell-work with skeletons, and dismember'd limbs ... with apposite inscriptions from the Latin poets'. His grand house in Amsterdam became a tourist attraction, visited by 'generals of armies, ambassadors, electors, and even princes and kings'. One such monarch, Tsar Peter the Great of Russia, was so impressed that he purchased the whole ensemble in 1717 for the princely sum of 30 000 guilders and installed it in his new city of St Petersburg, where many specimens still survive in the Kunstkammer of the National Academy of Sciences.

One lost exhibit, illustrated in a folding plate in Ruysch's *Thesaurus Anatomicus* of 1717, took the form of a small mountain scattered with gall, kidney, and bladder stones on which flourishes a forest of injected vessels. The elaborate tableau is completed with three grieving infants' skeletons, creating a miniature 'theatre' on the theme of the transience of life. The 'trees' of vessels and bodily rocks stress the microcosmic conception of the human body as a 'lesser world'.

Many of the preparations displayed the whole or parts of babies, whose small corpses were available to him through his obstetric activities and were readily susceptible to injection. Ruysch did not concentrate on the kind of monstrous deformities which attracted popular curiosity, but rather on preparations that aspired to evoke the beauty of 'innocents', dead before their time. In the Kunstkammer, we see amputated limbs emerging from lace cuffs, tenderly supporting a dissected heart, an intact placenta. An eye dangles from tiny fingers on a fine thread in an example remaining in Leiden. In the example from St Petersburg shown here, now housed and bottled far more plainly than in its original context, an infant's head, horizontally sectioned to reveal the open cranium, conceals its severed neck behind a fine lace scarf, whilst its glass eyes regard the enquiring viewer with an eerie similitude of consciousness.

Frederick Ruysch, 'Tableau of Injected Vessels and Body Stones' from *Thesaurus Anatomicus*, 1717. Wellcome Institute Library, London

Having experienced fleeting lives, at best, Ruysch's infant subjects have been accorded a kind of immortality, cheating rigor mortis and even long-term decomposition. At least, this is how they were seen at the time. As a poem printed in his *Thesaurus* said:

> Through thy art, O Ruysch,
> a dead infant lives and teaches
> and, though speechless, still speaks.
> Even death itself is afraid. ❧

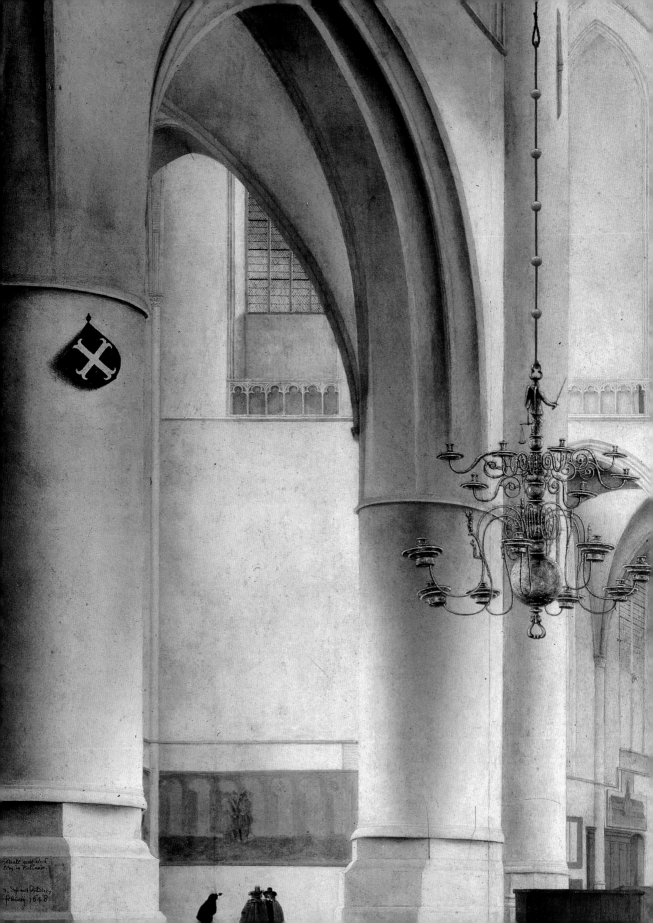

PART TWO
Spatial visions

The Baptistery of Florence Cathedral, photographed at 45° to Brunelleschi's line of sight. © Michael S. Yamashita/Corbis

Basically Brunelleschian

A historian of visual representation has an essentially easy task in choosing the most decisive act in the development of the kinds of naturalistic images with which we are constantly regaled in the media. However, the two seminal works which testify to this act are irredeemably lost. When, probably before 1413, Filippo Brunelleschi painted two demonstration panels to show how to represent space and objects on a two-dimensional surface according to the systematic optical rules of perspective, he was establishing a mode of depiction that was ultimately to affect the conveying of visual imagery in virtually every field of artistic, scientific, and technological activity. When we look into the implicit 'boxes' of space behind the screens of our televisions or computers, we are distant legatees of Brunelleschi's vision.

Our source for the lost images is an early biography of the Florentine sculptor, goldsmith, architect, and inventor, who was particularly famed for his great dome of Florence Cathedral. The biographer, generally assumed to be his friend, Antonio Manetti, describes how Brunelleschi charted the optical appearance of the octagonal Florentine Baptistery within its piazza from a vantage point within the central portal of the cathedral. He set up the resulting painting, which was about 30 centimetres square—with a silvered sky and executed so well that 'no miniaturist could have done better'—as a peep-show. He drilled a conical hole in the panel at the point where the perpendicular line of his sight struck the Baptistery, and spectators looked through the reverse of the

panel at a mirror held in front of the painted surface. The spectator would have been able to raise and lower the mirror to check the veracity of the depiction.

The second panel represented another site of great moment to the Florentines, the Palazzo de' Signori, the semi-fortified building that was their seat of government, as viewed diagonally from the corner of the piazza. In this instance, since the panel was larger, Brunelleschi cut out the upper silhouette of the array of buildings so that the real sky could be seen above the painted roofs.

We do not know the projective procedures used by Brunelleschi—I am inclined to think that he adapted the practical surveying techniques of which he was undoubtedly master—but we are assured by Manetti that Brunelleschi had invented what came to be called 'perspectiva' (the Latin term previously used to denote the science of optics).

The effect of Brunelleschi's invention on Florentine painting and relief sculpture of the next decade was revolutionary, not least in the fresco of the *Trinity* by Masaccio. A body of theoretical literature quickly gathered around the new science, including the seminal book by Leon Battista Alberti, *On Painting*, and the specialist treatise on perspective by the painter–mathematician, Piero della Francesca. During the next two centuries the painters' science was integrated into the sciences of projection by such mathematical luminaries as Federigo Commandino, Guidobaldo del Monte, Simon Stevin, and Girard Desargues.

The conceptual significance of Brunelleschi's invention was enormous. He had effectively established that there was a direct and verifiable relationship between something viewed from a particular point and its two-dimensional image on a plane surface—a canvas, panel, wall, or sheet of paper (most significantly, on the page of an illustrated book). A machine could be depicted to show how it would look to someone standing in front of it. Kepler's geometrical model of the cosmos could be shown as if it were a piece of divine clockwork. An animal could be portrayed standing solidly in a credible space. In short, anything could be represented in such a way that we seem to become surrogate eye-witnesses. The skilled image-maker persuades us to trust that what we are being shown has been portrayed, as they say, 'from life'.

It was not all gain, however. The technique that painters used to give compelling reality to scenes contrived in their imaginations could be used to convince the observer that a depiction of something chimerical, like a unicorn, recorded the real thing. Furthermore, an illusionistic picture necessarily hides aspects that cannot be seen from a single, static viewpoint—a particular disadvantage if we are seeking to understand all the parts of a complicated piece of machinery. However, later variants of orthodox perspective, such as orthogonal and isometric—in which consistent dimensionality rather than progressive diminution is shown—allowed further dimensions of precise information to be conveyed.

Not least, as a tool for visualization, the perspectival system lets us imagine objects in measurable space. Those artists and scientists gifted with high levels of spatial intuitions can manipulate form and space by mental sculpting. And they can demonstrate the results of these acts through perspectival images.

Lost they may be, but Brunelleschi's demonstration panels rival any surviving artefacts for their effect upon what we see on a daily basis. ∾

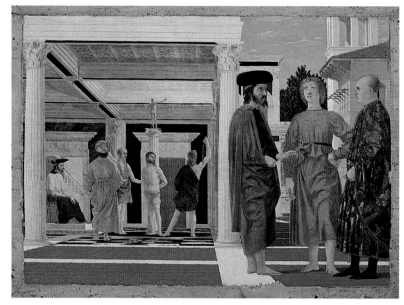

Antonio Criminisi, direct
analysis by computer of
the *Flagellation*, 1999

Piero della Francesca,
*Flagellation, c.*1465,
Urbino, Gallerie
Nazionale delle Marche.
Bridgeman Art Library,
London

Piero's perspective

If we search for cardinal examples of the *influence* of art on science, perspective provides the most striking and readily demonstrable example. It rapidly became a stock in trade for any artist who wished to remain abreast of the latest techniques—initially in Italy, and subsequently across Europe. We will subsequently see its widespread adoption by mathematicians and scientists concerned with the characterization of space.

For many artists, perspective assumed the status of a convenient technique—a routine geometrical-cum-optical trick to establish the illusion of a space behind the surface of a picture. For a minority of theoretically inclined artists, however, it acted as a research tool

through which the picture became an experimental field for the geometrical construction of illusions which might emulate the optical force of real space.

Even more exceptionally, the mastery and use of optical rules could become an ethical imperative. The greatest of such artists was the Renaissance painter, Piero della Francesca. Even a quick inspection of his relatively small painting of the *Flagellation* will reveal the meticulous construction of an exceptionally deep platform for the 'actors', passing back from the zone in which three figures debate the nature of Christ's torment, as disclosed in the middle ground, to a distant piazza. Careful analysis, either by hand or by computer, reveals the extremes to which he went to comply with mathematical rigour. For example, the complex tile pattern within the loggia is projected with scrupulous precision and is founded upon a series of related squares, the larger of which have side lengths equal to the diagonal of the smaller (i.e. √2).

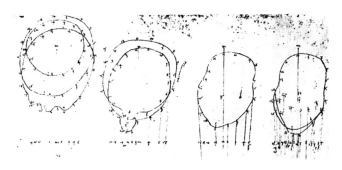

Piero della Francesca, projection of successive horizontal sections of a head on to picture plane, from *De Prospectiva Pingendi*, Parma Biblioteca Palatina, MS 1576

Exceptionally for an artist, Piero was the author of books on practical mathematics (with simple algebra) and the geometry of the five regular polyhedra, as well as *The Perspective of Painting*. His treatise on perspective shows how to plot the outlines of forms systematically on to a foreshortened plane, and how to use the plan and elevation of solid bodies to project them laboriously point by point on to an intersecting plane from a fixed viewpoint. The illustration included here shows the plotting of points disposed in horizontal bands around a head, the results of which are to be coordinated with plots from the same head in profile. We know that he followed such meticulous procedures in wall paintings even when the effects were so far away from the spectator that they could not be appreciated. Getting things right was integral to his contract with God's design of nature.

But amidst this extreme rationality, he is a painter of miracles which lie outside optical logic. The space occupied by Christ in the *Flagellation*, and the section of ceiling above his column, is paradoxically flooded by a burst of light from a source within the architectural space. Only Christ is aware of this miraculous intrusion, and it seems that he himself floods the coffered ceiling immediately above him with supernatural radiance. It is the very logic of Piero's perspectival consistency that allows him to highlight the supranormal power of the divine. ❧

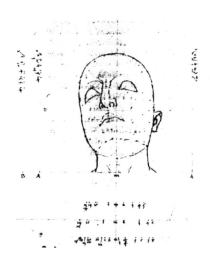

Piero della Francesca, completed projection of a titled head, from *De Prospectiva Pingendi*

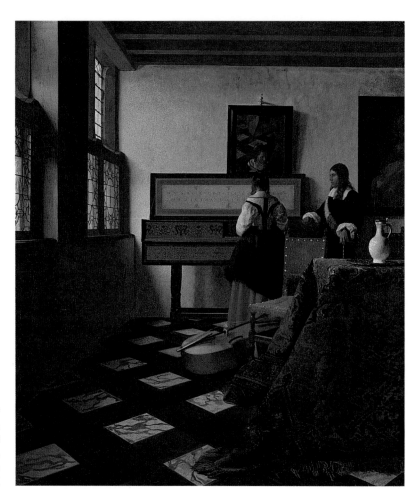

Jan Vermeer, *The Music Lesson*, *c.*1670, London, Buckingham Palace. The Royal collection © 2000, Her Majesty Queen Elizabeth II

Vermeer's vision

There are some artists whose works provide incontrovertible testimony to the highest levels of intellectual deliberation, and yet for whom we have virtually no firsthand evidence of any framework in pictorial theory or the science of vision.

The absence of substantial written testimony for such 'intellectual' painters as Velázquez, Chardin, and, above all, Vermeer, could simply indicate that all relevant evidence has been lost. However, it is more probably a reflection of a shared conviction that there were no contemporary theories of seeing and representation that could adequately describe the processes of perception and depiction they addressed in their paintings.

It has long been surmised that a number of seventeenth-century Dutch painters made use of the camera obscura—newly available in a developed form with lenses—as an aid to their supreme naturalism, and the research of Philip Steadman on a group of ten paint-

ings by Vermeer set in the same space suggests that he set up the far end of the room as a walk-in 'optical chamber'.

Steadman's model of the room confirms the extraordinarily high levels of internal optical consistency in paintings like *The Music Lesson*—even down to the penumbral fan of shadows beside the mirror on the end wall. It seems likely that the artist laid down the basic disposition of the forms on the basis of their projection through a lens inserted into an aperture in a partition and on to a screen attached to the opposite end wall. In such an image, the tones and colours would typically be condensed into a beguilingly unified 'picture' on an appropriate scale. The presence of pinhole pricks at the vanishing points in some of his canvases does not refute the use of the camera, but shows the care with which Vermeer drafted the resulting geometry on the pictorial surface.

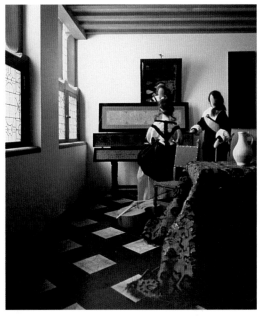

Philip Steadman, photograph of a model of *The Music Lesson*

What the projected image could not do, however, was to tell Vermeer how to translate the characteristic visual effects of the camera image into the actual substance of paint in such a way that the resulting image stood as a perceptual analogue of the real scene. Our immediate re-action is to think that Vermeer is a master 'describer', filling his scenes with meticulously rendered detail. But this is not the case. He had learnt, by a hard-won process of pictorial trial and error, that when the artist wishes to cajole our perceptual system into collaborative action that less is definitely more.

The hues and tones of the generalized patches of paint—virtually abstract on close viewing—are pitched with such deliberative skill within the spatial framework that we irresistibly see more than is actually there. It is like a very complex version of the optical illusions beloved of psychologists of perception. What Vermeer has discovered, using the picture as an experimental field, is that more compelling illusions can be achieved through encouraging our perceptual system to do the lion's share of the work than through the most niggling assertion of detail.

Yet there remains something uneasy in making such inferences about the artist's ideas from the pictures alone. There is, perhaps, one crumb of comfort. The great microscopist, Anthony van Leeuwenhoek—who somehow managed to see bacteria in one of his single-lens instruments—was an executor of Vermeer's will in 1667. What one would give to hear a conversation from the two great 'see-ers' on the business of human vision! ❧

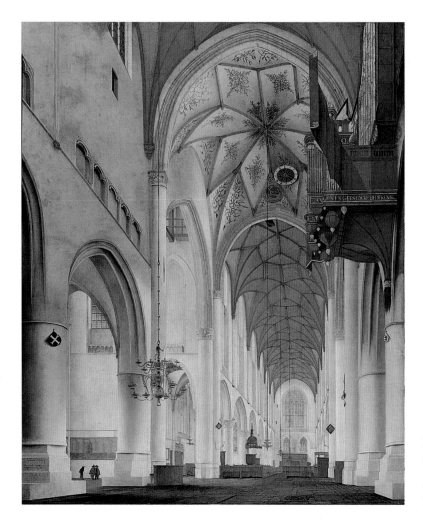

Pieter Saenredam, *Interior of St Bavo's, Haarlem*, 1648. The National Gallery of Scotland, Edinburgh

Saenredam's shapes

One of the peculiarities of linear perspective is that the more rigorously we follow the principles of mathematical projection to create convincing illusions of forms in space, the more we become aware of their strange shapes on the flat plane of the picture surface. This is particularly true for geometrical forms that lie near the margins of wide or tall pictorial fields.

Those perspectivists who have most assiduously followed the geometrical rules to make linear constructions have also exhibited the greatest awareness of the implications of the surface configuration of projected forms. Piero della Francesca in the Renaissance and Pieter Saenredam in seventeenth-century Holland stand supreme in this respect.

Saenredam specialized in paintings of churches. He transformed the apparently limited subject of sacred interiors into a genre devoted to hymns in praise of the geometrical art

of seeing space. We know from his drawings and related notes that he made on-the-spot sketches and obtained accurate measurements from building surveys. From these he developed elaborate construction drawings, projecting measurements from a scale along the base of the drawing on to the orthogonals (the lines that converge on the vanishing point).

He was at pains to emphasize that his was an art of the geometrical observer. He consistently marked what he called the 'eye point' on his first sketches, using a dot surrounded by a circle, and typically inscribed his presence as a witness somewhere on the fabric of the building in the painted versions. On the leftmost pier in the large 'portrait' of St Bavo's we read, 'This is the cathedral Great Church of Haarlem in Holland. Pieter Saenredam finished painting this on February 27, 1648'.

However, a close comparison of the final painting with a precise projection from his viewpoint shows that he has judiciously adjusted some of the shapes, most notably by stretching the two nearest arches upwards, to make his composition function to best effect on the surface of his wooden panel. He balances the requirements of precise illusion with need to orchestrate the fragile network of lines which endow his surface composition with such tensile beauty.

There is little doubt that Saenredam was fully alert to the way that projective geometry in his era was exploring the transformation and homologies of such figures as squares and triangles in perspective. He is known to have owned volumes by Simon Stevin, the mathematician, physicist, and engineer. Stevin's treatise on perspective, which is not actually listed in Saenredam's library but is almost certain to have been known to him, follows the uncompromisingly geometrical approach of Guidobaldo del Monte, whose perspective book of 1600 set the standard for projective geometry. A series of exercises by Stevin and his successors show how to project geometrical shapes positioned at any angle from a viewpoint at any given height and distance.

Samuel Marolois, 'Perspective Projection of a Square', from *Opera mathematica*, 1628, Amsterdam

For Guidobaldo and Stevin, and for the great French master of projective geometry, Girard Desargues, the abstract mathematics of perspective (for all its practical application in art) held a cerebral fascination sufficient unto itself as a manifestation of divine order. For Saenredam, it was the sensate geometry of light passing through mathematically realized space that provided the beginning and end of his quest to reveal the visual wonders of architecture made for worship. ∽

Kepler's cosmos

Copernicus' programme to purge the existing, Ptolemaic model of the universe of its growing burden of disfiguring complications was driven not least by what we would call aesthetic considerations. The architecture of his heliocentric system reinstated the geometrical integrity which the Greek astronomers had sought, and he sung a hymn in its praise:

> At rest … in the middle of everything is the sun. For in this most beautiful temple, who would place this lamp in another or better position than that from which it can light up the whole thing at the same time?

Although his new 'temple' obeyed the principles of harmonically unified design advocated in the Renaissance, his conventionally diagrammatic representation of the new scheme as a flat series of concentric circles did not avail itself of the new spatial vision inherent in the buildings and paintings of the Renaissance masters. It was Johannes Kepler, fervent Copernican and Platonist, who was to ally the new visual forms with the new astronomical vision.

Amongst the many visual testimonies to Kepler's extraordinary powers of spatial visualization, none is more remarkable than the great cosmological model he illustrated perspectively in a fold-out plate in his *Mysterium Cosmographicum* (1596). We know how the scheme came to be envisaged. He tells how, when he was teaching his 'students the way Great Conjunctions jump eight signs at a time', he drew 'many triangles, or quasi triangles, in the same circle', and it began to dawn on him that the distances between the orbits of the planets could be explained if the ratios between successive orbits were designed to be equivalent to the spheres successively circumscribed around and inscribed within the five 'Platonic solids' (the regular polyhedra), nested one inside the other.

Woodcut after Leonardo da Vinci, 'Truncated Icosahedron', from Luca Pacioli, *De Divina Proportione*, 1509

In its most ambitious form, Kepler envisaged that his Platonic machine would be driven by clockwork and that its hollow armature would be filled by alcoholic beverages of a suitable kind. (It was, after all, a courtly creation, dedicated to Duke Frederick of Wirtenberg, who literally acted as a protector for Kepler as a Copernican 'heretic'.) The form of visualization and representation in the model stood in direct line of succession from the form of spatial illustration invented by Leonardo da Vinci for the treatise on the five regular polyhedra, *De Divina Proportione*, originally written in 1496 by his colleague in Milan, Luca Pacioli. Even though this model was to be supplanted when Kepler determined that the orbits were elliptical, his view of the cosmos as 'aesthetically' perfect remained constant.

The pervasiveness of mathematical harmonics for Kepler was such that they not only explained the music of the heavens, but also provided a model for forms of government. Taking his cue from Jean Bodin's *Les Six Livres de la Republique* (1576), he set out broad equations between aristocratic republics and arithmetical proportions, and between royal governance and geometrical proportions. He argued that the rule of proportion is such that it should permeate every relationship in society from the formulation of laws to the weighting of punishment and from the delights of friendship to the division of inheritances. Tempered proportion and apportionment is the rule in all things; things should, as far as possible, be on earth as in the heavens. ❧

René Descartes, 'Celestial Vortices' from *Principia Philosophiae*, 1644. Wellcome Institute Library, London

Cartesian contrivances

How to envisage and represent the ways that nature works has been the major challenge for illustrators of physical phenomena. Such things as invisible forces or the mechanisms responsible for 'action at a distance' can be described abstractly in words or encapsulated in mathematical formulas, but generations of natural philosophers and physicists have felt an apparently compelling need to develop and express their theories in more visually concrete terms, frequently by reference to existing machines or specially contrived mechanical analogies.

For a philosopher as obsessed with mechanism as René Descartes, the relationship between 'seeable' machines and the unseen machinery of God's cosmos was a matter of the greatest moment:

> The operations of things made by skill are, for the most part, performed by apparatus large enough to be easily perceived by the senses: for this is necessary so that they can be made by men. On the other hand, however, natural effects always depend on some devices so minute that they escape all senses.

To overcome this problem, Descartes' publications brilliantly exploit virtually all the modes of illustration available in the seventeenth century, ranging from pictorial representations to abstract diagrams and including, of course, his key invention of co-ordinate geometry. He exhibited a particular genius for the demonstration of invisible phenomena in terms of mechanical contrivances. A number of his visual conceptions, such as his analysis of binocular vision and the inverted image on the retina in terms of a blind man with a pair of sticks, became oft-repeated classics.

Descartes was aware, however, that demonstration by mechanical analogy could be taken too literally—that the contrivance itself could all to easily be seen as constituting *proof* of what is actually happening. This was a trap into which many predecessors and contemporaries had fallen. Even for a philosopher who sought to explain all aspects of the physical world in terms of the action of matter on matter, illustration by mechanical analogy was a limited device. Accordingly, he scolded those who viewed his vivid aids to visualization in too obvious a way: 'I did not say that light was extended like a stick, but like the actions or movements transmitted by a stick.'

The blind man probing with his sticks simply helps us to understand how vision might work in terms of the underlying properties of things in action. The phenomenon and its mechanical visualization were analogous symptoms of the three prime properties of mechanical systems—magnitude, figure, and motion—through which causes and effects were to be analysed.

His desire to convey the physical texture of even the most qualitative of his speculations is vividly shown in the 'picture' of his famous celestial vortices. The analogy here is hydraulic. Between the extremes of the most refined and luminous kinds of particulate matter and the coarse, weighty material of the earth and planets were mobile globules that flowed in ceaseless whirlpools. These constituted a dynamic kind of cosmic foam that activated the apparent voids between celestial bodies. His extraordinary illustration of the sun in the midst of its own vortex, packed within a three-dimensional system of contiguous vortices, stretches even his illustrative resources to breaking point, but does a vital job in giving tangible reality to his hypothesis in a way that words could not emulate. ❧

Claude Nicolas le Cat, illustration of the optics of the eye and Descartes' crossed sticks analogy, from *A Physical Essay on the Senses*, 1750. Wellcome Institute Library, London

Galileo Galilei, 'Light and Shade on the Surface of the Moon', original telescopic drawing for *Siderius Nuncius* (Venice, 1610), Biblioteca Nazionale Centrale, Florence, Ms Gal. 48, fol. 28r

Maculate moons

We all exhibit a powerful tendency to see what we want to see. And it often takes a huge effort to effect a radical shift in our perceptions. When Galileo trained his improved 'spyglass' on the moon in the winter of 1509, he became convinced that 'sane reasoning' can reach no other conclusion than that the moon 'is full of prominences and cavities similar, but much larger, to the mountains and valleys spread over the earth's surface'. But he had reckoned without the powerful grip of those philosopher–theologians who wished to sustain their perception of the heavens as 'immaculate'.

For Galileo the argument seemed as clear as the nose on one's face—or as the Apennines that provide the spine of central Italy. Looking at the changing borderline between the lit and shaded hemispheres, he observed features that behaved like the shining and shaded ridges of mountains flanking valleys on earth. Bright points were seen to sprout and grow within the shadowy border, like earthly mountains progressively receiving more rays of the 'rising' sun. Working out the optical geometry of the most prominent spots in terms of the passage of light across the surface of a rough sphere, Galileo computed the most prominent mountains as no less than four miles high.

Not everyone saw the same thing however. Thomas Harriott in England had already viewed and drawn only a 'strange spottednesse' with his low-grade instrument, while Christopher Clavius and his fellow 'mathematicians' in Galileo's Rome reported that it was 'more probable that the surface is not uneven, but rather that the lunar body is not of uniform density and has its dense and rarer parts'. Roman Jesuits were committed to the translucent immaculacy of the moon, in accordance with the Song of Songs in the Bible

where the Virgin's pure beauty is identified with the moon—'*pulchra ut luna*'. Accordingly, they condemned the 'filth of opacity' implied by Galileo's characterization.

Why did Galileo see and represent so clearly? The quality of his telescopes was obviously important, as was his conceptual freedom from dogmatic theology. But an essential ingredient was his ability to articulate his acts of scrutiny and graphic record through a sophisticated understanding of mobile light on bodies with uneven surfaces. As an accomplished draftsman and aficionado of perspective, he was fully acquainted with the science of cast shadows outlined in such textbooks as Albrecht Dürer's *Instruction in Measurement* (1528) and Daniele Barbaro's *The Practice of Perspective* (1569).

A member of the artists' Academia del Disegno in Florence and friend of the leading artist, Ludovico Cigoli, Galileo was also aware of the tradition, inaugurated by Leonardo da Vinci, of minutely systematic observation and depiction of light in landscape according to the angles and direction of the sun relative to the observer. Cigoli's own treatise on perspective directly quoted from Leonardo's unpublished writings. When Cigoli came, in 1610–12, to portray the *Virgin of the Immaculate Conception* in the dome of the Capella Paolina in Santa Maria Maggiore in Rome, he depicted Mary standing on a pitted and maculate moon rather than the smooth crescent of convention. In his defence, the painter could have pointed to an earlier tradition which justified the placement of the moon below Mary's feet on the grounds that its patchy and inconstant appearance testified to its lowly status in the heavens.

Yet for all his hard looking and knowing draftsmanship, the details of Galileo's cratered moons are difficult to align precisely with actual features. With a field of view of less than half the moon's diameter, and the inevitable difficulties of charting details within no existing framework, Galileo has in effect shown what happens as sunlight skates over the lunar landscapes, within the limits of what his lenses could deliver, rather than being able to construct a precise map. His purpose was to show the moon as earth-like. He sees what *he* wants to see and persuades us to do the same. ❧

Ludovico Cigoli, *Virgin of the Immaculate Conception*, Rome, Santa Maria Maggiore, Capella Paolina. Bridgeman Art Library, London

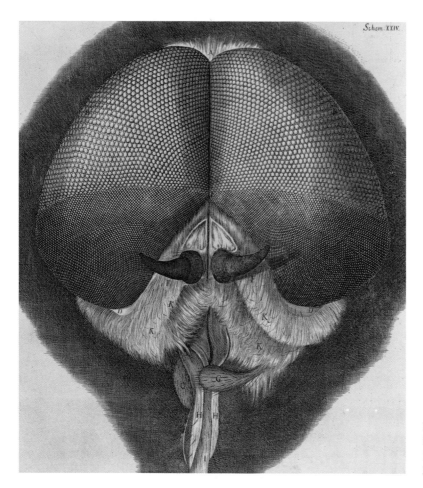

Robert Hooke, 'Eye of a Fly', from *Micrographia*, 1665. The Natural History Museum, London

Hooke's housefly

Every act of looking is an act of active interpretation. In our normal visual territories we unconsciously perform countless such acts each day without major problem. When we are confronted with unknown sights in visual landscapes of which we have no prior experience, the complex interaction between seeing and knowing becomes openly problematic. The arts of microscopic observation, no less than the images seen down telescopes, have posed and continue to present continued challenges to our perceptual abilities.

The perceptual issues and the philosophical implications of microscopy are encapsulated in its first all-round masterpiece, Robert Hooke's *Micrographia*, published in London in 1665. Working in the context of the newly founded Royal Society, Hooke was commissioned to complete the project of microscopical observation and representation begun for King Charles II by Sir Christopher Wren, mathematician and architect.

Hooke was dedicated above all to 'plainness and soundness of *Observation*'. But, as he

well knew, observing and representing are complex businesses, above all with the 'adding of *artificial Organs* to the *natural*', as is the case with both microscopes and telescopes. The crucial problem is the 'disproportion of the Object to the Organ'—whether the object is too big for the eye or too small, too close or too far away.

The key was to be able to translate the seen patterns of lights and darks into a coherent, three-dimensional image with reference to known forms. Hooke describes how:

> I have endeavoured … first to discover the true appearance … I never began to make a draught before by many examinations in several lights, and in several positions to these lights, I had discover'd the true form. For is it is exceeding difficult in some Objects to distinguish between a prominency and a depression, between a shadow and a black stain, or a reflection and a whiteness in the colour.

As an example of the perceptual problems, he cites the eye of a fly, which was the subject of one of his most stunning plates:

> The Eye of a Fly in one kind of light appears almost like a lattice, drill'd through with abundance of small holes … In the Sunshine they look like a surface cover'd with golden Nails; in another posture, like a surface cover'd with pyramids; in another with Cones; and in other postures of quite other shapes.

His text relies repeatedly on the use of analogies with the world of familiar objects. This use of resemblance serves to underline the ever more minute microcosmic affinities that microscopy was disclosing. As he wrote: 'Little Objects are to be compar'd to the greater and more beautiful Works of Nature, A Flea, a Mite, a Gnat, to a Horse, an Elephant, or a Lyon.' The flea, as a miracle of micro-engineering, is 'adorn'd with a curiously polish'd suit of sable Armour, neatly pointed, and beset with multitudes of sharp pins, shap'd almost like Porcupine's Quills, or bright conical Steel-bodkins'.

Robert Hooke, 'Flea', from *Micrographia*, 1665. The Natural History Museum, London

Throughout the *Microcraphia*, the beautiful mechanics and geometry of the smallest microcosms are made repeatedly manifest, courtesy of Hooke's intelligent eye and elegant hand. The early readers of his book were privileged to enter a world of form and space previously unimaginable and no less magnificent than the one with which they were already familiar. ☙

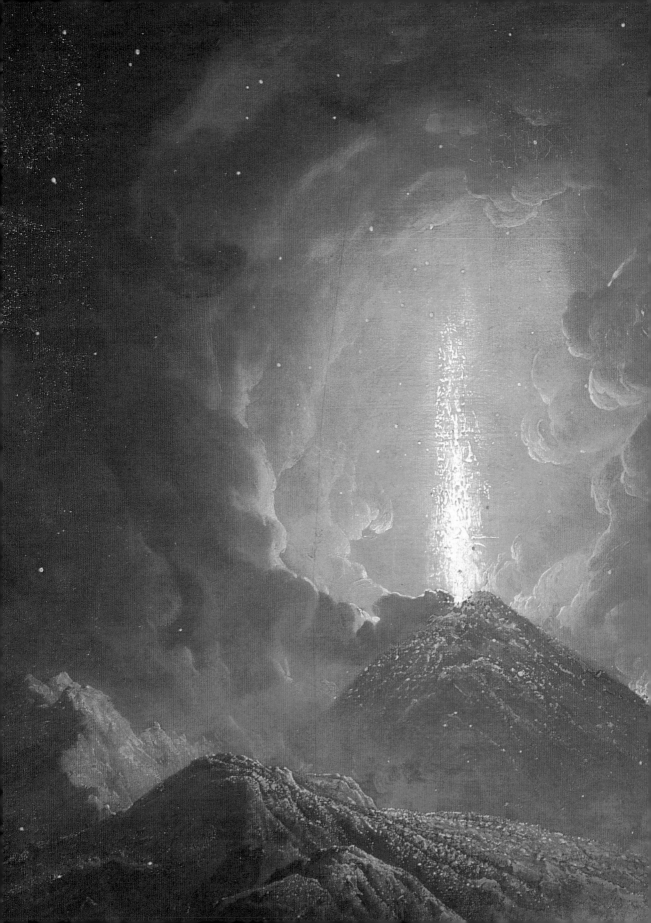

PART THREE
Nature on the move

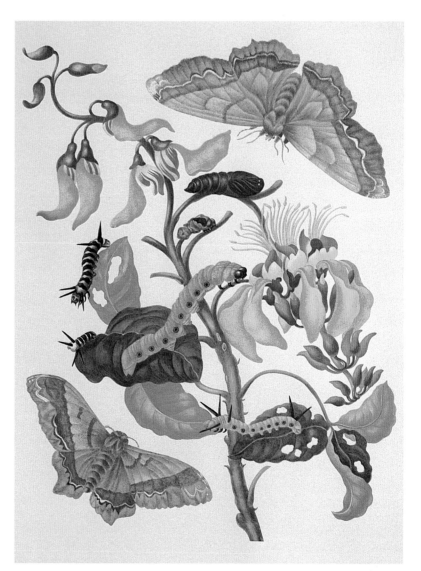

Merian's
metamorphoses

For a 52-year-old painter who specialized in illustrating plants and insects to undertake a self-financed sea voyage to Surinam in 1699 to document the metamorphosis of exotic butterflies and moths is remarkable enough. For a woman, accompanied only by her 21-year-old daughter, it represents one of the most heroic acts in the history of the natural sciences. Maria Sibylla Merian of Frankfurt was an extraordinary woman. She was

also responsible for the forging of a new vision of how the life cycles of insects could be brought before our eyes.

Her 'ecological' presentation, which she pioneered in *The Wondrous Transformation of Caterpillars and their Remarkable Diet of Flowers* in 1679 and 1683, found its finest expression in her *Metamorphosis of the Insects of Surinam* in 1714. The eggs, larvae, chrysalises, and mature insects are portrayed in living communion with the plant on which their 'worms' feed—sometimes showing more than one species per plate where she had observed that a plant was not the exclusive domain of one kind of insect.

In her depiction of the moth *Arsenura armida* on the 'Palisade Tree'—so called because it provides the thick poles from which 'the huts in America are built'—the stages in the life cycle are interwoven with the plant in a living tapestry. As she explains:

> Each year this kind of caterpillar comes three times to this tree; it is yellow with black stripes and decorated with six black spines. When they have reached a third of their final size they shed their skin and become orange–yellow with black spots on their limbs … Several days later they shed their skin once more; on 14 April 1700 they turned into chrysalises; on 12 June moths like those emerged. The lower and smaller is the male; the larger and the upper one the female.

Her aim was not systematic classification, anatomical description, or priority in academic disputes, but to conduct us on a visual journey through the wonders of transformation.

How was this vision conceived, when it is so different from the taxonomic 'portraits' of organisms that prevailed in the standard books? It can be seen as a highly imaginative extension of the kind of art in which she was steeped. Still-life painting, in the Dutch and German tradition, and naturalistic illustration were in her blood. She was the daughter of Matthias Merian the Elder, an engraver, illustrator, and publisher, and her stepfather was the still-life painter Jacob Marell. She married the painter, Johann Andreas Graff. The kinds of still lifes she learnt to paint with high skill were replete with descriptive detail and composed with decorative intent, but they also frequently embodied implicit narratives that remind us of the passing glories of the earthly beauty. Maggots create decay at the heart of luscious fruit; leaves are holed by caterpillars; and gorgeous butterflies flutter through their transitory existence.

Should we wonder whether this 'vanitas' motif was relevant to natural history, we need only cite the title of the publication devoted to the mayfly by the great microscopist and entomologist, Jan Swammerdam, *A Figure of Man's Miserable Life* (1675). Merian is not so explicit, and the beauty of her engaged observations and vivid depictions are satisfying in themselves. But she knew that her audience would place her world of transformation in the proper theological context. She would have known that description, decoration, and divine message were inseparably conjoined within an implicitly temporal framework. As a member of the religious community of the Labadists for five or six years of her life, she undertook her work in a spirit of intense devotion to the wonders of creation.

As she had written in the preface to her *Transformations*:

> I moved to present God's miracles … Thus do not seek to praise and honour me for this work, but rather God, glorifying him as the creator of even the smallest and most insignificant of these worms. ✑

Philip Reinagle, 'Cupid Inspiring the Plants with Love' from Robert Thornton's *The Temple of Flora*, 1804

Sexy stamens and provocative pistils

For centuries the study of flowers and the cultivation of gardens were deemed to be safe pursuits for young ladies. The behaviour of animals, by contrast, was all too likely to provoke difficult questions about sexual activity. Carl Linnaeus' sexual system for the classification for plants, based on stamens and pistils, changed all that.

Introduced to a worldwide readership in his *Philosophica Botanica* of 1751, Linnaeus' principles attracted fervent adherents and keen opposition. Amongst the devotees was Erasmus Darwin, Charles' grandfather, who was an open enthusiast for the French Revolution and adopted a radically libertarian stance on social matters. Erasmus' scientific poem, *The Loves of Plants*, published in 1789 as Part II of his *Botanic Garden*, blends sober scientific analysis with poetic rapture, the latter typified by his evocation of the polygamy practised by *Glorioa superba*:

> Proud GLORIOSA led by three chosen swains,
> The blushing captives of her virgin chains…
> When time's rude hand a bark of wrinkles spread

Round her limbs, and silver'd o'er her head,
Three other youths her riper years engage,
The flatter'd victims of her wily age.

If this should sound like a perversion of Linnaeus' method, we may recall that the great Swedish botanist had written that:

The flower's leaves … serve as bridal beds which the creator has so gloriously arranged … and perfumed with so many soft scents that the bridegroom with his bride might there celebrate their nuptials with so much greater solemnity. When now the bed is so prepared, it is time for the bridegroom to embrace his beloved bride and offer her his gifts.

Unsurprisingly, religious and conservative organizations began to express alarm. Most notably, the *Encyclopaedia Britannica*, published from the Calvinist redoubts of Edinburgh in 1768, railed against the 'disgusting strokes of obscenity' with which Linnaeus had disfigured the picture of nature's innocent beauties. In France, the philosopher Jean-Jacques Rousseau urged caution in introducing young ladies to the reproductive organs of plants at too tender an age.

The illustrated book that best captured the tone of Darwinian rapture was Robert Thornton's majestic but failed enterprise, the *New Illustration of the Sexual System of Linnaeus*, first advertised to subscribers in 1797 and appearing in parts from 1799. The illustrations ranged from tabular and diagrammatic representations of Linnaeus' system, to romantic pictures of particular plants in evocative landscapes and highly charged allegories of nature. For example, *Strelizia reginae* or 'queen plant' (named after Charlotte of Mecklenburg–Strelitz, George III's queen) is soberly anatomized in one plate, depicted in an exotic setting in another, and features as the target of Cupid's arrow in the allegorical image of 'Cupid Inspiring the Plants with Love' from the pictorial part of the *New Illustration*—retitled in 1804 as *The Temple of Flora*.

However, lest we should think that Queen Charlotte was being encouraged to distribute her favours with Darwinian profligacy, Thornton is at pains to eulogize the royal patron of his enterprise as a 'bright example of conjugal fidelity and maternal tenderness'. Unshakeably pious, staunchly monarchist, and very English, Thornton would have nothing of Erasmus Darwin's dangerously French attitudes.

Thornton argued that the mathematical, logical character of taxonomy was a 'noble exercise' which was eminently suitable for the training of the minds of the young, who are all too easily seduced by pastimes which 'inflame the passions'. By stressing the dispassionate character of classification, he was consciously confronting the accusation that the sexual basis of Linnaeus' method was an obscene perversion of the innocence of plants and besmirched botany as a study unfit for young ladies. Thornton was determined that the Linnaean binomial system should serve as the taxonomic science of the flower bed and not as a justification for abandoning the proper regulation of the human nuptial chamber. ✑

George Stubbs, *The Duke of Richmond's Bull Moose*, 1770. © Hunterian Art Gallery, University of Glasgow

Stubbs' seeing

The revolution in visual communication in the Renaissance nowhere exercised a more profound effect than on the illustration of natural history. Although skill in naturalistic representation can be a double-edged sword—an accomplished artist can make a unicorn look as 'real' as a narwhal—the rigorous portrayal of specimens from life played a key role in conveying knowledge about the ever-widening spectrum of natural marvels.

Merian and Thornton, as illustrators of insects and plants, were direct heirs to the Renaissance tradition and demonstrate vividly how pictorial evidence can serve as a powerful tool for information, entertainment, and scientific speculation. That most English of English painters, George Stubbs, was second to none in painting animals in the naturalist tradition, as well as contributing something of his own vision.

In 1770, probably in the autumn, the physician in ordinary to Queen Charlotte, William Hunter, 'obtained leave to have a Picture made ... by Mr. Stubbs' of the first bull moose to arrive from Canada, imported by the Duke of Richmond. As Hunter tells us, 'no pains were spared by that great Artist to exhibit an exact resemblance both of the young animal itself and of a pair of Horns of the full-grown Animal'. Hunter's desire to pin down the exact appearance of the moose was motivated less by old-fashioned curiosity than by the newest debates about extinction. Three years later he inspected a second moose imported by the Duke, 'carrying with us Mr. Stubbs's picture'. Although to our eyes Stubbs' moose looks a little too horse-like—perhaps unsurprisingly for a specialist

painter of equine subjects—Hunter clearly considered it met his documentary needs.

Hunter had already argued conclusively that the bones of the so-called *Ohio incognitum* (the mastodon) were not those of an elephant, and he intended Stubbs' painting to confirm that the 'Irish Elk', known through fossils, was not the same as the extant moose. Such a confirmation would have broken another of the links in 'the Great Chain of Being'—the traditional doctrine that maintained the eternal continuity of the full spectrum of God's creations.

Stubbs was the ideal artist for the task. He had already published his superb *The Anatomy of the Horse*, containing 'eighteen TABLES, all done from Nature', and he was passionately interested in comparative anatomy. The project on which he was working at his death in 1806 was *A Comparative Anatomical Exposition of the Structure of the Human Body with that of a Tiger and a Common Fowl*, for which he drew some remarkable images of a human skeleton in animal postures. His paintings of wild animals, particularly those of terrified horses savaged by lions in dramatic landscapes, purveyed an innovatory view of the dramatic interplay of animate and inanimate agencies in nature. Even if his static moose does not lend itself to exciting narrative, the stirring nature of the lakeland wilderness inhabited by the creature is enhanced by the febrile gloom of the encroaching storm.

Hunter never published his paper on the 'Irish Elk', in the absence of secure data about the range of antler types in the mature moose and uncertainty about the possible survival of the 'Elk' in as yet unexplored wastes. But the artist and the doctor were beginning to nurture the intellectual seeds that Darwin was to cultivate to such effect in the nineteenth century. ❧

George Stubbs, *The Human Skeleton in Crawling Posture, c.*1800, New Haven, Yale Center for British Art, Paul Mellon Collection

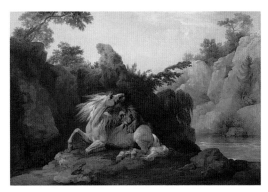

George Stubbs, *Lion Devouring a Horse, c.*1763. © Tate, London 2000

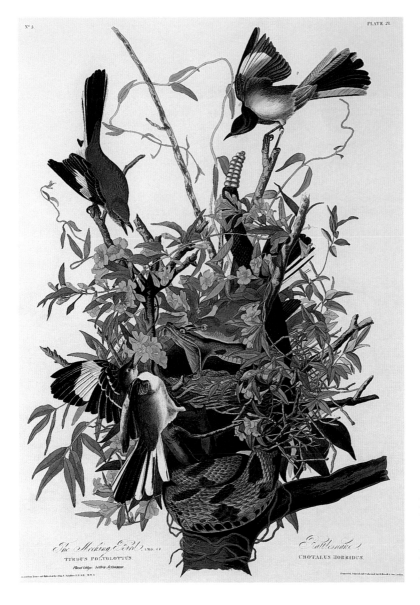

The Mocking Bird. Nºw. 11
TURDUS POLYGLOTTUS.
Plant Yellow Jessamine

Rattlesnake.
CROTALUS HORRIDUS.

John James Audubon,
'Northern Mockingbird'
(*Mimus polyglottos*) from
Birds of America, 1831.
The Natural History
Museum, London

Audubon in action

Naturalism—showing it as it is—was the declared aspiration of natural history illustrators such as Merian and Stubbs. But, faced with the extreme limitations of static depictions in line and colour on a flat surface, compared to the dynamism of living forms seen in radiant light by a mobile observer, the illustrator of animals and birds has to make radical choices. For example, evoking the play of light across the feathers of a bird camouflaged in its natural environment largely excludes a careful description of its plumage and silhouette. One variety of naturalism necessarily prejudices another.

John James Audubon's majestic *Birds of America*, issued in four volumes between 1827 and 1838, courtesy of a distinguished list of 161 subscribers in Europe and America, obviated one of the problems through sheer scale. His 'double elephant' portfolio, a metre in height, allowed the life-size depiction of his 435 subjects, albeit with some markedly twisted necks, bent legs, and curved bodies for the bigger species.

He operates almost exclusively with two registers of information. The first is the close-up observation of surface features, based on detailed scrutiny of dead birds, often shot specially for the purpose—'Alas, poor things', as even such an enthusiastic 'sportsman' as Audubon lamented. His goal is measured description: 'the compasses aided me…regulated and corrected each part'. The second is the use of outline to capture the silhouette, motion, and dynamic 'personality' of the bird in the field, as it might been seen fleetingly or at a distance. Defending his use of *outré* poses, he stressed that 'nothing can be more transient or varied than the position of birds'.

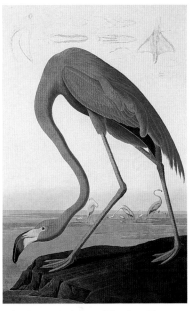

John James Audubon, 'Flamingo' from *Birds of America*, 1831. The Natural History Museum, London

Between these two registers, which play graphically to design and surface pattern, he eliminates much of the plastic description of the birds' three-dimensional form and the elaborate play of light on modelled surfaces. His resources for the foreshortening of forms are very limited, and he exploits tonal modelling in light and shade only to a modest degree.

This powerful emphasis upon surface design does not, as it might in other hands, lead to static or largely ornamental results. As a passionate field naturalist, more prone to romantic immersion than to systematic analysis, Audubon was concerned to capture the very nature of his subjects—the dynamics of lives dominated by feeding, survival, courtship, and reproduction within the rich texture of their environments. The accompanying text volumes, his *Ornithological Biography*, combine sober description with expressions of pantheistic rapture characteristic of Romantic art and science.

His account of the mockingbird opens with a florid account of Louisiana:

where Nature seems … to have strewed with unsparing hand the diversified seeds from which have sprung all the beautiful and splendid forms which I should in vain attempt to describe.

Fittingly for such an abode, the king of songsters conducts an ecstatic courtship, 'pouring forth his melody, full of exultation at the conquest he has made'.

In the more sober account that follows, he outlines the natural history of the mockingbird, noting that when marauding snakes attempt to 'suck the eggs or swallow the young' they are assaulted by 'many other Mockingbirds from the vicinity'. The tenor of his illustration—densely interweaving tree, plant, rattlesnake, birds, and nest—is typical of the threat and malevolence that is present, overtly or covertly, in so many of his plates. His birds, whether prey or predator, are part of a life and death struggle.

Appealing and decorative as his designs may be, the untamed world of action he depicts is closer to Darwin's than to the standard bird book. ❧

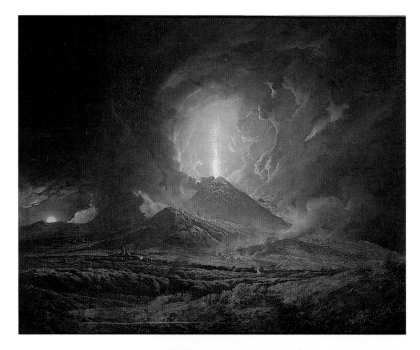

Joseph Wright of Derby, *Eruption of Vesuvius*, *c.*1776, Aberystwyth, University College of Wales

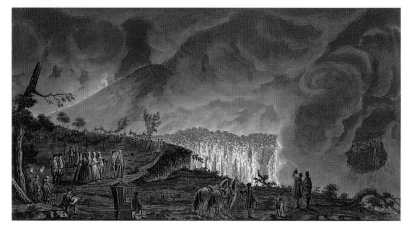

Pietro Fabris, 'Sir William Hamilton conducting their Sicilan Majesties to see the Lava of Vesuvius in 1771' from Sir William Hamilton, *Campi Phlegraei*, 1776. The Bodleian Library, University of Oxford, VET F5b.2 plate xxxviii

Wright's ruptions

Joseph Wright of Derby's continued residence in his home town, far from condemning him to provincial isolation, located him within the remarkable orbit of the Lunar Society, whose luminaries included Josiah Wedgewood, James Watt, Matthew Boulton, Erasmus Darwin, and Joseph Priestly.

Wright's exceptional range of subject matter, extending beyond conventional landscapes and portraits into iron forges, industrial premises, alchemists' dens, air pumps, and orreries, plunges us visually into the rising scientific ferment of the second half of the

eighteenth century. The sciences of chemistry (not least discoveries relating to combustion and oxygen) and of physics (particularly electricity) were revealing new dimensions to the forces that animate nature.

Volcanology—the discipline which may be said to have been founded by Sir William Hamilton, King's Envoy in Naples, antiquarian and passionate observer of geological phenomena—played a significant role in demonstrating that the vast formative forces in the body of the earth lay far beyond the scope of the biblical Creation and Flood in time and magnitude. The fields of lava around Mount Vesuvius, now serving as fertile land, were in Hamilton's view, 'so very ancient, as to be far out of the reach of history'. Rugged topographies resulted not from God's static design but from huge effusions of material molten by subterranean fires—'mountains are produced by volcanoes, not volcanoes by mountains'—a process which was still very much under way. Indeed, Hamilton believed that the present surface of the earth contains no surviving part from its original, 'primitive' state.

Wright visited Vesuvius in 1774, two years after Hamilton had published his *Observations on Mount Vesuvius*. The painter wrote excitedly back to John Whitehirst in Derby that he had witnessed 'a very considerable eruption … of which I am going to make a picture'. Four years later Whitehirst was to publish his *Inquiry into the Original State and Formation of the Earth*, which talked about the great sea of inner fire which surged through what Wright called the 'bowels of the mountain'. In the event, Wright painted not one picture of Vesuvius, but more than thirty.

Pietro Fabris, 'Frontispiece on Vesuvian Themes' from Sir William Hamilton, *Campi Phlegraei*. The Bodleian Library, University of Oxford, VET F5b.2 frontispiece to 1779 supplement

His series of pictures, composed in the studio as sublime exercises in visual poetry, are quite different in method from Hamilton's professed system of 'collecting facts', and exceed in power the images of Pietro Fabris, Hamilton's favoured illustrator. The vertical jet of white-hot debris, the vortex of clouds, and emergent moon correspond less to what Wright witnessed at a single moment than to an artistic synthesis of the essence of Vesuvius' grandeur within the drama of world history. The granular globs of white paint which comprise the jet and bedeck the fiery slopes stand for, rather than literally describe, the phenomenon.

Yet Wright's vision does strike to the very heart of the vitalistic and animistic enthusiasms which did so much to convince European scientists like Luigi Galvani, Antoine Lavoisier, Alexander von Humboldt, and Humphry Davy that the great key to the mystery of life lay in the kinds of universal electrochemical forces which twitched a frog's leg into life and breathed the life of 'oxygenated air' into every living thing. Wright's images strike to the heart of the visual and intellectual fires that fuelled so much Romantic science. ❧

Joseph Mallord William Turner, *Shade and Darkness—the Evening of the Deluge*, 1843. © Tate, London 2000

Joseph Mallord William Turner, *Light and Colour (Goethe's Theory)—the Morning After the Deluge*, 1843 © Tate, London 2000

Turner's trinity

W hen J.M.W. Turner, towards the end of his spectacular and prolific career, was asked to explain the pair of paintings he was exhibitng at the Royal Academy in 1843, *Shade and Darkness—the Evening of the Deluge* and *Light and Colour (Goethe's Theory)—the Morning after the Deluge*, he tersely responded, 'Red, blue and yellow'. This

triad comprised the painter's traditional 'primaries', from which (in theory) all other colours could be mixed.

Looking at the swirling chaos of colour in Turner's vision of the *Deluge*'s aftermath, it is difficult to believe that it is founded on scientific ideas, yet he cites 'Goethe's Theory'— that is to say, the anti-Newtonian doctrines expounded in Goethe's *Farbenlehre* in 1810. Goethe, although on the eccentric fringe of science, was far from alone at this time in reviving the three-colour theory in the face of Newton's apparently triumphant doctrine of seven unrefrangible hues.

For example, Sir David Brewster, the Scottish scientist and biographer of Newton, polemically advocated what he called the 'Trinity' of colours. Relying upon observations of the decomposition of light by absorption through coloured filters, Brewster argued that white light was produced by three overlapping spectrums of red, yellow, and blue, and not by the recombination of the Newtonian spectrum.

Although Turner, who met Brewster, realized that actual mixtures of 'aerial' colours (additive mixing of coloured lights) and 'material' colours (subtractive mixtures of pigments) produced quite different results, he welcomed the idea that there was a direct correspondence of hue between the primaries for lights and pigments.

Given Turner's status as the supreme exponent of Romanticism in British art, committed to emotional expression, his avid interest in scientific theory may come as something of a surprise. He devoted long hours to the preparations for his lectures as Professor of Perspective at the Academy, where he introduced his audience to Euclidean geometry and the complex issues surrounding the strengths and fallacies of conventional perspective. He also expounded his own colour theories, using huge watercolour studies to demonstrate colour circles and observations on the behaviour of light. Such scientific insights, for Turner, were never subjected to 'restrictive rule', but provided access to the awesome powers of nature. He was fascinated by the magnetizing properties of light, and by the action of sunlight on silver salts as exploited to such effect by the pioneers of photography.

Joseph Mallord William Turner, *Colour Circle No. 1*, diagram of the 'aerial' colours from Turner's lectures (TB CXCV 178). © Tate, London 2000

Turner did not swallow Goethe's theory whole. 'Poor Dame Nature' he wrote in one of his annotations to his copy of the 1840 translation of *Farbenlehre*, when he felt that Goethe was downgrading nature's supreme powers. But he was attracted to the way that the German set his two 'polar' colours, yellow and blue, in concert with paired forces of nature: plus and minus; action and negotiation; force and weakness; warmth and coldness; proximity and distance; repulsion and attraction; acids and alkalis; and so on.

In his pair of paintings, the dark, hollow, fractured vortex of the looming *Deluge* in the evening, dominated by negative hues, is set against the spherical whirl of warmly radiant hope which arose on the following morning. Yet, as the poetic fragment Turner appended to *Morning* warns, 'Hope's harbinger'—in the guise of the multicoloured bubble studied by Goethe—is 'as ephemeral as the summer fly, Which rises, flits, expands and dies'. For Turner, scientific awe and such sentiments as poetic melancholy coexisted within a single mental spectrum. ∾

PART FOUR

Graphic
precisions

Johann Erdman Hummel, *Polishing of the Granite Bowl*, 1831. © Bildarchiv Preußischer Kulturbesitz 2000, Nationalgalerie Staatliche Museen, Berlin

Johann Erdman Hummel, *The Granite Bowl in the Lustgarten, Berlin*, 1831. © Bildarchiv Preußischer Kulturbesitz 2000, Nationalgalerie Staatliche Museen, Berlin

Monge's maths;
Hummel's highlights

Linear perspective, as we have seen, is about the portrayal of the position and relative scales of objects in Euclidean space. Yet in its pictorial mode, it creates an illusion which can only be used to provide measured definition of the dimensions of forms if the diminutions are reversed through a knowledge of the parameters of the construction or, more recently, using the computer programme that reconstructed the space in Piero's *Flagellation* (see page 30). To overcome this shortcoming, a special mode of perspectival description was developed for technical drawing, above all for fortifications, that both presented spatial effects and retained dimensional accuracy. It became the speciality of military draftsmen, engineers, and stonecutters in the eighteenth century.

What was known as *perspectiva militaris*, and is now generally called orthographic or isometric perspective, set the vanishing point at a notionally infinite distance, in such a

way that parallels do not converge (or only meet at infinity), and distant forms can be measured on the same scale as adjacent ones. Gaspard Monge, the founder of descriptive geometry, was educated in this tradition at the military academy at Mezières. During the Revolutionary era, he reshaped mathematics teaching in the reformed school system.

His *Descriptive Geometry* of 1799, edited from his lectures at the Ecole Normale, zealously advocated his method 'to define the position of a point in space' by reference to 'those other objects that are of known position in some distinctive part of space', most directly by two intersecting planes. His procedures, closely related to shadow projection in the more technical books on artist's perspective, revived the power of drawn geometrical procedures after years of dominance by algebraic analysis in the Cartesian manner.

Monge himself extolled descriptive geometry as:

> … a means of investigating the truth; it perpetually offers examples of passing from the known to the unknown; and since it is always applied to objects with the most elementary shapes, it should necessarily be introduced into the plan of national education.

It was designed not only to serve the needs of technical draftsmen but also as a prime tool for the artist, for whom 'nothing is arbitrary' with respect to formal definition of form and position—even when curved surfaces are involved.

His methods exercised a huge impact on practical geometry and technical drawing in Europe and America, but few artists were predisposed to follow the demanding letter of his law. A striking exception was the Professor of Optics at the Berlin Royal Academy of Art, Johann Hummel. A rather graceless draftsman of figures, Hummel excelled in perspectival views. His *pièce de résistance* is a series of paintings on the making and erection of the huge granite bowl installed in the Lustgarten in 1831. The complex curvature of the bowl in itself set a stiff task for any conscientious perspectivist, but the geometry of the reflections presented problems that only the most dedicated investigator would attempt to resolve.

Well aware of the most technical accounts of geometrical projection, particularly of shadows on convex and concave surfaces of complex curvature, Hummel used his pictures of the bowl as virtuoso demonstrations of the intriguing con-

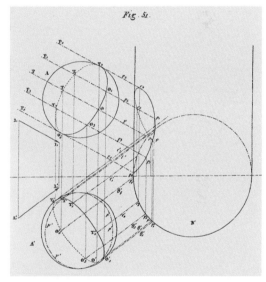

Gaspard Monge, 'Projection of a Shadow Cast by a Sphere on a Cylindrical Surface', from Monge's *Descriptive Geometry*, 1799

figurations of geometrical forms 'morphed' by reflection. As Jonathan Miller showed in *Mirror Image*, his 1998 exhibition at the National Gallery in London, the artist relies upon our perceptual ability to read the medley of strange shapes as highlights and reflections only through our grasp of the total context of the representation.

Hummel moulds the reflected contours of the leaded windows like a musician shaping a phrase and expresses elegant visual wit in the strange transformations wrought in the scene surrounding the bowl in its outdoor setting. The results are both precise and dazzling. ✑

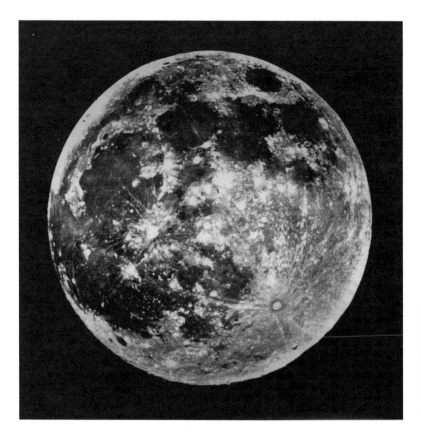

'Photograph of the Moon' by Warren de la Rue and Joseph Beck, from James Nasmyth and Edward Carpenter, *The Moon: Considered as a Planet, a World, and a Satellite*, 1874

Modelled moons

The problem of how to throw telescopic observations literally into relief had beset the representation of celestial bodies since Galileo's time. Galileo's own accomplished watercolours, engraved in his *Siderius Nuncius*, set the standards for articulate looking, as we have already seen. The advent of astronomical photography, virtually from the moment of the medium's first announcement in 1839, re-posed many of the earlier challenges to seeing and knowing.

The first surviving image of the moon of real quality was exhibited by John Whipple and George Bond at the Great International Exhibition in 1851, to be followed by rival moonscapes by other photographers, including Lewis Rutherfurd, whose detailed masterpiece of tonal modelling in 1865 did much to silence critics of the camera as an adjunct to astronomical observation.

The most sustained exploration of photography in the context of other visual techniques occurs in Nasmyth and Carpenter's photographically illustrated book of 1874, *The Moon: Considered as a Planet, a World, and a Satellite*. James Carpenter was a professional astronomer at the Royal Observatory in Greenwich, while James Nasmyth was a noted engineer who came from a leading family of Scottish artists. Indeed, Nasmyth's father, Alexander, was justly regarded as the 'father of Scottish landscape painting'.

'Wrinkled Hand and Shrivelled Apple' from *The Moon: Considered as a Planet, a World, and a Satellite*

Nasmyth and Carpenter explored a notable range of diagrammatic and representational modelling. They used prints of Nasmyth's own wonderfully crisp drawings, a photograph of the moon by Warren de la Rue and Joseph Beck, a 'picture map' with some shading, a 'skeleton map' of lines alone, an imaginative impression of an 'ideal lunar landscape', a representation of an eclipse of the sun as viewed from the moon, plaster models of the lunar surface photographed under immaculately controlled lighting, and a photograph of a laboratory simulation of a live volcano.

The authors' justified claims for high visual literacy were based on 'upwards of thirty years of assiduous observation' during which 'every favourable opportunity has been seized to educate the eye'. As part of this education, they resorted to exactly the same kind of visual analogies that had performed such a vital service for Galileo and the telescopists and Hooke and the microscopists. To this end, Nasmyth and Carpenter illustrate striking photographic 'heliotypes' of an aged hand and a shrivelled apple under lateral illumination. Elsewhere they reproduce a beautiful photograph of a glass sphere cracked by internal pressure.

Their visual analogies involve both appearance and process—in the case of the wrinkles between the mechanics of the folding that occurs when the inner core acquires a surface area smaller than its covering skin. Their diverse methods of modelling and representation brought with them a compelling sense of the universe and its parts in 'perpetual mutation', evolving from primeval matter. This conviction is nicely expressed on the first page of their text:

> the same laws work in the great as well as the smallest processes of nature, we are compelled to believe in an antecedent state of existence of the matter that composes the host of the heavenly bodies.

The microcosm–macrocosm analogy is thus reworked, less as a metaphysical principle and more in terms of shared physical causes and visible effects across a vast range of scales over huge expanses of time. ✁

David Hockney, camera lucida drawing of
Barry Humphries, 22 June 1999

Lucid
looking

What are we to think when one of the greatest draftsmen of our age resorts to a prephotographic drawing device patented in 1806 and primarily intended to provide assistance to 'amateurs'? The artist in question is the renowned British painter, maker of photoworks, printmaker, stage designer, and master of the pencil, David Hockney. The device is the camera lucida invented by William Hyde Wollaston, physician turned chemist and optician. Wollaston was stimulated to devise his optical aid by his inability to depict admired scenery with a reasonable level of skill.

The camera lucida stood in a long line of descent from various optical drawing devices, ranging from mechanical perspectographs to lens-based camera obscuras. Indeed, its name played on the fact that it did not need the 'dark chamber' of the camera obscura and could be used in any light conditions. The convenient and readily portable camera lucida used a four-sided prism, two faces of which are set at 135°, to send a twice-reversed image to the eye via two internal reflections. Wollaston explained how a draftsman could simultaneously see both the object to be portrayed and a horizontal drawing surface, providing the eye is 'so placed that only a part of its pupil may be intercepted by the edge of the prism'. This difficult trick was facilitated by a hinged eye-hole, while supplementary lenses helped with the problem that the eye was required to focus on both the object and the image plane.

Used by some professional draftsmen, including Sir Francis Chantrey, as well as countless hopeful novices, the camera lucida largely passed out of service (except for some mainly technical uses) with the popular spread of photography. Wollaston's prism was a

Prism, lenses, and eye-piece of a camera
lucida, from Cornelius Varley's *A Treatise*
on Optical Drawing Instruments, 1845

Camera lucida with case, London, Science Museum.
Science & Society Picture Library

demanding device to use, requiring considerable ocular control. Even then, an unskilful artist would only achieve 'lamentable results'—to quote William Henry Fox Talbot, whose failure to produce decent landscape drawings with the camera proved to be a powerful goad to his invention of calotype photography. By contrast, Sir John Herschel, adept at using his eyes with telescopes and well equipped with draftsman's skills, achieved beguiling results on his various travels.

Hockney, who has consistently been concerned with issues of seeing, representation, perspective, space, and the camera, has seized on Wollaston's invention to undertake a series of drawn portraits. Unlike an inexperienced artist, who is likely to attempt a laboured tracing of contours, Hockney essentially uses the instrument as a sighting device, briskly demarcating key points of the features, such as the corners of the eyes and line of the mouth. The advantage is that such key registers of expression can be rapidly established before the expression of the sitter freezes or sags. Removing the device, he then directly delineates the shades and highlights through an intense process of observation and depiction, in which his gaze incessantly 'tick-tocks' from face to paper at intervals of no more than two seconds. Being portrayed by Hockney is, as I can testify, to be machine-gunned by an ocular marksman of the first order.

The results share something of the quality of photographs, while not looking like photographic images. They remain, recognizably, drawings in Hockney's style, yet they are discernibly different from the entirely 'free-hand' portrait drawings from earlier in his career. They exhibit a combination of fresh immediacy (the short exposure) and unrelenting intensity (the long exposure) that entirely validates the artist's surprising adoption of the camera lucida.

The results also feed back into the history of device. Hockney took advantage of his visit to London from his home in California in 1999 to scrutinize the portrait drawings by the French neoclassical artist, J.A.D. Ingres, then on exhibition at the National Gallery. His intuition is that Ingres used a camera lucida to facilitate the making of drawn likenesses of visitors to Rome in the second decade of the nineteenth century. It is a happy intuition that may well be right, and which Hockney is extending into a radical assessment of the role of optical devices in painting from the fifteenth century onwards. ༀ

Sir Charles Wheatstone's
wave machine (two views),
London, Science Museum.
Science & Society Picture
Library

Wheatstone's waves

Gaining a visual grip on compound motions in more than one plane is a tricky
business, particularly when the mechanism cannot be observed directly, even in the
era of photography. Under these circumstances, the didactic machine or what was called
the 'philosophical toy' comes into its own.

The most obvious role for such devices is the inducing of the 'Ah-hah!' factor—that
instant of illumination when we find that we have suddenly acquired the elusive visualiza-
tion of how a complicated system works in spatial terms. In addition to instruction in
known mechanisms, 'philosophical' machines could also model hypotheses in a more
speculative manner, acting to confirm the feasibility of a theory. Exemplary cases are the
armillary sphere, which Islamic and Western astronomers had used to model the
Ptolemeic system of the cosmos, and, in the nineteenth century, Wheatstone's 'Wave
Machine', which gave visible shape to the interference of different wave-forms.

Best known as a pioneer of the electric telegraph, Sir Charles Wheatstone came to his main sciences of acoustics, optics, and electricity via the making and inventing of musical instruments. The enduring theme of his creative life may be described as the invention of mechanisms of direct practical utility and didactic cunning that were profoundly in tune with natural law.

Wave motion, such a crucial theoretical model in physics from Young and Fresnel in the early nineteenth century to the present day, was the subject of the most compelling of Wheatstone's didactic toys. His wave machine, invented in the early 1840s and produced for sale in handsomely engineered versions, ingeniously represents the motion of 'ether particles' in plane, elliptical, and circular polarization through the compounding of two sinusoidal (wave-form) motions at right angles.

White beads of mother-of-pearl are located at the tips of wiry rods that move sinuously in response to a set of more than two dozen wave-shaped, wooden templates inserted in pairs into the machine at right angles to each other. The instructions issued in 1884 by John Newman, 'Philosophical Instrument Maker', give a nice idea of the kinds of shapes supplied: 'The slides are marked R & L (right and left) H & V (horizontal and vertical); (1) the standard wave; (2) the lower octave, 2:1; (3) the major third below, 5:4'

A complimentary realization of the 'musical' principles governing the 'molecular vibrations' in both light and sound was provided by his 'Kaleidophone or Phonic Kaleidoscope . . . for the Illustration of

Sir Charles Wheatstone, 'Sonic Patterns Produced by a Kaleidophone'

Several Interesting and Amusing Acoustical and Optical Phenomena'. Named after Sir David Brewster's optical kaleidoscope, it used small illuminated mirrors attached to the top of vibrating rods that emerged from a base plate in which varied vibrations were induced. The paths of the oscillating mirrors, traced by the persistent impressions of reflected light, adopted beautiful and surprising patterns. This delightful transition of sound into visible shape stood in the same tradition as the experiments of Sir Christopher Wren and Robert Hooke, when they induced remarkable wave-forms in bowls of water by agitating their perimeters with a violin bow, and, more recently, the beguiling figures demonstrated by Ernst Chladni in sand on vibrating plates.

For Wheatstone, as for Brewster, the 'philosophical toy' was designed to induce delight in nature's concealed wonders, particularly in the young, and to model in mechanical form profound truths about physical law at the highest levels of understanding. ᪣

Festival of Britain periodic table, 1951

Mendeleev's matrix or 'Telling tables'

The 2D table is an ancient yet wonderfully potent graphic device. Its very neatness bespeaks the achieving of precision, and it has proved its utility as an ordering and mnemonic system from the earliest documented eras of intellectual endeavour. Any table of 3 × 3 units or more embodies a surprising variety of potential orders—progressing in sequence from beginning to end, either in discontinuous rows or bucephadonically (by S-shaped motion), connected in individual columns (vertically, horizontally, or diagonally), clustered with immediate neighbours (up to eight in number), and grouped in various blocks, lines, or other configurations.

Some tables are matters of orderly convenience; others graphically encode fundamental properties of natural systems. The king of all tables, ruling over the reconfiguring of the science of chemistry and governing much of its subsequent conduct, is Dmitri Mendeleev's 'Periodic Table' of the elements. As Mendeleev acknowledged, his table emerged from international endeavours to show that 'the relations between the atomic weights … was governed by some general and simple laws'. John Newlands' 1865 tabulation according to a musical 'law of octaves' gave inspiration, much to Mendeleev's taste, for all-embracing systems.

For his own part, Mendeleev seized upon the periodicity of elements arranged according to atomic weights and valencies, to provide the rules for what he called his game of 'chemical solitaire', each card in his deck marked with the names or symbols of the

Tabelle I.

Typische Elemente

			K = 39	Rb = 85	Cs = 133	—	—
H = 1			Ca = 40	Sr = 87	Ba = 137	—	—
	Li = 7	Na = 23	—	?Yt = 88?	?Di = 138?	Er = 178?	—
	Be = 9,4	Mg = 24	Ti = 48?	Zr = 90	Ce = 140?	?La = 180?	Th = 231
	B = 11	Al = 27,3	V = 51	Nb = 94	—	Ta = 182	—
	C = 12	Si = 28	Cr = 52	Mo = 96	—	W = 184	U = 240
	N = 14	P = 31	Mn = 55	—	—	—	—
	O = 16	S = 32	Fe = 56	Ru = 104	—	Os = 195?	—
	F = 19	Cl = 35,5	Co = 59	Rh = 104	—	Ir = 197	—
			Ni = 59	Pd = 106	—	Pt = 198?	—
			Cu = 63	Ag = 108	—	Au = 199?	—
			Zn = 65	Cd = 112	—	Hg = 200	—
			—	In = 113	—	Tl = 204	—
			—	Sn = 118	—	Pb = 207	—
			As = 75	Sb = 122	—	Bi = 208	—
			Se = 78	Te = 125?	—	—	—
			Br = 80	J = 127	—	—	—

der chemischen Elemente.

Dmitri Mendeleev, *Periodic Table*, 1869. Science Museum, Science & Society Picture Library

elements, their weights, and chemical properties—realizing the potential in Francis Bacon's 'shuffle of things' (see page 5) in the most literal way.

The potency of Mendeleev's table was not just that it functioned as a tool for arranging properties but that the gaps in the sequences predicted 'the discovery of yet *unknown* elements' (as first happened with gallium); that it became evident when an atomic weight may require emending; and that the properties of known and unknown elements could be predicted from their positions.

For Mendeleev, as a philosopher–chemist, who wrote on such things as the 'unity of matter', the success of his table triumphantly proclaimed the value of what we would call theoretical modelling in the face of narrow empiricism. His Faraday Lecture in 1869 not only provided telling reviews of the rationale and development of his system but also delivered a powerful defence of conceptual structuring as a fundamental complement to the experimental method. He constantly resorted to 'agreement between theory and experiment; in other words, to demonstrated generalization and to the approved experiment'.

He proclaimed that:

> … sound generalization—together with the relics of those which have proved to be untenable— promote scientific productivity, and ensure the luxurious growth of science under the influence of rays emanating from the centres of scientific energy.

At one point in his lecture, he told how 'the inductive or experimental method of studying Nature gained a direct advantage from the old Pythagorean idea'.

His tabular triumph stimulated a 'luxurious growth' of alternative configurations, including wheels, flat spirals, helices, trees, and intersecting vanes. When needed, as in the dynamic spiral devised for the Festival of Britain in 1951, the graphic rhetoric can be reworked in various styles.

It is now apparent that there is no absolutely definitive table of the elements, and that other arrangements can provide diverse insights into their properties and interrelationships. Yet it is Mendeleev's scheme variety that has generally continued to reign supreme for its wide-ranging utility. Justifiably, an icon depicting the periodic table was born aloft in Mendeleev's funeral procession in 1907 through the streets of St Petersburg. ❧

Axillary Glands.

Gray's greyness

The signal visual characteristic that marks the extensive and profound professionalization of the sciences and technologies in the nineteenth century is the progressive dominance of a style of representation that deliberately eschews stylishness. What I am calling the 'non-style'—a technical mode of illustration in which the dry imparting of information is the sole conscious focus—arrived in different disciplines at different times. Engineering drawing around 1800, especially in France, played a pioneering role. By 1850, there was no branch of institutionalized science that remained untouched, and much twentieth-century illustration was its direct heir.

The transformation was particularly conspicuous in medical illustration. The portrayal of the human body—diseased, deformed, or dissected—had always been a fraught business. A heroic mode of illustration displaying elegant figures in brave postures with decorous adornments in gracious settings became the favoured presentation in the erudite humanist picture-books of anatomy, from Andreas Vesalius and Charles Estienne in the Renaissance to Bernhard Seigfried Albinus in the Enlightenment. Such volumes, grand in format, expensive to produce, and not infrequently sold by subscription, were hardly the stuff of routine teaching.

The rise of the professional medical school in the nineteenth century did not signal the immediate end of the picture-book, but it did mark the growing domination of the plain, technical textbook, epitomized by Henry Gray's *Anatomy, Descriptive and Surgical* which,

Henry Gray's *Anatomy, Descriptive and Surgical*, 1858, first edition, showing the binding, title, and spine. Wellcome Institute Library, London

'Lymphatics of the Upper Extremity', from Paolo Mascagni's *Vasorum Lymphaticorum Corporis Humani*, 1787. Courtesy of the Clendening History of Medicine Library, Kansas University Medical Center.

as *Gray's Anatomy*, established itself as the anatomical bible for generations of students required to 'name the parts'. First published in 1858 and bound in business-like brown buckram, it achieved an awesome degree of abstinence, and bids fair to be the most remorselessly unexciting book ever written on an engaging subject.

It begins with no eloquent preface, extolling the ethical worth of dissection to reveal the wonders of bodily mechanisms. Instead, it plunges almost immediately *in medias res* with osteological descriptions. And, having conducted his even-pace survey with the recto-vesical fascia, Gray's only conclusion is a 30-page index.

The 363 plates in the lucidly descriptive text are by the pictorially-named Henry Vandyke Carter, displaying the parts of the body (all parts and no whole) in sober, matter-of-fact line illustrations, the woodcut technique being used to achieve a single, consistent level of unseductive description, the register of which is unwavering throughout the book. The plainness is all the more striking when Gray draws directly on the work of his stylish predecessors, as in his 'Lymphatics of the Upper Extremity', based on a splendid engraving in Paolo Mascagni's *Vasorum Lymphaticorum Corporis Humani* (1787).

Gray's sterling sobriety survived more or less unscathed through many editions, though a photograph of Gray, accompanied by a facsimile of his signature and a brief testimonial, was introduced to certify the volume's authenticity. Anatomical photography and, later, X-rays were long resisted. Gradually, during the course of the twentieth century, successive editors introduced a fresh battery of illustrative techniques, including state-of-the-art microscopy and, inevitably, the latest in computer graphics. Between the brightly coloured covers of the present edition (the 38th), the only consistent visual characteristic that can be discerned is a cacophony of styles and registers of communication. It is most unlikely that Gray would have approved. ∾

Thomas Edison, *Sketches for a Sextuplex Set-up in Multiple Telegraphy*, signed by Thomas Edison, James Adams, and Charles Matchelor, 10 April 1877

Graphic gropings

Behind the kind of graphic precision we expect in scientific and technological literature often lie successive acts of creative manoeuvring. Rough sketches in a notebook, on a blackboard, or even on the back of the proverbial envelope have played central roles in scientific and technological creativity. The rapid act of graphic visualization, the 'thinking' doodle, the schematic thought experiment, the improvised diagram, the scribbled solution, are now familiar to us through the publication of scientists' private papers. The informal fragments seem to bring us closer to the workings of the inventive mind. But it was not always so.

With a few exceptions, informal graphic material has not been preserved from earlier eras of science. Some of it was on erasable surfaces but, more importantly, it was not generally thought worthy of preservation, not least by the originators of the material themselves.

Whereas artists' sketches had been collectable since the Renaissance, scientists' notebooks generally attracted little attention until the later part of the nineteenth century, and those that did survive were preserved for reasons of archival piety rather than as precious records of creativity, inspiration, false starts, changes of mind, and so on. The difference speaks of a substantial gulf in attitudes towards creativity in art and science over the ages.

It is now broadly accepted that informal jottings can provide fascinating insights into the varied nature of the processes of visualization and creativity in different kinds of scientific activity and in individual scientists' work. The private papers of two of the greatest visualizers, Thomas Edison and Henri Poincaré, show how spontaneous acts of notation on paper can service concrete technological design no less effectively than they can nourish mathematical theorizing of the most abstract kind.

Edison consciously projected his own image as a genius of invention. His Menlo Park 'invention factory' in New Jersey, where he originated a remarkable string of patented devices between 1876 and 1883—an improved telephone, the phonograph, incandescent lighting, and so on—was knowingly established and publicized as a crucible for his creativity. His notebooks display an endless fertility in the conducting of thought experiments. Impulsive jottings of circuits, components, interconnections, and new mechanisms served a serendipitous process of mental and graphic invention, in which ideas could be tested, approved, refined, or eliminated. Even highly informal sketches by Edison and his closest associates were scupulously dated and signed (often collectively), in order that his priority might be clearly demonstrable.

For his part, Poincaré, uniquely elected to all five sections in the French Academy—geometry, mechanics, physics, geography, and navigation— became the very model of mathematical creativity, particularly through his own *Science and Hypothesis* of 1902 and Edouard Toulouse's psychological study, published as *Henri Poincaré* in 1910. Poincaré himself lauded 'intuition' as the key to his 'ability to perceive the whole argument at a glance' and to determine where the 'beauty' of truth lay within nature's mathematics.

Toulouse describes how, when his subject

Henri Poincaré, a back-of-the-envelope calculation, Poincaré Archives

searches, he often writes a formula automatically in order to awaken some association of ideas…Poincaré proceeds by sudden blows … During the intervals he assumes … that his unconscious continues the work of reflection.

The mathematician's manuscripts reflect just this kind of dynamic, associative creativity, darting down formulas and diagrams here and there on any writing surface to hand. Well might Toulouse express surprise that supremely rational expositions originated from processes that were 'seemingly throughout apt for works of pure imagination' in the manner conventionally associated with the arts. ✷

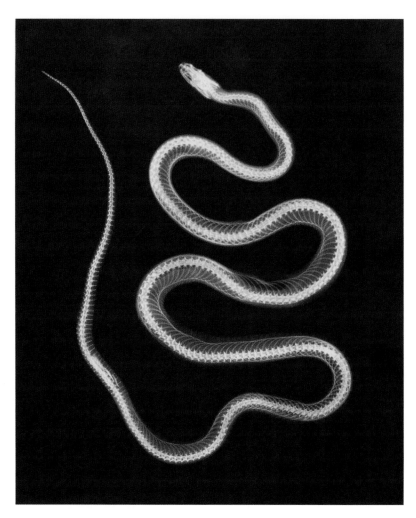

Joseph Maria Eder and
Eduard Valenta,
'Aesculapian Snake', from
*Versuche über
Photographie Mittlest der
Röntgenschen Strahlen,*
1896

Röntgen's rays

When Wilhelm Röntgen discovered X-rays in 1895, he not only gave the world a tool
that was to revolutionize such sciences as crystallography and medicine but he also
provided for the first time a device that could enable us to 'see' in a way that is untram-
melled by the restriction of our visual apparatus to a narrow band in the total spectrum of
radiations. The conceptual leap was as great as the technical.

Röntgen discovered X-rays when he was not looking for them. He was pursuing his
investigations into cathode rays, when he noticed that his Crookes' tube was emitting
something that penetrated black paper and travelled further from the tube than forecast.
These peculiar emissions not only passed through many solid items placed in their path,
including his wife's hand (but not her wedding ring) and a wooden box which contained

impervious metal weights, but also activated phosphorescent materials and imprinted themselves on photographic plates, rendering the images permanent.

After the main published debut of X-rays in *Nature* on 23 January 1896, the major debates centred not on their utility but on what they were. They belonged more in the realm of theoretical research into 'luminiferous ethers' and the nature of electricity than in the world of practical and commercial exploitation—although Thomas Edison characteristically saw that others would grasp 'how to profit by it financially'.

Alongside the serious science—Röntgen was the recipient of the first Nobel prize for physics in 1901—the 'see-through rays' attracted much popular attention, both humorous and alarmist.

Detail of Wilhelm Röntgen's radiograph of a box of weights

If we could now see through opaque surfaces, what was there to prevent the making of devices which allowed voyeuristic men to inspect the naked bodies of fully-clothed women? A poem in the journal *Photography* in 1896 precisely captured the air of circus that inevitably came to surround the invention, in spite of Röntgen's own public reticence:

> The Roentgen Rays, the Roentgen Rays,
> What is this craze:
> The town's ablaze
> With the new phase
> Of X-ray's ways.
> I'm full of daze,
> Shock and amaze,
> For now-a-days
> I hear they'll gaze
> Thro' cloak and gown—and even stays,
> These naughty, naughty Roentgen Rays.

The *Pall Mall Gazette* was disgusted by the 'revolting indecency of Röntgen rays' and one enterprising London entrepreneur advertised 'X-ray proof underclothing'. The moral fears aroused by the supposedly voyeuristic rays have found a reprise in the recent decision of Sony to withdraw its infrared digital camera from public distribution following outcry in Japan that the new camera can actually achieve what Röntgen's critics only imagined to be possible.

The rays were also seized upon, more validly, as a means to reveal the aesthetic of nature's hidden order. Just one year after Röntgen's announcement, Joseph Maria Eder, Viennese photographic chemist and author of authoritative texts on the technical history of photography, and Eduard Valenta, also a photochemist, collaborated on a portfolio of 15 beautifully modulated photogravures of inner skeletal orders.

Like instantaneous photography, X-radiography simultaneously developed as an important tool of scientific research and as a public performance, exploited across Europe and America by 'scientific' showmen, heedless of what we now know about the risks of prolonged exposure. Like today's hyped announcements of 'cancer cures', once a discovery leaps out of the professional box, there is little way of controlling its public journeys. ∾

C.V. Boys, 'Experiment for showing by intermittent light the apparently stationary drops into which a fountain is broken up by the action of musical sound', from *Soap Bubbles and the Forces that Mould Them*

Boys' bubbles

The burgeoning shelves of 'popular science' in bookshops seem to suggest that we are witnessing a recent phenomenon. In fact, campaigns to broadcast science to mass audiences proliferated in the nineteenth century, and had been preceded by such individual initatives as Count Algarotti's *Newtonianism for Ladies* in 1737. In Britain, luminaries such as the polemical physicist, Sir David Brewster, aspired, through accessible publications and the founding of the British Association in 1831, to educate the public in the observational wonders of natural phenomena and experimentation, above all in a Christian spirit of devotion to nature.

One of the most delightful and enduring contributions was Sir Charles Vernon Boys' *Soap Bubbles and the Forces Which Mould Them*, originally delivered as three lectures for young people at the Royal Institution during the winter of 1889–90, and first published by The Society for Promoting Christian Knowledge in 1902. As late as 1959 they were reprinted in the American *Science Study Series*. John Durston remarked in his preface 'that this book remains as valuable to beginning scientists today as the lectures were seventy years ago is remarkable in this age of revolution'.

Boys, born in 1855 as the son of a clergyman, studied chemistry and physics at the Royal School of Mines. His first paper, published in 1880 under the wing of T.H. Huxley, described experiments to determine if spiders would be lured by the 'buzz' of a tuning

fork—which they were. Renowned for having determined the Newtonian constant for gravitation, he was also the inventor of quartz fibres, which he drew out by shooting a crossbow, and an innovator in instantaneous photography. He was delighted to discover that a quartz fibre dipped into castor oil was indistinguishable in micro-photographs from the beaded filaments made by a spider. Music, fibres, viscous beads, photography, and spiders became interwoven themes in his rapturous exploration of the visual and aural music of physical phenomena.

Typical of his approach is the experiment that provided the frontispiece for his little volume on soap bubbles. A beam of light is projected on to a screen through a small hole in a card, behind which is a spinning disk with six holes round its rim. The pulsing beam casts the shadow of a fountain which is vibrated by a tuning fork. The speed of the disk is literally fine-tuned by blowing through the holes until the note is precisely that emitted by the tuning fork. The apparently continuous jet is revealed as an arc of beads. If the card turns fractionally slower:

C.V. Boys, Chichester Bell's 'Singing Water Jet', from *Soap Bubbles and the Forces that Mould Them*, 1902

> … all the drops will appear to slowly march onwards, and what is so beautiful … each little drop may be seen to gradually break off, pulling out a waist which becomes a little drop, and then when the main drop is free it slowly oscillates, becoming wide and long, or turning over and over, as it goes on its way.

This pretty experiment is followed by an account of Chichester Bell's 'Singing Water Jet' in which an arched fountain falling on a rubber sheet stretched over the end of a tube 'begins to sing of its own accord' under the agitation of vibrations transmitted to its nozzle from a chiming watch and muffled musical box.

In his love of the visual realization of musical sounds through the exciting of vibrations in visible media, Boys stood in the distinguished tradition of Wren, Hooke, Wheatstone, Chladni, and Hemholtz. They would not in any way have dissented from Boys' conviction that 'experiment is a question we ask of Nature, who is always ready to give a correct answer, provided we ask properly, that is, provided we arrange a proper experiment'. ஒ

Milk Marque Tanker showing the familiar
'splash of milk' logo, 1999

Stilled splashes

Some of the images made visible by modern science are at once so arresting and so beautiful that they have come to be regarded as supremely representative of natural forms and processes. The momentary coronet of the splash made by a spherical object plunging into a pool of milk has entered general consciousness to such effect that it serves as the logo of Milk Marque, the British company which replaced the Milk Marketing Board in 1994 and is responsible for distributing some seven billion litres of milk per year.

The unexpected and wonderfully complex configurations of 'simple' splashes were first revealed in 1908 by Arthur Worthington, Professor of Physics at the Royal Naval College at Devonport, where research into the behaviour of water and the dynamics of projectiles were of obvious relevance. Worthington's *A Study of Splashes* and his photographic montages now in the National Museum of Photography, Film, and Television at Bradford, are under-recognized classics of scientific photography. Each fleeting phase in splashes formed by falling bodies of various kinds and sizes was effectively stilled in the light of a spark lasting less than three millionths of a second. Sets of splashes formed under identical conditions were successively photographed using a plate camera with an uncovered lens in a darkroom, with each successive splash captured at an interval of around one

hundredth of a second later than its predecessor—on the assumption that each splash passes through essentially the same sequence of phases.

Worthington was justifiably excited by the 'exquisite forms the camera has revealed'. On one hand, the beguiling sequence of fluid configurations appears 'orderly and inevitable', while on the other 'it taxes the highest mathematical powers to elucidate', requiring a precise knowledge of 'the real path of any particle'.

The sensitivity of the process to its initial conditions was confirmed when smooth and rough spheres of identical dimensions and weight were shown to generate quite different shapes, one more roundly protuberant and the other more crater-like. Fluids of differing viscosity, most notably water and milk, adopted varied configurations of splash. We now understand that the necessary 'mathematical powers' to model such dynamic systems reside in computer-driven chaos theory rather than with the analytical tools available at the turn of the century.

Although Worthington's experiments were drawn into a wider arena by their illustration in D'Arcy Thompson's *On Growth and Form* in 1917, in which the Scottish biologist characteristically intuits morphological analogies with medusoids and hydroid polyps, Worthington's pioneering work was subsequently submerged by the entrepreneurial flair of Harold Edgerton at MIT's 'Strobe Alley' during the 1930s. Edgerton so perfected his stroboscopic system that it could deliver 3 000 images per second.

Alert to the commercial potential of such striking photographs as that of a bullet passing through an apple, Edgerton vigorously promoted his pictures to the public, not least through his 1939 book, *Flash*, and his film *Quicker 'n a Wink*. It was one of Edgerton's spectacularly well-defined prints of the splash coronet that was accorded pride of place in Thompson's 1948 revision of his classic text and, in its luridly coloured 1957 version, that entered the collections of museums, adorned posters, and sold postcards.

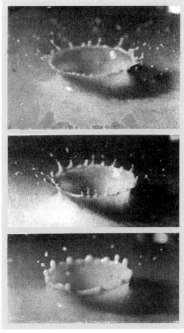

Arthur Worthington, 'Phases of a Splash', from *A Study of Splashes*, 1908

In selecting a tidied-up graphic version of the milk coronet, seen by implication from below rather than looking down on the surface, Milk Marque are clearly relying upon our ability to see both the regal crown and the photographic splash, exploiting our receptiveness to visual puns. Seeing the splash makes more demands on us than seeing the stock icon of the crown and it transpires that, famous though the Worthington–Edgerton image has become, not everyone picks up the ingenious allusion to the stilled splash in the logo which is familiar on the roads of Britain. ∿

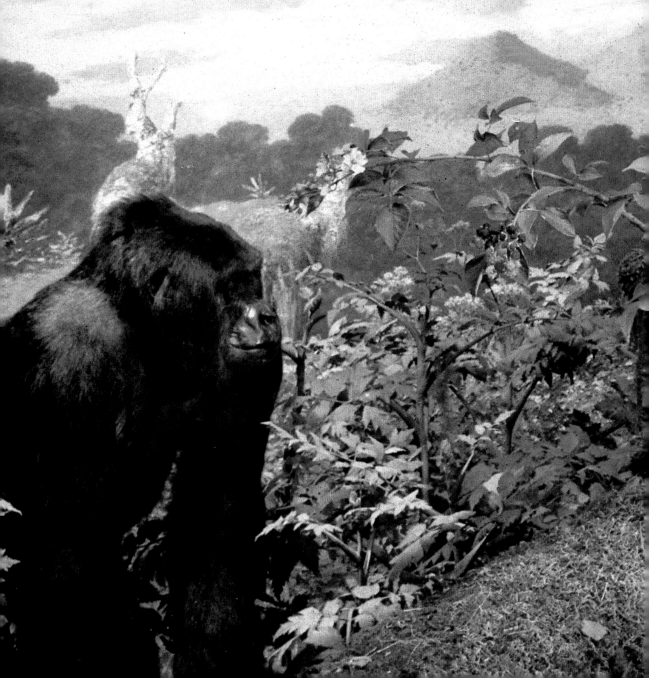

PART FIVE

Man and beast

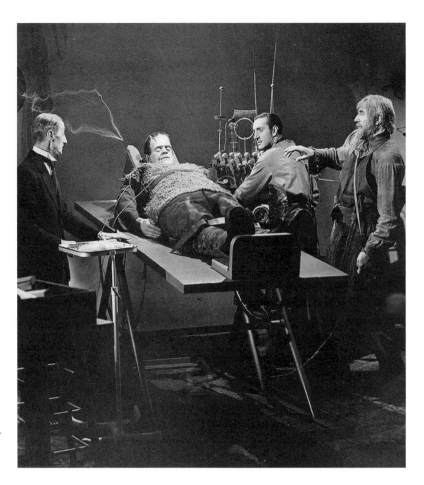

'The Infusion of the Spark of Life', still from *Son of Frankenstein*, directed by Rowland V. Lee, 1939

Shelley's shocks

The popular image of the magus–scientist who discovers the ultimate key to the creation of life has a long history, from the era of the alchemists to the more alarmist accounts of the recent cloning of a sheep, coyly named 'Dolly'. Never was there a greater sense that the very secret of life itself was in the process of being disclosed than in the late eighteenth century, in the wake of revelations about the life-giving properties of 'oxygenated air' and sensational experiments with electricity.

Frankenstein or The Modern Prometheus, written by the 19-year-old Mary Shelley and first published in 1818, is the supreme and most enduring literary product of these obsessions. During 'long conversations' with Percy Shelley and Lord Byron in the latter's Swiss villa, she tells how:

> … various philosophical doctrines were discussed, and among others the nature of the principle of life … They talked of the experiments of Dr (Erasmus) Darwin … who preserved a piece of Vermicelli … till by some extraordinary means it began to move with voluntary motion … Perhaps a corpse could be re-animated: galvanism had given a token of such things.

The reference to galvanism is hardly surprising. Huge interest centred upon Luigi Galvani's account in 1781 of how the detached leg of a frog could be made to move when an arc of two metals formed a bridge between the muscle and the crural nerve. Galvani's claim to have discovered animal electricity attracted an enthusiastic following. The chemical potency of electricity as it was being progressively disclosed seemed perfectly suited to be the mysterious ingredient which infused dead things with vital powers.

A series of experimenters took up the challenge to produce life from death. The German physician, Karl August Weinhold, introduced a zinc and silver amalgam into the spinal chord of a kitten whose brain had been spooned out, with the result that it 'hopped around, and then sank down exhausted'. Galvani's nephew, Giovanni Aldini, used electrical currents to stimulate vivid expressions in the heads of executed criminals. And, in the year of the publication of *Frankenstein*, Andrew Ure, a Scottish chemist working in London, sensationally adapted Aldini's methods to induce apparent life in a criminal's corpse.

Shelley is careful not to describe explicitly Victor Frankenstein's 'instruments of life', but it is clear that he utilized the unleashed powers of 'electricity and galvanism'. After witnessing a bolt of lightning destroying an oak tree, Victor exults in these powers as 'new and astonishing to me'. The repeated filmic reworkings of the story—ranging from the seriously shocking to the overtly burlesque—typically characterize the mechanism that infused the 'spark of life into the lifeless thing' as harnessing vast electrical power, sometimes directly from lightning. Inevitably, the cinematic realization of the crucial moment requires an explicitness that Shelley avoided—leaving the visualization to the reader's imagination rather than to literal illustration. Indeed, the early illustrations to *Frankenstein* fell far short of contributing anything rewarding to the text. This difficulty has not detered successive film-makers from taking up the challenge of bringing her vision to life.

What shocked Mary Shelley, as she lay in bed imagining the terrible scene, still has the power to haunt the public imagination:

> I saw the hideous phantasm of a man stretched out, and then, on the workings of some powerful engine, show signs of life, and stir with an uneasy, half-vital motion. Frightful it must be; for supremely frightful would be the effect of any human endeavour to mock the stupendous mechanism of the Creator of the world. ❧

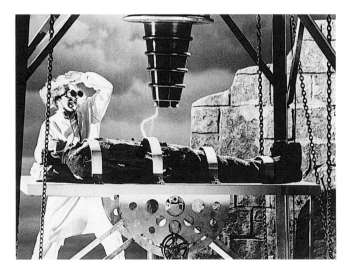

'The Infusion of the Spark of Life', still from *Young Frankenstein*, directed by Mel Brooks, 1974. The Ronald Grant Archive

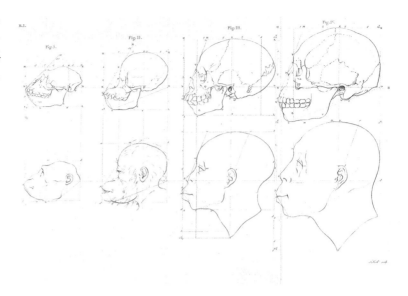

Slanted statistics

We have inherited a notably persistent image of 'primitive man'. 'He' is characteristically hairy, raw boned, mighty in hand and foot, and endowed with a prognathous jaw. The basics of this stereotype were laid down with the 'wild' or 'savage' human races believed by the ancients to inhabit regions remote in place or time. The new factor in the nineteenth century was the simian nature of his cranium and face. Most specifically, primitive character was signalled by a facial angle which ran obliquely backwards from protruding jaw to receding forehead.

Such an ape-like physiognomy can most obviously be recognized as an outcome of Darwin's theories of human evolution. However, the key feature of facial angle had been established as a measure of beauty in the later part of the preceding century, above all in the widely read publications of Petrus Camper, the learned Amsterdam doctor. In his *Dissertation sur les Variétés Naturelles qui Caractérisement la Physionomie des Hommes*, published in 1791, and translated in *The Works of the late Professor Camper, on the Connection Between the Science of Anatomy and the Arts of Drawing, Painting, Statuary &c* in 1794, he noted that 'it is amusing to contemplate an arrangement…in a regular succession: apes, orangs, negroes, the skull of a Hottentot, Madagascar, Celebese, Chinese, Moguller, Calmuk and diverse Europeans'. This was precisely how he had arranged his own collection of ethnic crania 'on a shelf in my cabinet'.

Using an elaborate measuring frame of his own devising, Camper tabulated and illustrated a progression of facial angles: the skull of a *simia caudata* (tailed monkey) measured 42°; that of a small orang-outang (on which Camper had written a monograph) was 58°; a young negro exhibited a 70° inclination; a Calmuk ('deemed the ugliest of all the inhabitants of the earth') weighed in at the same angle; while the typical European profile attained the near vertical with 80°. This peak could be surpassed 'by the rules of art alone',

as in the lauded ancient sculpture of the Apollo Belvedere which stands at the head of Camper's sequence.

In retrospect, it is all too easy to see how this succession could be used to align apes and human races in a moral order which placed the 'negroes' nearer the baser animal end of the scale. In conjunction with the voguish physiognomics of Johann Caspar Lavater, this diagnostic move was readily made, not least in Charles White's *An Account of the Regular Gradations in Man and in Different Kinds of Animals and Vegetables* of 1799, in which drawings of crania were arranged in ascending succession from a long-beaked bird (literally bird-brained) to the noble profile of an exemplary European. However, this was not a move that Camper himself was prepared to make.

Camper definitively rejected the 'extravagant' notion that 'the race of blacks originated from the commerce of the whites with orangs and pongos; or that these monsters, by gradual improvements, finally become men'. The morphological differences between quadruped apes and upright men 'seem to mark the boundaries which the creator has placed between the various animals'. The 'divergences' persuaded the anatomist that 'the whole human race as it is now spread over the face of the earth' was originally 'descended from a single pair, that were formed by the immediate hand of God, long after the world itself had been created and had passed through numberless changes'. While Special Creation or a sequence of Special Creations remained the norm, there was a limit to the conclusions that could be drawn from any supposed similarities between the skulls of 'negroes' and apes.

One consequence of the Darwinian revolution for the burgeoning science of craniometry was to arrange the Camperian sequence of angles in a *temporal* succession. Once the steps represented by God's discrete creation of separate species had been replaced by the transformation of one species into another —or monkeys into men, as was popularly said—the kind of fallacious ranking effected by White was granted a new scientific licence. Camper's 'negro', with relatively shallow facial angle, could be stigmatized as evolutionarily more primitive. The extensive campaigns of craniological measurement and ethnographic photography, together with the assembly of huge collections of skull types during the nineteenth century provided great banks of data that could be exploited to detect those races that stood closest to the animal origins of man.

The progressive misuse of Camper's non-racist characterizations is a salutary reminder of what can happen to apparently 'neutral' results when a climate of belief is radically transformed. Place his observations together with Lavater's diagnostic physiognomics and Darwin's *The Descent of Man* in the same social cooking pot, and we can see how an ugly dish can result. ☙

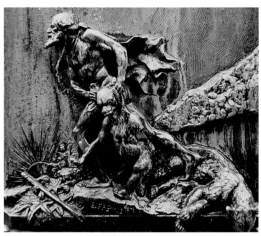

Emmanuel Frémiet, *Orang-utan Strangles a Native of Borneo*, 1898, foyer of Gallerie d'Anatomie Comparée, Jardin des Plantes, Paris

Emmanuel Frémiet, *Man Triumphant over Two Bears*, Jardin des Plantes, Paris

Frémiet's frenzy

The Jardin des Plantes in Paris is far more than a garden of plants. In the heyday of Lamarck, Geoffroy de Saint-Hilaire, and Cuvier, it was an international crucible for scientific natural history and the centre for controversies about the great prehistoric transformations that were becoming increasingly apparent through studies of the fossil record. Comparative anatomy, the chair occupied by Cuvier from 1795, was at the centre of the intellectual conflagrations.

Visiting the Jardin today, the visitor is presented with the striking spectacle of the Gallerie d'Anatomie Comparée as a testimony to Cuvier's legacy and to its subsequent Darwinian transformation. Constructed by the architect Ferdinand Dutert, the Gallery opened in 1898 with displays devised by Albert Gaudry, a leading French evolutionist, who admired Darwin's *Origin of Species* without espousing the more radically competitive and apparently random aspects of 'natural selelction'. On the first floor are the palaeontological collections, arranged according to evolutionary principles, while on the ground floor the visitor is immediately confronted by a veritable Noah's Ark of marching skeletons, headed triumphantly by a painted *écorché* statue of an upwardly aspiring man.

Less regarded today, but no less integral to the gallery's message, are the notable sculptural adornments on the exterior and interior of the building. The leading participant was the specialist sculptor of military and animal subjects, Emmanuel Frémiet, who had succeeded the great *animalier*, Antoine-Louis Barye as Professeur d'Iconographie Naturelle at the Jardin in 1875. Famed for his equestrian monument to Joan of Arc in the Place des Pyramides, Frémiet's animal tableaux courted controversy. His favourite subjects represented humans and animals in frenzied competition, initially as realizations of

French theories of human history in its dynamic guise and latterly in a manner that seems more generally Darwinian in its vision of the hard-won 'ascent' of man.

In the foyer of the Gallery is one of his stock images of natural violence, *An Orang-utan Strangling a Native of Borneo*, originally enhanced by polychrome touches of gore, while one of his exterior bronze reliefs on the facade overlooking the Rue Buffon depicts a key combat in evolutionary iconography, the hard-won triumph of man over the bear. The relief itself, scoured by acid rain, can now best be appreciated via the reduced version that adorns the reverse of the plinth of the memorial statue erected in front of the Gallery.

Victory over the bear, not least in the battle for supremacy as cave-dwellers, was seen as a vital step in human progress. Louis Figuier's popular *L'homme Primitif*, in its 1870 edition, illustrates competition with the 'great bear' which lends its name to the first of his stone-age epochs. It was the advent of tools, such as the hafted axe slung over the shoulder of Frémiet's Herculean cave-

Ecorché Man Leading the Parade of Animal Skeletons, Gallerie d'Anatomie Comparée

man, that enabled humans to 'repulse the attacks of ferocious animals which prowled around his retreat and often assailed him', to quote the English translation of Figuier in 1872.

In the smaller bronze, one of the sculptor's bears hangs limply over the base of the relief, mortally wounded by a broken spear, whilst a youngster is literally hauled away by the scruff of its neck. The heroic man strides forth, beard thrust resolutely into the distance, marching irresistibly towards the rising sun of the new age (a detail less apparent in the larger relief). However, to remind us that the struggle between man and beast was by no means one-sided, an external bronze group standing in the Jardin shows a wounded she-bear fatally 'hugging' a hunter who has previously strangled her cub.

We may now be inclined to see such images as pieces of decorative nonsense, if we notice them at all, but they were as much part of the public understanding of science as any of the displays within the museum and have, particularly through related book illustrations, done much to fire the public imagination and inspire aspiring palaeontologists. We exclude such works from our image of mainstream scientific endeavour at the risk of severe misunderstanding of the public dynamic of the scientific vision. ❧

Four stages in the metamorphosis of
Spencer Tracy from Dr Jekyl to
'Mr Hyde', stills from *The Strange Case of
Dr Jekyl and Mr Hyde*, directed by Victor
Fleming, 1941

Hyde's horrors

How the image of science and its practitioners enters public consciousness through the popular media—frequently in caricatured form—cannot be dismissed as irrelevant to its professional practice. The institutions of science are as subject to political decision-taking in the context of public opinion as any other bodies funded from state and private purses. And even the grossest of visual distortions feed on images ultimately promulgated by scientists themselves.

Robert Louis Stevenson, the Edinburgh engineer and qualified lawyer, wrote his classic

The Strange Case of Dr Jekyll and Mr Hyde (1885) in the heyday of physiognomics, craniology, and anthropometry, and in the wake of Francis Galton's new science of eugenics. Looking again at Stevenson's original text, it is striking how subtle and elusive were the visual signs of the degenerate and regressive Hyde released by the chemical cocktail. Mr Enfield, the first witness, typifies the problems:

> He is not easy to describe. There is something wrong with his appearance; something displeasing, something downright detestable. I never saw a man so disliked, and yet I scarce know why. He must be deformed somewhere; he gives a strong feeling of deformity, although I couldn't specify the point.

A conviction that measurements of extraordinary refinement—beyond simple descriptions—were needed to define 'types' through facial and cranial formations lay at the heart of such large-scale enterprises as Paul Broca's craniometry, Galton's photographic databanks of eugenic groups, and François Bertillon's programme of criminological identification at the Prefecture in Paris.

Inevitably, when 'the animal within me licking the chops of memory' came to be visualized in popular cinema, a more blatant characterization was required. The physiognomy provided by director Victor Fleming for Spencer Tracy in 1941 was not the most crudely bestial of the filmed Hydes, but his range of manic expressions stood in a long tradition of exaggerated pathognomics. The images used by Charles Darwin in his *The Expression of the Emotions in Man and Animals* (1872), including his potent use of photographs and his commissioning of drawings by leading illustrators, such as Joseph Wolf, stand in this tradition. Most notably he availed himself of the striking and often grotesque photographs taken by Duchenne de Boulogne in Paris, who used electrodes to activate individual facial muscles so that specifc expressions might be more sharply characterized.

Joseph Wolf, 'Niger Macaque (*Cynopithecus niger*) Aroused by Stroking', engraving in Charles Darwin's *The Expression of the Emotions in Man and Animals*, 1872

Darwin, for his part, set human expression in the broader context of evolution, not in terms of traditional parallels between human facial types and animal physiognomies but through an understanding of the origins of the expressive mechanisms:

> … as long as man and all other animals are viewed as independent creations, an effectual stop is put to our natural desire to investigate as far as possible the causes of expression . . . With mankind some expressions, such as the bristling of the hair under the influence of extreme terror, or the uncovering of the teeth under that of furious rage, can hardly be understood except on the belief that man once existed in a much lower and animal-like condition.

We still talk of those who perpetrate atrocities as 'animals' or 'beasts', and scrutinize the faces of villains who stare at us out of newspaper photographs for signs of evil. And the Galton Laboratory at University College London has a web site seeking physiognomic volunteers for its collaborative project on the genetics of human facial features, for which the Forensic Science Service is a funding agency. ❧

Amniota	Paired nostrilled or Amphirrhina with Amnion, without gills.										
Reptiles, Reptilia.								Birds, Aves	Suckling animals, Mammalia.		
Primæval Reptiles, Tocosauria.	Lizards, Lacertilia.	Snakes, Ophidia.	Crocodiles, Crocodilia.	Tortoises, Chelonia.	Flying Reptiles, Pterosauria.	Dragons, Dinosauria.	Billed Reptiles, Anomodontia.	Birds, Aves	Billed Animals, Monotrema.	Pouched Animals, Marsupialia.	Placental Animals, Placentalia.

Ernst Haeckel, 'Single or Monophyletic Pedigree of the Stem of the Back-Boned Animals based on Paleontology', detail of the right half, showing the Amniota, from *The History of Creation*, 1875–6, vol. II, opposite p.223

Haeckel's hierarchies

The tree as a schema for lines of descent, not least in the form of 'family trees', is one of those devices that have become so familiar as to give us little pause for thought. Yet the diagrammatic tree is often rich in implicit meaning, far beyond its immediate graphic utility.

The leading early designer of evolutionary trees was the fervent German Darwinian, Ernst Haeckel. Famed for his beautifully illustrated publications of the Radiolaria—those geometrical masterpieces of micro-engineering—and as an anti-Catholic polemicist, Haeckel sought to so extend and consolidate Darwin's theory that it would brook no contradiction. He insisted that 'ontogeny is a short and rapid recapitulation of phylogeny'—that is to say that the essence of the evolutionary process is restated in the embryological development of vertebrates. So firmly did he believe in this theory that he subtly bent his visual evidence to demonstrate identical stages in the embryological development of different species—a bending that modern studies have revealed as unnecessary to confirm the fundamental insight.

Haeckel aspired to a monist philosophy which dissolved the traditional dualisms of science and religion, reason and revelation, soul and body, mind and matter, man and animals, living and non-living, and organic and inorganic. His monism, unificatory on the surface, was nevertheless suffused with hierarchical values, not least in his evolutionary trees.

In his first major contribution to evolutionary theory, his *General Morphology of Organisms* in 1866, the tree assumes its most organic guise, with nicely rounded trunk and convincing ramifications, while in *The History of Creation* (translated by E. Ray Lankester in 1875–6) the trees are transformed into fern-like structures, with a degree of impressionistic suggestiveness commensurate with the uncertainties of the fossil record. Such trees were not the inevitable outcome of an awareness of the successive phases of the appearance of species. Louis Agassiz's elegant spindle diagram in his book on fossil fish in 1833, eloquently expounded by Steven Jay Gould, resists the joining of the branches to the trunks, because Agassiz was 'convinced that they do not descend, one from the other'. If Agassiz's scheme is concerned with special creations and descent, Haeckel deals with the remorseless *ascent* of humankind.

Acknowledging that 'man is separated from the other animals by quantitative not qualitative differences', Haeckel recognized the continuity of all natural things. However, he argued that 'if one must draw a sharp boundary ... it has to be drawn between the most highly developed and civilised man on one hand, and the rudest savages on the other, and the latter have to be classed with the animals'. Unhappily, on the eve of the First World War, he was inclined to agree with the chemist and colour theorist Wilhelm Ostwald, that the Germanic race was leading the way into new evolutionary uplands, having 'discovered the factor of organisation', whereas 'other peoples live under the regime of individualism'.

Haeckel's hierarchical trees, all too readily lent themselves to such forms of social Darwinism and eugenic perfection. However, it would have behoven him—and it certainly repays us—to reflect that the unbroken persistence of some 'primitive' species from the lowest ramifications of his trees can just as readily suggest that the human race, as a newcomer on the evolutionary stage, has a long way to go to demonstrate comparably sustained durability. ❧

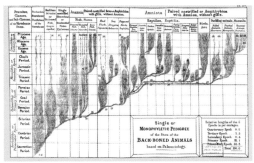

Ernst Haeckel, 'Single or Monophyletic Pedigree of the Stem of the Back-Boned Animals based on Paleontology', whole plate, from *The History of Creation*, vol. II, opposite p.223

Louis Agassiz, 'Diagram of the Evolution of Fishes' from *Les poissons fossiles*, 1833, vol. I, p.170

Carl Akeley and Albert
Butler, *Gorilla Group*,
with landscape by
William Leigh, African
Hall, American Museum
of Natural History,
New York. Transparency
no. 6918, courtesy Dept.
of Library Services.

Carl Akeley's photograph
of William Leigh
(standing) and A.A.
Jansson, making studies
for the African lion
diorama, 1926–7. Neg. no.
412182, courtesy Dept. of
Library Services,
American Museum of
Natural History

Akeley's Africa

Even in this age of multimedia extravaganzas, the most brilliant of the old habitat
dioramas in museums of natural history still attract enthralled viewers. Tableaux of
stuffed animals in vivacious poses are renaturalized in panoramas dense with biological
and geological detail, the 'real' foregrounds merging indiscernibly into deep backgrounds
painted by specialist artists in shallow niches.

The concept was perfected by the Swedish taxidermist and sportsman, Gustaf Koltoff.
His Biological Museum, which opened in Stockholm in 1893, stands as the supreme
surviving example of a habitat panorama. From two viewing platforms the spectator is

presented with almost 4 000 zoological specimens, ecologically integrated within eight successive landscape types, the backgrounds of which were painted by Bruno Liljefors, Sweden's supreme nature artist. Scientific demonstration and popular appeal coexist in perfect harmony.

Outside Sweden, the ecological diorama was adopted with unrivalled enthusiasm in America. The diorama halls in the American Museum of Natural History in New York, into which huge resources were poured in the first half of the twentieth century, vividly convey the American vision of the sublime 'wilderness', the definitive expression of which was the African Hall of Carl Akeley.

Gustaf Koltoff, Biological Museum in Stockholm, 1893, with painted landscapes by Bruno Liljefors

A taxidermist who devised new techniques for naturalistic animation, Akeley gained public renown as an intrepid explorer, environmental conservationist, animal sculptor, and inventor, who was said to have killed a leopard in hand-to-paw conflict. It was on his return in 1911 from an expedition to hunt animals for a dynamic tableau of alarmed elephants that Akeley conceived the African Hall, within which *The Alarm* still stands. The grand hall of luminous dioramas, in a framework of rich wood decorated with sculptural reliefs, became the great vehicle for his 'biography of untouched Africa', conveying his mission to conserve the wonderful wildlife threatened by human encroachment.

Mountain gorillas, the subject of a dramatic group in an awesome landscape, were in particularly urgent need of protection from hunting. Akeley's 1922 proposal to the Belgium government to save the gorillas led to the establishment of the first national park in the Congo. The foreground of the diorama contains over 75 000 laboriously mounted artificial flowers and leaves, while the scenery—hailed by Akeley as beyond compare— was painted by William Leigh, a specialist in background panoramas. The overall effect of sublime grandeur stands in line of descent from the eighteenth-century depictions of the awesomeness of nature, such as Wright's pictures of Vesuvius and Turner's Alpine views.

A photograph by Akeley portrays the expeditionary force, including Leigh and a fellow painter, armed with brushes, paints, canvases, easels, and a small-scale diorama box. Meticulous care was taken in assembling field data on every aspect of the flora, fauna, geology, and meteorology of the setting, to capture the complex totality of the environment. The goal was, in Leigh's words, 'complete pictures, faultless history, perfect science'. To achieve such authenticity, the museum's investments of time, energy, organization, and money were prodigious.

Eventually, the high costs incurred by the expeditions and the expense involved in the assembly of the dioramas left the museum's education department, under whose aegis the enterprise was conducted, open to criticism from scientific curators who believed that the museum's primary role should be research—not public displays 'totally devoid of intellectual content'. Such claims failed to recognize the role the dioramas played in persuading both biologists and the public of the need to view every living thing in the rich and evolving panorama of nature's complexity. ∾

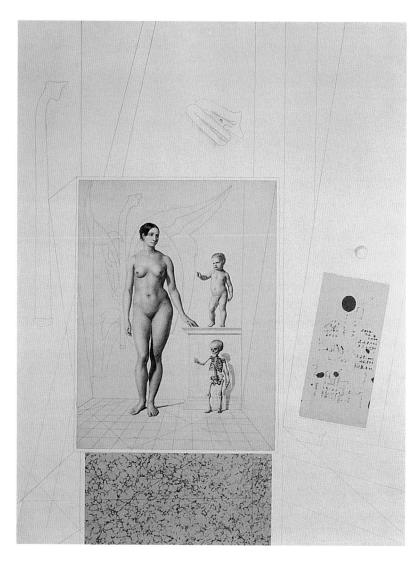

Ernst's ego

The charting of the darkly mysterious labyrinths of the unconscious mind in early twentieth-century psychology, above all by Freud, seemed to promise a new science of human nature based upon our most basic instincts. The new science also posed a profound threat to those who believed that the intellectual structures of other institutionalized sciences were the only true models of knowledge and, as such, provided the secure foundations for human progress and the structures of modern life. The double-edged nature of the psychological sword was explored more profoundly by Max Ernst than by any other artist of his era.

Educated at the University of Bonn in 1909–12, Ernst was introduced to the experimental psychology of Wilhelm Wundt and his followers. Throughout his life the artist's grasp of contemporary psychology extended far beyond the bowdlerized Freudian formulae favoured by many of his surrealist colleagues. The prime vehicle he exploited to evoke

the tangled *mélanges* of memory images and the symbolic fantasies of dream states was the collage. He cannibalized, juxtaposed, and overlaid images garnered voraciously from a huge range of general and specialist publications to paint the enigmatic landscapes of his inner mind. The popular science periodical, *La Nature*, was a favourite source.

The juxtapositions may appear irrational yet his method was avowedly 'experimental'. 'Collage is a hypersensitive and rigorously exact instrument, a seismograph capable of registering the exact potentialities of human welfare in every epoch' he wrote.

In series of collages from the early 1930s, pictures within pictures are 'presented' by Loplop, the semi-mythical bird of his childhood, a pet cockatoo who had died at the moment of his sister's birth. This 'ouiseau supérieur' appears as a sinister caricature above the central image, and stands as his 'alter ego', into which he displaces himself as a 'third' person. Ernst was undoubteldly aware of Freud's *Leonardo da Vinci and a Memory of his Childhood* (1910), which centred on Leonardo's infant memory of his mouth being touched by a bird's tail. The 1919 version of Freud's essay included a line diagram of Oskar Pfister's fantastical theory that there was a vulture concealed as a 'picture-puzzle' in the skirts of St Anne in Leonardo's painting in the Louvre—'visible' only if the painting rests upside down on its upper right corner.

Facility, also, Loplop Presents combines images cut from an anatomical atlas with marbled paper and a blotter with scribbled sums, against a drawn background. The space of the inner picture is systematically laid out in geometrical perspective—a reference to facile academic naturalism—while the ground occupied by Loplop's disembodied head offers no such coherence. The marbled paper also alludes to the superficial nature of literal illusionism. The pedestrian 'science of art' as a mirror of scientific rationality is mocked by the leering bird in its schematic graphic form. Using scientific imagery to undermine itself, the juxtaposition of the naked woman and the infant, who is both alive and dead, aspire to plug into unconscious reveries of a sexual and procreative kind.

Specialized scientific illustration, in Ernst's eyes, often seemed to be oddly mocking of its own claims. He found that:

> . . . anatomical or physical demonstrations…united such mutually distant physical elements that the very absurdity of the array called forth in us a hallucinating succession of contradictory images, superimposed on one another with the persistence and rapidity of remembered lovemaking.

From Ernst's perspective, modern sciences and technologies, with their array of often alien visual images, were themselves manifestations of the strange obsessions of our psyche and, as such, were full of the contradictions and ambiguities that bedevil all constructions of the human mind. ∽

Space and time

Umberto Boccioni,
*Development of a Bottle in
Space*, 1912, Zurich,
Kunsthaus. Bridgeman
Art Library, London

Boccioni's ballistics

A new art for a new age. Such was the refrain that ran through the avant-garde, from
the time in the nineteenth century when Baudelaire announced his search for a
'painter of modern life'. By 1900, the 'modern life' was being defined by the remorseless
spread of the new technologies of energy, transport, and communication, and by revolu-
tionary notions of the human mind and of time and space. Cubism seemed to provide an
art that embraced the new situation.

The pictorial revolution of the Cubists, undertaken during 1907–12 by Pablo Picasso
and Georges Braque, involved the dissolution of perspectival space into fractured, inter-
penetrating planes and plural viewpoints. Their innovations have sometimes been
interpreted retrospectively as the realization of Bernhard Reimann's non-Euclidean
geometry and even as the embodiment of Einsteinian relativity. That there are suggestive
parallels between the Cubist rejection of orthordox pictorial space and the new physics is
not in question. The problem for the historian lies in demonstrating any documented
connection between the artists working in Paris and the scientific pioneers. In the case of
the Italian Futurists, who wrote explicitly about what they were doing, we can gain a more
secure sense of how the new ideas seeped into the artists' consciousness.

The Futurists in Italy knowingly pushed the Cubists' pictorial reforms in the direction
of the new sciences and technologies. In *Foundation and Manifesto of Futurism* in 1908, the
moustachioed poet F. T. Marinetti belligerently advocated the destruction of museums—
the 'cemeteries' of art—and lauded the beauty of 'a racing car whose hood is adorned
with great pipes, like serpents of explosive breath' over the most revered sculptures of
antiquity. The new age of science-based technology was to sweep away the out-moded
civilizations.

Umberto Boccioni, the most creative and versatile of the Futurist artists, was the leading voice behind the *Technical Manifesto* of the painters in 1910 and sole author of the *Sculptural Manifesto* two years later. His passionate writings were liberally laced with neologisms, printed in capitals—UNIVERSAL DYNAMISM, INTERPENETRATIONI OF PLANES, EXTERIOR and INTERNAL PLASTIC INFINITE, PHSYCIAL TRANSCENDENTALISM, INVISIBLE INVOLVING SPACE—which alluded, poetically as much as technically, to current mathematics and physics.

There was little direct mastery of the technicalities of the new sciences, but rather an intuitive translation of what was sensed to be the crux of developments, not least as translated by the philosopher Henri Bergson. Indeed, Bergson's *Creative Evolution* (1907) argued that 'intelligence', as 'the luminous nucleus' of scientific understanding, must be extended by 'instinct'—though 'instinct, even when enlarged and purified into intuition, forms only a vague nebulosity'. Boccioni's emphasis upon 'states of mind'—both in his writings and as a title for paintings—clearly signalled that more was involved than scientific logic if the new notions of space–time were to be integrated into our imaginative lives.

Georges Braque, *Clarinet and Bottle of Rum on a Mantelpiece*, 1911. © ADAGP, Paris and DACS, London 2000. Photograph © Tate, London 2000

Boccioni strove, in works like *Development of a Bottle in Space*, to express a series of relativities—as far as such a thing might be possible in the intractably solid medium of bronze sculpture. We are asked to experience form, space, and light as interpenetrating energies rather than as separate physical entities. The spaces occupied by the artist, the work, and spectator become interactively fused. Fixed perspective is abandoned in favour of continuously mobile viewpoints, revolving in space and transformed over time. The *Bottle* draws space into itself and, in Boccioni's words, makes its own 'extension into space, palpable, systematic and plastic'.

None of this is 'scientific' in our circumscribed sense, but it does bear witness to Boccioni's determination to use the artists' special toolkit of intellect, imagination, illusion, and allusion to forge his own kinds of poetic experiment, in a way that was analogous to the revolutionary acts of the physicists. ❧

Richard Feynman's diagrams of the interaction between two electrons' from 'Space–Time Approach to Quantum Electrodynamics', *Physical Review*, 9 May 1949, p. 787

Feynman's figurations

How are we to interpret Richard Feynman's statement, repeated in various forms, that 'nobody understands quantum mechanics'? As the great authority on quantum electrodynamics and an eloquent communicator of difficult physics to non-specialist audiences, his aphorism clearly cannot be taken at face value.

He could not have meant that it was impossible to comprehend the basic principles, nor was he intending to dismiss the analytical and predictive efficacy of the mathematics of quantum mechanics. Rather, his assertion has to be interpreted in the light of the gravitational pull of physical modelling and graphic picturing in his approach to the physics. It was a pull that ran into the same dilemma that faced anyone, artist or scientist, when they aspired to depict more than three dimensions—namely our lack of representational resources to depict four- or n-dimensional space.

Feynman was continually bothered by the way that physical behaviour could be expressed in algebraic conventions without concrete visualization: 'Strange! I don't

understand how it is that we can write mathematical expressions and calculate what the thing is going to do without being able to picture it'. As Freeman Dyson recalled, 'he was a natural physicist, and he thought in terms of concrete objects. The mathematics was an encumbrance, something you had to stick on afterwards, more or less . . . as a necessary evil'.

The now ubiquitous 'Feynman diagrams' achieved the graphic encoding of phenomena whose very nature means that they cannot be subject to direct picturing, though they bear a generic resemblance to the traces left by atomic particles in cloud and bubble chambers. In the 1949 paper which inaugurated his method, he provided the classic demonstration of the 'fundamental interaction' in which electrons exchange a photon. The electrons are figured as solid lines, while the process of exchange of a 'virtual quantum' is represented by a wavy line, which graphically signals that the photon can be emitted from one electron and absorbed by the other, or, if it travels backwards in time, in reverse. Either way, the result is the deflection of both electrons, denoted by their angular deviation.

Feynman diagrams look superficially like the simple graphics that physicists have used for centuries, but they are devices of exceptional power. Within their space–time co-ordinates, Feynman was able to sidestep the long-winded algebraic formulae which treated electrons and positrons separately. All the equations came together in one picture in a way that preceded and even directed calculation.

The diagrams rapidly and economically explained and predicted in ways that were at once intuitive and analytical. Feynman himself described the intuitive element in a characteristically graphic way:

Richard Feynman and a blackboard with diagrams, graphs, equations, and words, from *No Ordinary Genius: the Illustrated Richard Feynman*, ed. C. Sykes, 1994 (**reproduced courtesy of Weidenfeld and Nicolson**)

It's like asking a centipede which leg comes after which—it happens quickly, and I'm not exactly sure what flashes and things go on in the head. I do know it's a crazy mixture of partially solved equations and some kind of visual picture of what the equation is saying is happening, but not as well separated as the words I'm using.

The diagrams mirror his conviction that 'there is . . . a rhythm and a pattern between the phenomena of nature which is not apparent to the eye, but only to the eye of analysis'. The entangled interplay of instincts, theories, graphic visualizations, words, analysis, and formulae is nicely encapsulated by a typical blackboard of the kind with which he enjoyed posing.

Yet, given the very ubiquity of his diagrams, is it possible to wonder whether such a potent grammar of diagrams and matching equations not only provides a marvellous tool but also constrains what minds lesser than Feynman's permit themselves to envisage. ◗

Salvador Dali, *Corpus Hypercubus (The Crucifixion)*, 1955. The Metropolitan Museum of Art, gift of the Chester Dale Collection, 1955 (55.5). Photograph © 1987 The Metropolitan Museum of Art. © Salvador Dali–Foundation Gala–Salvador Dali/DACS 2000

Dali's dimensions

A recurrent theme of world art has been the striving to reach out into transcendental realms. Any artist so minded inevitably has to confront the paradox that transcendence implies access to dimensions (spatial, material, temporal, conceptual, and so on) beyond those that are open to literal description by the solid surfaces of visible artefacts.

Early in the twentieth century, pioneers of modernism in France, Italy, Russia, and other centres of the avant-garde seized in various ways upon the popularized notions of non-

Euclidean geometry, the fourth dimension, infinity, and relativity as providing grounds for the rejection of traditional illusions of three-dimensional space. The levels of understanding achieved by artists varied greatly and, as we saw with Boccioni, the general picture is one of opportunistic annexing of new theories in a suggestive rather than exact manner.

One approach, particularly favoured by Russian artists like Kasimir Malevich and El Lissitzky, was to exploit abstraction as a way of negating conventional space. Malevich's famous *Black Square* and *White on White* use extreme reduction of means to evoke the infinity and nothingness that lie beyond material definition, but the effect relies on absence and denial rather than positive visualization.

Charles Howard Hinton, 'Hypercube' from *The Fourth Dimension*, 1912

The dilemma was not one exclusive to artists. All the ingenious attempts by mathematicians and cosmologists to provide visual tools for the concrete envisaging of the fourth dimension have struggled with the irredeemably three-dimensional parameters of the sensory space beyond our bodies and within our minds—and with the limited representational techniques available to us. The kinds of diagrammatic solutions proposed at the end of the previous century by the eccentric mathematician and convicted bigamist, Charles Hinton, seem to be about the best we can do. He devised an unfolded four-dimensional hypercube or tesseract as the spatial counterpart of a normal cube that has been unfolded into a flat template—the kind of unfolding that was first published by Albrecht Dürer in the Renaissance. Hinton's hypercube became a popular and mystical symbol of the transcendent spaces of the new mathematics.

As such it was adopted by the renowned Spanish Surrealist, Salvador Dali, in his *Corpus (or Christus) Hypercubus*, in which Christ's sacramental body is transfixed ambiguously within the foremost of the

Albrecht Dürer, 'Template for a Cube' from *Instruction on Measurement*, 1528. © The British Museum

cubes of a Hintonian tesseract, floating in front of the Virgin above a pavement decorated with an unfolded 3D cube. Is this more than slick visual opportunism or, at best, knowing symbolic allusion? We may gain some comfort from learning that Thomas Banchoff, author of *Beyond the Third Dimension* (1990), had earlier been contacted by the artist and was impressed by his 'technical knowledge'. Yet doubts remain. Dali is not working visually with anything beyond standard cues for the representation of forms in space.

However, in our present context, Dali's painting does stand effectively for an age-old striving in art, theology, mathematics, and cosmology for access to those dimensions that lie beyond the visual and tactile scope of the finite spaces of up-and-down, left-and-right, and in-and-out that imprison our commonsense perceptions of the physical world we inhabit. The scientists' success in colonizing the extra dimensions is defined mathematically. The artists—and Dali's corporeal Christ—reach out by visual inference. ❧

Max Bill, *Monoangulated Surface in Space*, gilded brass,
1959, Detroit Institute of Arts. © DACS 2000

Bill's bands

The idea that mathematical ideas can exhibit beauty and, more particularly, that pure geometrical forms exhibit aesthetic perfection at the highest level, has an ancient ancestry. The figures of the five regular polyhedra—the so-called 'Platonic solids'—together with the sphere, were particularly revered for their perfect symmetries and became favourite objects in Renaissance decorative schemes such as the perspectival panels of inlaid wood which adorned aristocratic studios. They continued to be produced as pretty teaching aids and objects of delight well into the modern area.

Writing in 1949, Max Bill, the Swiss sculptor, painter, and architect, delighted in the 'aesthetic reaction' provoked by 'models at the Musée Poincaré in Paris where conceptions of space have been embodied in plastic shapes or made manifest by coloured diagrams'. With the advent of abstraction in classic Modernism in the twentieth century, such geometrical forms have been liberated to become self-sufficient subjects for autonomous works of art—and this is just what Bill exploited in his own sculpture.

He saw his works as presenting something analogous to the mathematics of his day, as a form of intuitive visualization of 'theorems' that were escaping the reach of any con-

ventional 'visualizing agency'. He was striving for an art which would be to Einstein what Phidias, the ancient Greek sculptor, was to Archimedes. A series of sculptures, in a variety of media, work variations of the Möbius band or strip, originally devised by the German mathematician in 1858. For Bill, such a figure evoked the idea of a 'finite infinity' which he characterized as an 'essential guide to the speculations of contemporary physicists'. The precise form adopted by Bill's topological variations was not determined by mathematical theory. Rather he wished to evoke how space could be energized to reveal 'latent forces that may be active or inert, in part revealed, inchoate or still unfathomed, which underlie each manmade system and every law of nature it is within our power to fathom'.

His aim was less a pure formalism than the construction of a new kind of content based upon a higher sensing of the cosmic significance of 'fields of attraction'.

To most modern mathematicians, however much attuned to the aesthetics of spatial forms, Bill's ecstatic metaphysics will seem alien and, to use the sculptor's own term, 'phantasmagorical'. However, he stands very much as an heir to the geometrical metaphysics of many cosmographers in the past, not least Johannes Kepler, whom we have already encountered as the Platonizing constructor of a cosmos designed along aesthetic lines. More surprisingly, Bill's energized spaces also exhibit affinities with Descartes's graphic efforts to portray the dynamism of the matter of the cosmos.

It may be that the unembarrassed nature of Bill's 'astral flights … of the imagination' achieves something that modern science has striven to drive underground. The draining of overt *meta*physics from modern physics has served to give lie to the instinctual passions that actually motivate and sustain scientific enquiry in its most abstract and mathematically demanding forms. Is it necessary that we should now be condemned to segregate into separate mental zones faculties that past ages could see married in the work of one mind? ‿

Berenice Abbott, *Wave Interference Pattern*, 1950s, New York. Commerce Graphics Ltd, Inc

Abbott's absolutes

The 'objective eye' of the photographic camera and impersonal traces of light on a photographic emulsion were, virtually from the public announcements of the new medium in France and England in 1839, hailed as powerful tools in scientific recording. In that very year William Henry Fox Talbot wrote to Sir John Herschel that 'he had great hopes' for photographs taken with his 'Solar Microscope … as for instance in copying the minute forms of crystallisation which are so complicated as almost to defy the pencil'.

Not the least of the achievements of the artificial eye has been the capturing of motions too rapid for human sight, most famously as in the revelations of a horse's gait by Eadweard Muybridge in 1878. And, as already noticed, the stilled splashes by Worthington and Edgerton provide supreme examples of the revelations of instantaneous photography. No one has explored the potentialities of the 'snapshot' more potently than the American photographer, Bernice Abbott.

In the 1930s Abbott was associated with a group of 'objectivist' photographers who looked to Alfred North Whitehead's *Science in the Modern World* (1925) and *Process and Reality* (1929) in their attempt to define a remorseless form of impersonal realism which revealed the 'absolute' as manifested in the appearance of things. The idea was that the

constant gaze of the camera would inexorably disclose the underlying pattern of the physical world.

The tone of the endeavour is conveyed by her remarks in 1929 on Eugène Atget, the devoted photographer of a depeopled Paris: 'as an artist he saw abstractly, and I believe he succeeded in making us see what he saw'. Best known for her portraits and cityscapes, Abbott's most innovatory work involved the reform of the techniques, communicative values, and aesthetics of the photography of scientific phenomena.

She served as photographic editor of *Science Illustrated* and collaborated on two high-school science books, *Physics* and *Physics: Laboratory Guide*. Using a projection system she christened 'supersight', she at first concentrated on the kinds of traditional subjects that directly revealed their structure to the lens, such as insects' wings and soap bubbles. During the 1940s and 1950s she invented devices that could capture invisible motions, not least the behaviour of waves and the paths of fast-moving bodies, which were so engaging contemporary physicists.

Berenice Abbott, *Transformation of Energy*, 1958–60. National Gallery of Canada, Ottawa

She was particularly drawn to some of the classic problems of Galilean dynamics, such as the path of a projectile fired upwards from a moving platform and the response of a pendulum to gravitation. Her exploitation of high-speed flash and dark backgrounds allowed the phenomena to 'draw' their own diagrams in a way that surpassed in vividness and beauty any conventional diagrammatic representation.

Her aim was neither to act as a mere documenter of phenomena nor to exploit scientific photography for its decorative potential. Rather, she sought to use those properties of photography as a visual medium that distinguished it from painting and hand-made graphics. Above all, she wanted photography of physical phenomena to speak eloquently of the transformation of energy in terms of invariable structures embedded in the mechanics of the material world.

The spirit of her endeavour is nicely captured by the heading accorded to a two-page spread in the *New York Times Magazine* in 1959, 'Portraits of Natural Laws'. Like any good portraitist, Abbott knew that a good likeness makes huge technical and aesthetic demands on the artist. ❧

Mario Merz, *Boards with Legs Become Tables*, 1974. Giorgio Colombo, Milan

Mario Merz, *Igloo di Stoffa*, 1968–81

Merz's maths

Mario Merz, born in Italy in 1925, has been one of the pioneering artists who have aspired to transform the art gallery into something resembling a laboratory for the experimental interaction of visual imagination and intellectual enquiry. A major focus of his own intellectual enquiry has been the Fibonacci series, in which the product of an addition is added to the immediately preceding number of that addition, beginning with 1: 1, 1, 2, 3, 5, 8, 13, 21, 34, 55, 89, and so on, ad infinitum.

First recorded by the thirteenth-century Italian mathematician, Leonardo Fibonacci of

Pisa, the series has exhibited fascinating resonances with such classics of geometry as the so-called 'golden section' and the progressively widening logarithmic spiral.

Whether working with paint on canvas or with the materials he uses in his constructions—stone, clay, wood, fruit, metal, liquids, glass, neon tubes, fabric, paper—a consistency of purpose can be recognized in Merz's ceaseless dialogues between shape, structural principles, physical forces, the enclosure and expansion of space, and the mathematics of growth, all in the context of human existence. Expressed in this compressed way, his agenda seems both pretentious and unrealizable. But a series of themes has opened windows on how it might be realized by a programme extending beyond his own production. Two such themes are his 'tables' and his 'igloos'.

His tables, closer to Japanese than western examples, envisage a population growing in accordance with Leonardo da Pisa's series, which was itself formulated as a model for rabbit populations. It is as if we are planning a refectory for proliferating bands of factory workers. As he wrote in part of his accompanying poem:

> I reject the linear, one by one, or assembly-line fabrication of spaces…
> The space grows like a bunch of grapes.
> For a growing number of people it is necessary to make tables that grow like a bunch of
> grapes.
> For one person.
> For two people then…

He takes the series as far as 34, but its potential is boundless, reaching out to infinities of number and space.

For Merz, the Fibonacci series signifies life beyond the apparent inertness of numbers. The lower numbers remain implicated within the larger terms, and the progression embodies the principles of organic growth: 'the numerals in PROLIFERATION have in themselves the power of SUCCESSION or PROPAGATION'. Expressed in such figures as a cone or logarithmic spiral, the series exhibits a power of propagation to infinity through morphologies that are self-similar at every stage.

The structure of Merz's 'igloos'—the form of primitive houses in many cultures—expresses the interplay between growth and structure in terms of volume. The number of wall units neeeded to fill the interstices—whether Merz's stone, clay, and glass or the snow and natural materials of actual dwellings—both enact a process of numerical growth in each instance and register the exponential increase with each successive enlarging of the radius of the structures.

The igloos strike a balance between gathered strength at their summits and percarious equilibrium as they reach out to cover ever larger areas. The tension is nicely encapsulated in the paradoxical aphorism of the Vietnamese leader, General Giap, who inspired one of Merz's igloos: 'If the enemy concentrates it loses ground: if the enemy disperses it loses force'. Such paradoxes, for Merz, permeate not just structure and growth but also the operations of human society. ∾

Making models

Susan Derges, *Embodied*, 1994, Cibachrome photogram
(obtained via Michael Hue–Williams Fine Art, Cork St,
London)

Animal arts

As soon as ancient philosophers first attempted to differentiate human from animal intelligence, a few celebrated cases of 'animal geometers' attracted avid attention. The webs of spiders, the honeycombs of bees and the spiral shells of molluscs provided the classic examples, to stand alongside the six-cornered snowflake and phyllotaxis. They testified to what Johannes Kepler called 'nature's formative virtue', the *facultas formatrix*, through which God insinuated 'world-building figures' into matter.

The building bee is eulogized in Kepler's *The Six-Cornered Snowflake* (1611): 'the architecture is such that any cell shares not only six walls with the six cells in the same row, but also three plane surfaces on the base with three other cells from the contrary row'. Such symmetrical packing, which he compares to the seeds in a pomegranate, he attributes to the same necessity as operates when pellets are systematically compressed in a round vessel.

The outlines of the basic solution to the geometry of the walls had been proposed by the Greek fourth-century mathematician, Pappus of Alexandria. The preface to Book V of his *Collection* is devoted to 'the Sagacity of Bees', to introduce 'a problem of wider extent, namely that, in all equilateral and equiangular plane figures having an equal perimeter, that which has the greater number of angles is always greater'. While bees are not accorded the reason needed to formulate such a general case, God has 'granted that each of them

should, by virtue of a certain natural instinct, obtain just so much as is needful to support life'. Thus the bees 'would necessarily think that the figures must be . . . contiguous with each other . . . in order that no foreign matter could enter . . . and defile the purity of their produce'.

Pappus knew that only three rectilinear, equiangular figures would fill the space: the triangle, the square, and the hexagon. For their part, the bees, 'by reason of their instinctive wisdom chose . . . the figure which has the most angles because they conceived it would contain more honey'.

However, in spite of sustained attention from Kepler's successors, the full proof of why the hexagon delivers the maximum area for the minimum perimeter, compared to all other possible combinations of packed figures, remained elusive. The bees seemed to know more about the isoperimetric problem than the best mathematicians, including Sir Christopher Wren. The conundrum still warranted a substantial historical review by D'Arcy Wentworth Thompson in *On Growth and Form* in 1917. Most recently a proof of mighty dimensions, occupying 19 pages on the web, has been offered by Thomas Hales of the University of Michigan, an expert in geometrical packing (www.math.lsa.umich.edu/~hales).

If such effort is still needed to emulate the humble bee, the question of animal intelligence returns with even greater force. To express the problem in modern terms, are the architectural bees obeying a marvellous genetic predisposition, or is the regularity the outcome of the self-organizing principles of packing? The wonderfully precise assembly of the thin cell walls at 60° angles from tiny pellets of wax, to minute tolerances of 0.002 mm, excludes self-organization as the immediate mechanism. However, geometrical packing, like that of bubbles in foam, is as much a 'cause' of the configuration as genetic predisposition.

We can now see how Kepler's 'formative virtue' elided two distinct but complimentary processes. One is the kind of physical self-organization he observed in snowflakes, while the other is the instinctual programme that permits the bees to carry out such symmetrical acts of waxen engineering within the physical parameters of their world. It seems to me that the relative weights accorded to either of the interlocked processes in each complex instance of animal and vegetable artistry needs to be argued case by case, even if the roles of geometry and genes now seem to be susceptible to clear definition in the long-running case of the honeycomb.

It is hardly surprising that such wondrous masterpieces of design have provided inspiring examples for artists and architects, no less than for mathematicians of nature. For Susan Derges, who provides our illustration, the bees' geometrical habitations not only embody the principles of natural order but also encode patterns of thought as the bees weave the tapestry of their industrious motions across the geometrical network.[1] ∽

[1] *Nature*, **390**, 27; and the published book of her work, *Susan Derges. Liquid Form* (published by Michael Hue–Williams, 1999, London).

Albers' abstracts

The effects of colour in painting would, on the face of it, seem to be one of the most obvious areas in which to forge a 'science of art', and there have been repeated attempts to create two- or three-dimensional models to codify the relationships between the colours. Yet the colourist's science remains, in the words of a sixteenth-century commentator, the 'true alchemy of painting'. The colourist–magician compounds base materials into radiant wholes that invariably seem to transcend the systematic explanation and predictability that colour circles and other such models promise.

The old Aristotelian system of colour, which ranged hues along a scale from lightness to darkness, actually worked quite well with painters' practice. A yellow pigment, for example, inherently occupied a position at the light end of the tonal scale, while ultramarine blue stood closer to black. Far from clarifying painters' practice, Newton's spectral division of white light presented sustained problems, not least before Helmholtz's elucidation of the essential difference between subtractive colour mixing for pigments and additive mixing for lights. Newton's most useful idea for artists was his conceptual arrangement of colours aound the circumference of a circle, which allowed the painters' so-called primaries (red, yellow, and blue) to be disposed opposite their so-called complementary colour (e.g.

Farbton 1 Farbton 13

Joseph Albers, 'Section
Through the Colour Solid
of Wilhelm Ostwald' from
Interaction of Colour,
1963. © DACS 2000

red opposite green), as a way of denoting that each complementary would enhance the other's effect through optical contrast.

The key problem for the colourist arises from the high levels of fluidity in our perception and subjective response to the same colours in different combinations and configurations, on various scales, and in variable conditions of viewing. This fluidity continues to provide complex challenges for experimental psychology. A logical response is for the painter to adopt an empirical stance, giving primacy to practical testing rather than theoretical prediction. This is exactly the course followed by Joseph Albers in his series *Homage to the Square* and his book *Interaction of Colour* in 1963.

As a student and teacher at the Bauhaus in Germany from 1920 to 1933, where he worked directly with Paul Klee, Albers reached maturity in the environment of experimental questing which characterized this extraordinary modernist laboratory for art and architecture. It was in 1950, while working at Yale University, that he arrived at his definitive fusion of practice and theory. The square, as the motif that appears ubiquitously in his paintings, was intended as a neutral container, as 'the dish I serve my craziness about colour in'. The matt areas of colour similarly aspire to establish a neutrality devoid of the personal handwriting and individual style of traditional painting. The resulting vehicle is akin to a modern scientific experiment in which just one variable—in this case colour— is left unfixed. The 'experiments' and results are then set beside the tenets of colour theories, such as those of Goethe and Wilhelm Ostwald, the Nobel prize-winning physical chemist who published *The Colour Primer* in 1916. Ostwald had devised one of the most effective of the colour solids, in which three dimensions—corresponding to hue, saturation, and tone—are used to compose a spatial model for the interrelationships of visible colour.

For Albers, such attempts to construct a precise science of colour could inform practice but never provide absolute prescriptions for the making of works of art. It was within this space of empirical action that Albers tunes his colour chords, balancing the widths and 'gravities' of the squares to achieve effects that are specific to a particular painting but also indicative of Albers' distinctive style. Each work may be regarded as an experiment that is simultaneously dependent on the laws of colour and individually subversive of their predictive power. The elusive complexity of the particular arises from visual means of the utmost simplicity. ❧

Naum Gabo, *Torsion: Variation, c.* 1974–5, family collection. Graham and Nina Williams

Gabo's geometry

Intuition of the resonances between natural and human structures is as old as the oldest surviving writings on architecture—even older if we take into account Aristotle's fascination with nature's 'constructivists', such as the cell-building bee and geometrically accomplished spider.

A key motif for the early theorists and apologists of abstraction in the first half of the twentieth century was an appeal to the mathematical structures underlying natural appearance, as they were being revealed by contemporary sciences—or in Naum Gabo's case, to the *principles* at work in the structures. Such an appeal was particularly favoured in the circles of British abstractionists, who continued to stand in the native tradition of nature-based art. It was this tradition with which the Russian sculptor, Naum Gabo, interacted when he joined the St Ives colony of artists in 1939.

Educated as an engineer, Gabo had already formulated a credo based on nature's structural artifice. In *The Realist Manifesto* which he composed in 1920 with his brother,

Antoine Pevsner, he explained the principles on which they constructed their sculptures:

> With a plumb line in the hand, with eyes as precise as a ruler, with a spirit as taut as a compass, we build them in the same way as the universe builds its own creations, as the engineer his bridges, as the mathematician the formulae of his orbits.

Given such a predilection, he was well placed to benefit from D'Arcy Wentworth Thompson's masterpiece of scientific writing, *On Growth and Form* (1917), to which he was introduced by the critic, Herbert Read. In Thompson he could read the beguiling analyses of the structural and dynamic geometry of biological morphology in the context of physico-chemical forces, both internal and external to the organism. In particular he could read of the microscopic miracles of natural design, such as the Nasselarian skeletons illustrated so beautifully in Ernst Haeckel's publications, not least his two-volume *Kunstformen der Natur* (1899–1904). It was on the basis of Haeckel's radolaria that a geodesic dome was precociously constructed in Jena, to house the Zeiss Planetarium, as early as 1923. Thompson, for his part, drew attention to the suggestive analogies between the skeleton of *Callimitra agnesae* and the curved films formed when Joseph Plateau dipped a tetrahedral cage into a soap solution. (Plateau's elegant experiments had been warmly recognized by Charles Vernon Boys in his 1902 book, *Soap Bubbles*.)

I am less concerned to argue that a Gabo sculpture like *Torsion Variation*, tensely constructed from a stainless steel exoskeleton with internal filaments of spring wire, is directly *influenced* by Thompson, though this may have been the case, but that the works of the sculptor and scientist are comparably engaged in intuitive and intellectual communion of a profound kind with fundamental aspects of the statics of natural form. In the micro-skeletons depicted by Haeckel and the soap films of Plateau, Gabo and Thompson would have seen how the organic becomes geometrical and how the geometrical becomes organic—giving new substance to age-old intuitions about the mathematics of natural form. ✑

D'Arcy Thompson, '*Callimitra agnesae*' (after Haeckel) from *On Growth and Form*, 1917

D'Arcy Thompson, 'Geometrical Construction of *Callimitra* in Terms of Bubbles Suspended in Wire Cages' from *On Growth and Form*

MAIN CHAIN
SIDE CHAINS
OXYGEN
NITROGEN
HYDROGEN BOND
SULFUR
HEME GROUP
IRON ATOM
WATER MOLECULE

Detail of Irving Geis'
model of the myoglobin
molecule from a sperm
whale', from John C.
Kendrew, 'The Three-
dimensional Structure of
a Protein Molecule', 1961,
from *Scientific American*,
205, no. 6, 98–9

Kendrew constructs; Geis gazes

Anyone with even a passing interest in the big molecules that lie at the heart of life knows what they look like on computer screens. Standard imaging packages, such as MolScript, introduced by Per Kraulis in 1991, have made us familiar with the colourful and gently shining tangles of linked atoms, seductively spot-lit and floating weightlessly in space behind the windows of VDUs and on the pages of specialist and popular publications. What is all too easy to forget is that the basic visual choices in the design of the programmes relied on the perceptual and aesthetic visions of the pioneer illustrators during

the 1950s and 1960s. Of the illustrators, none was greater than Irving Geis of New York, who died in 1977 at the age of 88.

Having studied architecture, art, and design, Geis found his true *métier* as a leading illustrator and artist of science working for *Scientific American* from 1948 onwards. It was in this capacity that he created his first masterpiece of protein portraiture for John Kendrew's article 'The Three-dimensional Structure of a Protein Molecule' published in December 1961, which remains an all-time classic of visual and verbal exposition. In the bound annual volume I consulted, Kendrew's article was immediately identifiable by its thumbed pages, dog-eared corners, and torn edges reinforced by tape.

Visual and verbal excitement go perfectly in hand. Kendrew begins, 'When the early explorers of America made their first landfall', and concludes that 'students of the living organism do indeed stand on the threshold of a new world'. Kendrew and Geis avail themselves of virtually every kind of available technique to portray their new world. There are flat diagrams of molecular skeletons, linear maps of electron density, line drawings of ball-and-rod structures, X-ray photographs and photomicrographs, together with photographs of equipment and of various kinds of models composed of clips and rods, Lucite sheets, and a lumpy sculpture. And, above all, there is Geis' remarkable painting, produced during six months of intense activity.

The subject was the 2 600-atom molecule of sperm whale myoglobin, of which Kendrew had caught his first sight on a Sunday in May 1957. At first Kendrew worked to six angstroms, but determined that a higher resolution was needed—'as in the case of a musical note, the greater the number of higher harmonics that are included, the sharper and more precise is the resulting picture'. The two-angstrom scale he finally used involved two sets of 10 000 X-ray reflections. The refined data was used to build the astonishing three-dimensional contour map of electron density on 50 layered sheets of Lucite—at the cost of six man-months of work.

'At first sight' the density map 'seemed completely irregular', but just as 'driving past an orchard' will disclose different orders from different perspectives, so Kendrew found that if he 'looked through the stack of Lucite sheets in a direction corresponding to the axis of one of the rods' (the concentrations of higher density already observed at lower resolution), the rods could be seen as hollow and spiral in configuration.

The next step was the construction of a model composed from a forest of uprights with coloured clips which represented the whole molecule with every side chain in place. Other models were made using brass skeletons. It was at one such skeletal model that Geis gazed with remorseless concentration in painting his portrait of the molecule, using his unrivalled command of perspective, light and shade, colour recession, and judicious distortion, to reveal on a two-dimensional surface the intricate sculptural web of spatial linkages.

John Kendrew *et al.*, a lucite sheet density map of myoglobin, 1961, from *Scientific American*, 205, no. 6, 105

Looking at his painting 38 years later, it is difficult to credit that it was not done by computer. Indeed there is a case for saying that our current computer graphics, for all their novel features such as animation and stereoscopy, are basically providing a series of powerful, dynamic, and convenient glosses on the graphic modes invented by Geis and his fellow pioneers of handmade representation. ∽

A. F. Cullis *et al.*, model of the haemoglobin molecule, from Max Perutz, *Proteins and Nucleic Acids. Structure and Function*, 1962. Elsevier

Max's modelling

When Linus Pauling and Roger Hayward entitled their 1964 book *The Architecture of Molecules* they were resorting to an age-old style of metaphorical allusion. As knowledge of molecular structure has entered worlds which are impossible to 'see' in any normal sense, analogies with objects in our normal range of visual experience have lost none of their efficacy as aids to visualization, even if their metaphysical and religious dimensions have retreated.

One of the most spectacular acts of modelling was initiated in 1937 by Max Perutz's work on haemoglobin. As Perutz graphically recalled, 'the first protein structures revealed wonderful new faces of nature'. That he found it necessary to reveal these 'faces' visually rather than mathematically became rapidly apparent:

> I began giving a course in X-ray crystallography of biologically important molecules for students of biochemistry and other biomedical subjects. In my first lecture I introduced lattice theory, trigonometric functions, and Fourier series … but half the students failed to turn up for my second lecture … The following year I replaced my forbidding lecture with a non-mathematical, largely pictorial introduction called 'Diffraction Without Tears'.

The potency of the visual model goes far beyond the need to sweeten the mathematical pill for biologists and medics. The three-dimensional model has proved a vital tool in how new substances can be 'engineered' (Perutz's term).

General agreement on a definitive model to 'fit' a particular X-ray pattern, as happened when Watson and Crick's model of the structure of DNA crystallized Rosalind Franklin's experimental data, does not solve the fundamental problems of what sort of model is appropriate. The early range extended from the kind of spidery lattice that Watson and Crick revealed to the world in 1953 to the weighty sculptural edifice of the haemoglobin models produced for Perutz.

What is striking to a historian of the visual is how the models have period 'styles'. The compound of factors that go to make up this style—the 'look' or visual 'feel' of the object —include materials, constructional techniques, colours, textures, scales, and the vocabulary of the shapes. The choices, in science no less than design, involve hugely complex permutations of utility, technology, and (often inadvertently) aesthetics.

Our sense of the period style of the Watson–Crick model— linear, wiry, openly mechanical, unadorned, and rhetorically 'functional'—is necessarily framed by reference to earlier and later systems of representation. Their precarious spatial lattice stands very much within the design parameters of the 1951 Festival of Britain, the event which decisively marked the pragmatically British embrace of a modern style for a new age. In contrast, the 'Glyptic Formula' kits for modelling molecules in the nineteenth century, with their polished balls, firm rods, and turned mahogany stands, exude the air of a gentleman's billiard room; while recent computer images ostentatiously parade the high-tech rhetoric of electronic graphics. The haemoglobin model has its own 1960s look—assertive and futuristic, like a visionary model for a concrete block of layered residences. As in any work of architecture, more is involved than mere structure.

In 1960, following his illustration of a horse haemoglobin molecule in *Nature*, Perutz received from a friend in New York a reproduction of Ettienne Martin's sculpture, *Anemone* in the Museum of Modern Art, which exhibited uncanny formal similarities to the scientist's model. Perutz was moved to respond that 'the artist's imagination anticipates the patterns which the scientist discovers in nature'. ❧

James Watson and Francis Crick, model of DNA. Science Museum, Science & Society Picture Library

Anemone
Ettienne Martin

Haemoglobin
(horse)

Ettienne Martin, *Anemone*, New York, Museum of Modern Art; and Max Perutz, *Myoglobin (horse)*, 1960; a joint photograph sent by Perutz to the author, January 1998

Visible
viruses

The exciting disclosure of the polyhedral structure of viruses during the 1950s and
early 1960s presents a perfect example of collaborative interaction between different
methods of experimentation, observation, analysis, and visualization. This interplay
occurred most creatively at the vital stage when no one method was alone delivering all
the answers, because each was itself operating at the very margins of credibility, not least
given the immense problems of concentrating and purifying the viruses. Relatively crude
X-ray diffraction, chemical analysis, shadow electron microscopy, and structural
hypotheses had begun to hint at the fascinating structures that might be involved in viral
architecture, but direct viewing of inner structures remained frustratingly out of reach.

The technique of negative staining, following H.E. Huxley's study of the tobacco mosaic
virus in 1953, opened a visual door on the beautiful structures and symmetries displayed
in the submicroscopic world of viruses. Given wide currency in 1959 by Sidney Brenner
and Robert Horne, collaborating in the vibrant atmosphere of Cambridge, the method
involves the staining of the interstices in the structure by embedding the viruses in potas-
sium phosphotungstate, an electron-dense material. Suitably prepared, stained, and
mounted, the rod-like tobacco mosaic virus and the 'spherical' turnip-yellow virus stole
suggestively into view, regular in configuration yet tantalizingly elusive in the precise
details of their structural geometry.

The technique rapidly proved its efficacy in a notably energetic branch of molecular biol-
ogy, providing ever better definition of the symmetrical properties of these and other
viruses. The improved images stimulated the building of three-dimensional models that
were consistent with the emerging patterns—often still unresolved in their smaller
details—in creative dialogue with the X-ray diffraction procedures that had originally dis-

closed the existence of symmetries somewhere within the viruses. Working in Glasgow in 1960, Peter Wildy, William Russell, and Bob Horne obtained revealing pictures of the herpes simplex virus. When devoid of their surrounding shell, the protruding prisms of the morphological units or capsomeres appeared to be arranged in the 5–3–2 symmetry of an icosahedron. The capsomeres were hexameric in cross-section, with the exception of 12 at the apices that were pentameric.

P. Wildy, W. Russell, and R. Horne, electron micrograph of herpes viruses, with a five-sided unit (A) and a six-sided unit (B), 1960, from *Virology*, 12, 213

A neat wooden model served to demonstrate the hypothetical structure. Jo Wildy, Peter's widow, recalls that 'the original … was made with quantities of corrugated card-board, Polyfilla, and wire, and occupied the dining room table, dresser, floor, and any other horizontal surface for weeks as the entire family grappled with its complications'. As somone skilled in woodwork—he made harps and spinning wheels as a hobby—Wildy was well equipped to play a central role in such model building. Behind the team's search for a coherent structure lay the enduring stimulus of D'Arcy Thompson's quest for the mathematical rationale of natural forms.

The most extended investigation of the geometrical parameters of the architecture was undertaken by Donald Caspar and Aaron Klug, as outlined at the Cold Spring Harbour Symposium in 1962. They proposed that the icosahedral regularity of the capsid and the less regular distribution of the capsomeres revealed by the electron microscope pictures could be reconciled by reference to the families of polyhedra characterized by Buckminster Fuller, the American visionary architect and inventor with whom they corresponded. As we will shortly see, Fuller's name has subsequently become indelibly associated with the carbon molecule, C_{60}, which has been christened 'Buckminsterfullerine'. As with the modelling of C_{60} in 1985, Fuller's geodesic domes proved a vital catalyst in the process of the spatial visualization of virus structure. The design principles for domes, viruses, and Thompson's radiolaria similarly combined structural economy and operational efficiency with symmetrical beauty.

The story of the disclosure of the regular structures of viruses combines all the best elements of a scientific detective story. There are related bodies of visual evidence that each hover on the border of intelligibility; there is elegant speculation shaped by the search for coherent order and spiced with aesthetic intuition; and, not least, there are the empirical 'cookbook' procedures for preparation and staining to reveal the hidden secrets.

Not for nothing did Wildy and Douglas Watson quote Lewis Carroll in their contribution to the 1962 symposium:

> You boil it with sawdust: you salt it with glue:
> You condense it with locusts and tape:
> Still keeping one principle object in view—
> To preserve its symmetrical shape.

And, as always, there is the question of 'whodunnit'. The suspects in this case remain, on the one hand, self-organization according to rules of mechanical necessity and, on the other, the organizing dictates of the nucleic acids, as favoured by current orthodoxy. Or do they share joint responsibility? ∞

Molecule of
Buckminsterfullerine in
galactic guise. Ken Edward,
Science Photo Library

Kroto and charisma

It's sometimes difficult to know why some scientific discoveries hit the public headlines. The hugely technical solution to Fermat's last theorem hardly seemed to possess the ingredients for a hit. It could not even resort to the kind of visual appeal that normally helps to bring a discovery before the public eye. By contrast, the popular impact of the 'Buckyball', C_{60}, unabashedly relied upon visual charisma.

The story of the identification, modelling, and naming of Buckminsterfullerine in 1985 already has the quality of legend—like the famous account of the origin of the benzene ring in August Kekulé's dream of a snake biting its tail.

Sir Harry Kroto tells how his work at Rice University, with the team that included Robert Curl and Richard Smalley, led to the identification of the 60-atom cluster of carbon which exhibited a stability at odds with any graphite-like or diamond-like configuration. An architecture was required that closed off the apparently dangling valencies in any of the immediately plausible arrangements. It was difficult to see how a closed polygon of hexagons, like a ball of graphite, could work.

The key moment came with the introduction of pentagonal faces (prefigured by Eiji Osawa in 1970), which can effect closure on extended orbs of hexagons of varied dimensions.

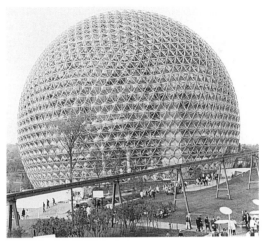

The Buckyball five-a-side team (from left: Sean O'Brien, Richard Smalley, Robert Curl, Harold Kroto, and James Heath). H. Kroto, University of Sussex

Buckminster Fuller, geodesic dome of the American pavilion at Expo' 67 in Montreal. Jimmy Fox, Science Photo Library

The suggestion welled up from Kroto's memory of the geodesic dome designed by the architect and visionary inventor, Buckminster Fuller, for the American pavilion at Expo '67 in Montreal (see p. 123). Kroto also recalled making a Fuller-style cardboard sky map for his children in the form of a 'stardome'. The 'stardome' comprised a truncated icosahedron of 20 hexagonal and 12 pentagonal faces, with 60 vertices. It was on this hunch that pentagons were involved that Smalley worked into the night to construct by hand the first paper model of the hypothetical structure. In retrospect, it was fascinating to find that the same Fuller-type symmetry had been discovered as early as 1969 by the Japanese scientists, Kamaseki and Kadota, in the protein clathrin.

A crucial component that Kroto brought to the Buckyball team was his natural instinct as a designer. Indeed, he had long hankered after a career in graphic design and, before the consuming success of C_{60}, planned to found a studio for scientific graphics. He is one of those scientists, like Leonardo and Kepler, naturally drawn to the tangible beauty of complex symmetries in works of nature and art.

Compared to the initial announcement of C_{60} and technical outline of 'our somewhat speculative structure', which occupied less than one and a half columns of dryly laconic prose in *Nature*, the public broadcasting of the victory of the Buckyball team was marked by a hatful of metaphorical goals. Extolling the 'cosmic and microcosmic charisma of the soccerball', Kroto's 1996 Nobel prize address expressed delight with its ascent to stardom: 'this elegant molecule … has fascinated scientists, delighted lay people, and has infected children with a new enthusiasm for science and in particular it has given chemistry a new lease of life'.

At present it looks as if the Buckyball is to become the kind of modern icon for chemistry that DNA has become for molecular biology. It also helps, of course, if one or more of the discoverers exhibit a public charisma to match that of the molecule. ❧

Bela Julesz, random-dot
stereogram showing a
diagonally disposed
square in front of a
textured background,
from his 1971 book
*Foundations of Cyclopean
Perception*

Julesz's joyfulness

The process of coherent seeing involves our astonishing powers to extract order from
apparent chaos. Not the least of the powers is our ability to use binocular vision to
define things in 3D. Yet seeing simultaneously with two eyes generally results in one men-
tal image. How this comes about has perplexed investigators from the very beginning.

However effective the techniques forged by painters and photographers for the evoking
of three dimensions on a flat surface, the absence of parallax cues remained a serious
limitation in the achieving of truly compelling illusion. It is surprising that the idea of
presenting a slightly different image of the same object to each eye did not occur to the
Jesuit 'magicians' of optics in the Baroque era. In the event it was British exponents of
'natural magic' in the 1830s who performed the trick.

There was a lively dispute as to whether credit should be given to James Elliott of
Edinburgh in 1834, as claimed by the disputatious Sir David Brewster, or to Sir Charles
Wheatstone (of the wave machine), whose 1838 publication backdated his own invention
by at least six years. Either way, it was Wheatstone's two-mirror stereoscope that decisively
entered the public arena. His earliest images—linear drawings of geometrical solids
which lacked other spatial clues—had already showed how fundamental was the process
of stereopsis in the presentation of 'a solid figure … in such a manner that no effort of
imagination can make it appear as a representation on a plane surface'.

The making and viewing of stereo-images underwent a series of refinements over the years, most notably the introduction of stereo-photographs, taken in a two-lens camera and to be viewed in a binocular apparatus. Brewster himself refined the optics of viewing with his lenticular stereoscope. Perhaps the most remarkable and unexpected move came with the invention of the random-dot stereogram in its definitive, computerized form by Bela Julesz in 1959. He showed how the 'cyclops within us' exploits stereo-processing to unscramble two apparently unintelligible random-dot arrays in which a central region is invisibly 'lifted' and displaced to the right in the left image and vice versa. Using an appropriate viewing device, or less readily by crossing our eyes in front of the images, we discern the displaced zone as if it were a shape suspended in front of the background.

Lenticular stereoscope by Brewster, Science Museum. Science & Society Picture Library

Looking back on Julesz's 1971 book, *Foundations of Cyclopean Perception*, it is striking how much it stands in line of succession from Brewster's *Letters on Natural Magic* (1832) and his monographs on the kaleidoscope and stereoscope, and how different in tone it is from David Marr's posthumously published *Vision* in 1982, in which a 'cooperative algorithm' is posited as a computational alternative to Julesz's more mechanistic explanatory framework.

Julesz, like Brewster, stands within a tradition of culturally expansive science. Not only does Julesz joyfully make big claims for the technical innovation as the gateway to a theory of 'global stereopsis' and as a 'real paradigm' but he also aspires to place his discovery on a 'broad foundation by using analogies from many disciplines, including music'. Characteristically, he terms his technique as 'random counterpoint'.

He claimed that random-dot stereograms allow experimenters to communicate directly with internal processing, with access to 'the mind's retina', bypassing the peripheral processes in a way that 'eclipses' monocular clues and isolates stereopsis 'without rivalry'. He proposed that if the classic experiments on perception and illusion could be replicated in random-dot stereograms, they would be identifiable as centrally located within the processes of the brain rather than attributable to the retina.

His intended readership of the book comprised, primarily, 'students' and 'workers in visual perception', together with 'clinicians' (who might want tests for stereopsis), and 'the 'mathematician and designer' interested in 'the visualization of complex surfaces'. He also stressed that his illusions would, 'last, but not least, delight the layman or student of the visual arts'.

It is not my intention here to present a historical choreography of the successive refinements and challenges to Julesz's conclusions, nor to examine the interactions between the experimental 'grit' and the algorithmic modelling. Rather, my intention is to remind ourselves how the experimental psychologists' modern bag of tricks, however technical the techniques and theories, can still serve to induce popular awe at the 'natural magic' residing with our perceptual system—with a sense of joy that is undiminished from the age which saw the invention of the stereoscope. ∞

Michael Brady and Ralph Highnam, juxtaposed images of an actual X-ray mammogram of a tumour in the left breast (right picture) and the computer modelled tumour in the right breast (left picture)

Mammary models

Modern diagnostic medicine involves countless life-and-death decisions taken on the basis of images formed without normal acts of seeing—using non-visible emissions, artificial perceptual systems, and computerized cognition. Layered on top of artificial procedures are our own complex natural processes for seeing and knowing. Clinicians and technicians who use machine-generated images understand the physical means of image formation and gain an intuitive sense of how to see what they seek, but they are unlikely to be aware of the mathematics behind image processing.

The more elusive a clear image, the more significant will be the mediating procedures. Nowhere is this more apparent than in the scanning of women's breasts for tumours—an urgent matter given that breast cancer accounts for almost a fifth of cancer deaths in women. X-ray mammography is beset by difficulties, which stock imaging packages do not solve reliably. For example, the image can be sharpened in such a way that the fuzzy edges of a malignant growth acquire the defined boundary of a benign tumour.

Complex structures in breast tissues result in poor signal-to-noise ratio (always remembering that one person's noise is another person's signal). In particular, the tiny signs of crucial microcalcifications are easily lost. The low levels of 'safe' doses limit clarity; scattering of X-ray photons blurs definition; features at different depths in the breast are confusingly superimposed; and the compression of the breast during the procedure results in non-linear relocations of internal features.

Michael Brady and Ralph Highnam of the Department of Engineering Science in Oxford are approaching these problems through the building of a highly sophisticated model of the physics of X-rays passing through breast tissues, to such good visual effect

that they can closely simulate actual images and replicate the way that different imaging processes transform the information. They can filter out the particulate noise that masks microcalcifications, augment zones of interest through 'hot light' simulation, ape the definition that could theoretically be achieved with mono-energetic emissions, imitate the effect of an anti-scatter grid (which in normal practice requires a doubling of the dose), and investigate the 2D effects of 3D structures in normal and compressed configurations.

Such algorithmic modelling is not just a powerful tool for understanding—and a handy device for teaching. It also permits the processing of a standard image so that those features deemed to be of clinical significance can be perceptually highlighted, with a developed awareness of the parameters of what is being done. The approach is potentially applicable to any image processing system and is being extended at Oxford specifically to MRI breast scans, for women of any age.

Ultimately, even such meticulously controlled images have to be scrutinized by our own infinitely more complex apparatus, and judgement by the 'educated eye' of a clinically trained connoisseur remains crucial. Indeed, it may happen that such eyes may feel uneasy working with images that look virtually identical but instinctively seem not quite the same.

Experienced and perceptive radiographers acquire a clear sense of how to work with 'their' radiologists, operating the machine to produce images that their radiologists can 'read', but may experience difficulty in seeing precisely what they want in images taken by another radiographer. This variability

Michael Brady and Ralph Highnam, computer modelled tumour in the right breast

does not necessarily mean that one will see a malignant cancer while another sees a benign one, or even sees nothing unusual, but it does indicate the subtly personal factors involved in the making and interpretative viewing of images which to the untrained eye reveal no useful information. Why we see certain things and overlook others remains a highly complex business.

Not only do theoretical models of different types of machine perception and cognition serve as enormously valuable tools within the technical field of diagnosis—permitting the systematic exploration of image formation and processing in a way that is not possible with actual X-rays and actual breasts—but they can also alert us to the way that the perceptual systems of individual observers work to extract meaning from the resulting radiographs.

And, beyond their medical utility, they serve to underline the selective and purposeful nature of all kinds of image processing—artificial and human—and to the marvellously refined way that the human perceptual system can learn to attune itself to visual worlds of astonishing elusiveness, even to those that lie quite outside the compass of our normal experience. ❧

New worlds revealed

Bruce Heezen, the first physiographic sketch of the western North Atlantic, from *The Ocean Floor*, 1982, ed. R. Scrutton and M Talwani

Bruce Heezen, profiles, physiographic panorama, and globe, from *The Face of the Deep*, 1971, by Bruce Heezen and Charles Hollister

Heezen's highlands

Given that the greater part of our planet is deeply covered with water, most of its topography is not visible to us. It is only since the Second World War that we have begun to scan the uncharted depths. Systematic mapping of the ocean floor has progressed, in the relatively short time of its existence, through stages which mirror in important respects the history of terrestrial maps from the time of the Renaissance.

However, the pioneering techniques for the representation of undersea topographies did not involve emissions discernible by our eyes.

Using the sonar technique of echo-sounding, the technical development of which was driven by submarine warfare, a number of pioneering oceanographers, including Ivan Tolstoy and Maurice Ewing, Bruce Heezen and Marie Tharp, turned their attention to the remarkable highlands and lowlands that were being progressively disclosed in the depths of the oceans.

The earliest charts or 'physiographic diagrams', made possible by the increasingly high resolution of echo-sounders in the 1950s, relied upon exactly the same components of observed measurement, logical extrapolation, reasonable approximation, theoretical modelling, and imaginative guesswork that had characterized the mapping of *terra incognita* in the wake of the Renaissance voyages of discovery.

The basic data consisted of the linear tracks of the surveying lines, often quite widely spaced, and the sonar measurements of the profiles of the ocean floor along these lines. Marie Tharp has described how she and Heezen first conceived their own kind of relief map of the Atlantic in 1952, and how Heezen dashed off his first inspirational sketch: 'he seized a piece of paper and within an hour or so drew in the topography'. On the basis that 'the proper way is to present it as it would be seen if all the water were drained away', they came to operate with three principles.

Firstly, 'hypotheses of ocean floor structure must be used to supplement the often meagre data, and only the use of correct hypotheses will result in maps closely approximating nature'. Secondly, 'what data exist in several disciplines must be put at one scale'. And, thirdly, 'sketching proceeds from the shoreline seawards and then from the mid-ocean crest landwards, as the policy was to go from the known to the unknown'.

Their maps have been greatly refined in data and technique over the years, involving, amongst others, Heinrich Berann, an Austrian painter of Alpine panoramas. The resulting images strikingly resemble early terrestrial maps in fictive relief, exemplified by the sixteenth-century painted topographies designed by Ignatio Danti (Palazzo Vecchio, Florence, and the Vatican) and by the eighteenth-century military survey of the unruly Highlands of Scotland by Paul and Thomas Sandby.

Paul Sandby and William Roy, detail of the fair copy of the survey of Scotland (Loch Lomond), London, British Library (K. Top.XL.VIII. 25-lb,c, Sheet 14)

Heezen and Tharp's results, published in the form of both technical diagrams and popular panoramas, satisfy ancient and modern pictorial impulses in equal measure. Reflected sound at the frequency of birdsong has been translated into pictorial images. Much the same has happened in the pictorial realization of data obtained with recent scanning devices that use such non-visible emissions as X-rays and positrons. It seems that our pictorial proclivities refuse to go away, however non-sensory the techniques of machine perception become. It is telling that Heezen should have entitled the book he published with Charles Hollister in 1971, *The Face of the Deep.* ❧

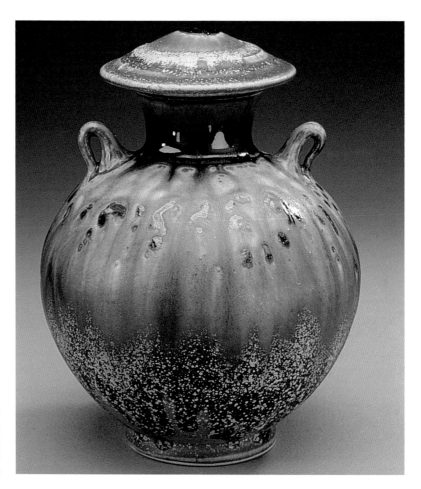

Joan Lederman, handled jar, coated with mud, glazed with a lavender matte glaze assembled from refined ingredients

Dendrites from
the deep

For many cultures in varied civilizations ceramic vessels have borne profound meaning —not just functional objects which can, at their best, aspire to a modest kind of beauty. In modern Western culture a pot tends to be a pot, and the person who makes it is a potter, a craftsperson. Joan Lederman calls herself a 'potter and imageer'. The extended title for her vocation is well deserved; she is creating a form of ceramic art that sustains thrilling resonances across time and space, drawing materials from the deepest oceanographic surveys.

On 16 July 1996, Chris Griner, a member of the palaeoclimate research team at the Woods Hole Oceanographic Institution on Cape Cod brought to Lederman's 'The Soft Earth' studio a bucket of sediment raised from the Atlantic floor east of Virginia (latitude

32° 21′N, longitude 68° 50′W) at a depth of 4500 metres. Fired in her kiln at 1100°C, lava-like, it congealed. Three months later she experimented with the mud as a glaze for stoneware vessels. Thinned gently with water but otherwise unmodified and applied evenly over the clay bodies, the fired sediments wondrously metamorphosed from a uniform layer into modelled patterns and beguiling arrays of colour.

A series of experiments followed in a new, hotter kiln using mud not only from the seas around the USA but also from such far-flung sources as the Arabian and Indian Oceans, the latter dated by the visual inspection of the foraminifera to be 35–40 million years old. The illustrated example, using sediments brought back to Woods Hole by the *Knorr* and the *Oceanus*, show how the resulting glazes 'seem to have a life of their own—like a fingerprint'. While the 'glazes that humans have concocted are often exquisite … they have a different voice. They are more contrived from nature than they are released by nature'. In contrast to standard methods, Lederman sees herself as 'a channel for what the sea muds might do … I adjust the form, the application, the thickness, the claybody, the firing, the juxtaposition to other glazes, to make what could happen actually emerge'.

What emerges, most notably with sediments that are dense in foraminifera, as on the inside of the bowl, are beautiful variations on dendrite formations, seemingly rising and ramifying, endowed within the inferno of her kiln with a new life, accessible now to our touch, and visible in our eyes, after aeons of remote stillness in the depth of the seas. At one level, it can be readily seen that the results are beguiling examples of the potter's art, but at another they carry an extraordinary frisson. To cradle one of her vessels in our hands is an evocative, even eerie experience, akin to holding a fragment of meteorite or peering in wonder at a sample of moon rock.

Visually, the emergent patterns resonate with the dendritic forms that comprise one of the recurrent organizational configurations in nature, ranging from roots of nerve cells to river deltas, and now modelled on computer through diffusion-limited aggregation, in which particles in Brownian motion (the constant random motion of particles within fluids) adhere successively around a fixed particle to generate fern-like radiations.

Lederman is knowingly providing an open rather than closed field for perception and interpretation, looking towards 'the envisioning and creating of holistic experiences that call people to the learning that is alive for them'. But she is our guide in this field. In her collaboration with the ancient muds that hold secrets to palaeontological climates, she is actively inducing us to share her sense of wonder with the way that the earth, fire, and water—the very stuff of the potter's art—speak of elemental forces that have repeatedly attracted human creators across distant times and spaces. ❧

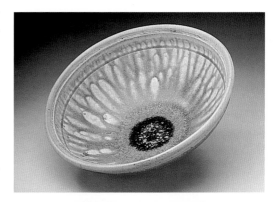

Joan Lederman, inner and outer views of *North Atlantic Deep Sea Bowl*, glazed with sediments from the research vessels *Knorr* and *Oceanus*, July 1998

James Turrell, *Roden Crater—Negative Site Plan*, 1992, detail of the main crater. Courtesy of the artist and Michael Hue-Williams Fine Art, London

Turrell's tunnelling

J.M.W. Turner, the magician of light and colour who was the dominant figure in British Romantic painting in the first half of the nineteenth century, dealt less with conventional boxes of pictorial space than with 'the wide concave of the circumambient air'. His phrase should be understood in the context of his intuition that 'the building of Nature' was 'too colossal for the intellectual capacity, its height to measure or its depth to fathom —the Universe and Infinitude'.

Turner's visual resources were limited to the traditional medium of paint on flat surfaces—if 'limited' is the right word for a painter whose floating visions of space, light, and colour suggest more in the way of 'Infinitude' than seems possible. By contrast, the American artist, James Turrell, is creating spatial structures on a huge scale to sculpt the passage of natural light and even to reshape the sky itself—in a Turnerian quest to stretch out to infinite reaches of time and space.

In 1975, Turrell searched for a suitable site for the realization of his vast vision of a new 'Skyspace'. An aerial survey of the western USA drew his attention to Roden Crater, a cinder cone located at the east of the San Francisco volcanic plateau. The project, commenced in 1979 and due to be completed early in this millennium, involves the excavation of geometrical spaces that will serve as exploratories for our perceptions, as vessels for the enclosure of solar, lunar, and stellar illumination, as devices for the inscription of time

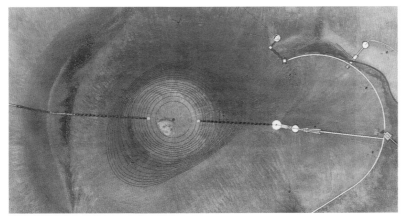

James Turrell, *Roden Crater—Negative Site Plan*, 1992

(like a sundial or gnomon), and as a compound observatory in which precision, wonder, and imagination are united.

At the centre is the crater transformed into a bowl with an even rim, 3 000 feet in diameter. For the observer low in the bowl, the vault of the heavens is transformed. Subjectively perceived as a shallow dome—a phenomenon much debated in psychology—the sky appears to be anchored circumferentially to the crater's rim. Around the crater, chambers are being tunnelled out, in such a way that the passage of light—night into day—will paint the interiors with a succession of shaping shadows and luminous colours.

The fumarole, or secondary vent, will be the focus for chambers oriented towards the four compass points, joined to a series of linked interiors to provide varying spatial perceptions. A tunnel 1 035 feet long will lead into an oval sky chamber as an atrium for the main bowl. Subsequent progress to the top of the rim culminates in the reattachment of the dome of the sky to the far horizon of the land.

The resonances of Turrell's project, which is presented through models, paintings, drawings, prints, and photoworks are astonishingly rich. They range from the prehistoric observatories of stone circles and ancient temples, through the great astronomical castle and garden of Tycho Brahe on the Danish island of Hven around 1600, and the camera obscuras of Jesuit magicians in the seventeenth century, to the huge dishes of modern observatories. And, at its heart, is a vision of 'Infinitude' worthy of Turner.

As Turrell says, 'looking at light in a Skyspace is akin to a worldless thought'—and such a thought has boundless potential. ❧

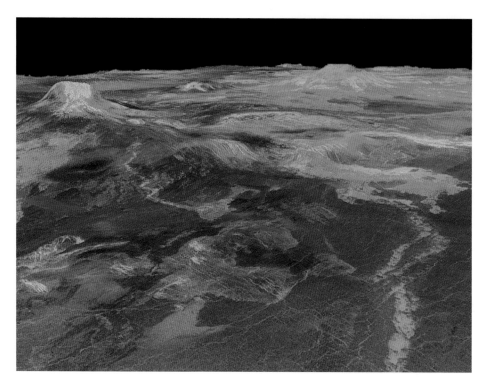

NASA, perspective view of volcanoes on Western Eistla Regio on Venus, provided by the *Magellan* mission, 1991

Venus' voyeurs

When images of Jupiter, beamed back by a 'suicide probe' from the spacecraft *Galileo*, were published in *The Independent* on 7 June 1997, the text began, 'It may look like a Turner painting …'. We have seen how Turner himself was striving to express the awesome infinity of a scaleless cosmos characteristic of Romantic science, art, and literature.

Spectacular examples of what appear to be landscapes seen with normal vision are provided by the views of Venus generated from the huge quantities of data transmitted from the *Magellan* spacecraft in 1991–4. Such is the nature of the atmosphere of Venus that it cannot be penetrated by rays within the normal visible spectrum. The 'visual' technique involved synthetic aperture radar scanning, in which a radar beam is directed diagonally downwards and sideways from *Magellan's* rapid path, exploiting the Doppler effect. The sideways look, akin to that of side-scan sonar in oceanic surveys, was complimented by radar altimetry, using a beam pointed directly downwards.

Some of the effects of 'seeing' by radar are visually anomalous. For example, highly reflective surfaces will return little or no reflections directly back to the laterally positioned transmitter/receiver and will therefore register as 'black'—in contrast to their reflective lustre when viewed by the eye in normal lighting conditions.

To achieve the beautiful land-scapes, those synthesizing the images from the side-scans and altimetry need to take a series of overtly pictorial choices which affect every aspect of the rendering—from the basic decision to map the data using orthodox perspectival scaling, to detailed choices of what 'false colours' should be used and how they are to be modified by distance.

The pictures are masterpieces by largely anonymous masters of galactic landscape painting. They have been exhibited in art galleries and marketed as 'works of art'. The pic-turesque and sublime beauties of

NASA, image of the atmosphere of Jupiter, provided by the *Galileo* spacecraft, 1997

our 'sister' planets are revealed according to the same kinds of pictorial rendering as has come to certify the visual delights of our terrestrial habitat. But why are they produced, when our scientific understanding of the planet does not appear to be significantly advanced by such seductive extravagance?

I can think of various reasons. One relates to the human impulses of those who undertake the incredible journeys of exploration. The naming of the craft *Magellan*, after the great Renaissance voyager, provides a strong clue. The desire of intrepid explorers, ancient and modern, to see the wonders of the newly discovered terrains with their own eyes is irresistible. Another explanation lies in the satisfying of the voracious public need for pictures of new discoveries within a culture which ceaselessly demands cascades of visual novelty. A further reason is that the huge budgets for space exploration need to be justified. Some kind of spectacular public output is required if the enterprises are to continue.

The professional explorers and the public audience share a series of predilections long built into our visual culture. Courtesy of the pictures assembled from electronic data, we become armchair tourists and aesthetic voyeurs in extraordinary voyages of stellar exploration. ✀

Nancy Lane, freeze-fracture replica of plasma membranes in a septate junctional area, from the mid-gut of the moth, *Manduca sexta* (\times 28 000)

Lane's landscapes

Just as Robert Hooke in the seventeenth century was beguiled by the microcosmic wonders of the world in miniature disclosed by his microscope, so the successively refined technologies of modern electron microscopy have revealed ever more spectacular worlds on the tiniest scales available to direct imaging techniques. In keeping with the perceptual practices of those who first looked through optical devices, the topographies of the unfamiliar worlds are certified by analogy to morphological features visible within the normal compass of our unaided vision. The metaphorical language of science often speaks of this mode of seeing and describing.

When Gerd Binning viewed the multiple diamond pattern of the 7×7 surface of silicon in the scanning tunnelling microscope, which he had invented with Heinrich Rohrer in 1982, he responded rhapsodically, talking in terms of aesthetic revelation: '… here one saw little hills, and the hills formed a complicated pattern with this symmetry. We like symmetry. If something is symmetrical, it is very pretty. This was complicated but regular, extremely surprising and pretty.'

The less overtly symmetrical landscapes of organic tissues are equally 'pretty' in their

own way. The technique of freeze-fractured cells and tissues, introduced in the late 1950s and perfected during the 1960s, has been producing some of the most appealing of the miniscule topographies. The Cambridge cell biologist, Nancy Lane, talks of the freeze-fracture replicas of plasma membranes as 'providing stunning evidence, if such were required, of the beauty of the cell'. Yet it is a beauty that can only be disclosed by complex techniques of preparation.

Nancy Lane, detail showing septate junctional intramembranous particles in linear arrays (\times 65 000)

Lane's highly refined technique involves the fast freezing of contiguous plasma membranes of eucaryotic cells from invertebrates, mainly arthropods, which have been treated with 'antifreeze' to avoid crystal formation. The two adhering membranes are cleaved with a knife in an evacuated chamber, the fracture plane running medially through either membrane. The resulting relief surfaces, each of which may carry some residues from the other half of the membrane, is then shadowed with a heavy metal 'sprayed' at an angle on to the sides of the hills and valleys. The surface is next 'faced up' with a thin film of carbon—non-opaque to electrons—and the biological tissue removed when the preparation has been thawed. The metallic 'death mask' (Lane's term) is then examined under a transmission electron microscope.

What we see in the micro-domains are the configurations of intramembranous particles that form the intercellular junctions. In some places we see the prominences of the proteins anchored in their 'sea' of lipid. In others we see the depressions which retain, in negative, the imprint of the projecting features from the half-membrane that has been cleaved away. Reading the complex and subtle configurations of convexities and hollows involves considerable visual agility, accentuating the positive and, unlike the popular song, *not* eliminating but asserting the negative. Seeing what's what is complicated. Lelio Orci and Alain Perrelet in their 1975 book, *Freeze-Etch Histology*, helpfully juxtapose freeze-etch replicas with thin sections of a more conventional kind, acknowledging that 'it requires both time and experience to move from one to the other'.

Navigating through the landscape, devoid of the recognizable features of our human terrain, demands hugely disciplined scrutiny, the cultivation of visual memory, and considerable perceptual control. It also needs the 'correct' orientation of the highlights and metallic shadows as if lit, ideally, from the upper left, if prominence and hollow are not to be misleadingly reversed. Newly accessible territories are yielding their secrets through the ingenious reapplication of enduring visual habits. ❧

PART NINE

Process and pattern

Metzger's mission

Art that relies upon the witnessing of a process confounds our expectation that any act of making in the 'fine arts' should result in a collectable artefact—an expectation that we do not impose on theatre or musical performance. The work of Gustav Metzger is particularly infuriating in this respect. His programme of 'auto-destructive art', launched in his London manifesto of 1959, leaves behind no permanent object or enduring trace— frustrating mercenary dealers and acquisitive museum curators. His 'aesthetic of revulsion' which relishes forms and modes of expression that 'are below the threshold of social acceptance' insults the established criteria of those who aspire to appreciate 'art'. And his apparently anarchic media, such as the nylon canvases dissolved by acid spray into apparent nothingness, set him up as a prime candidate for ridicule by the popular press and those who decry 'modern art' as fraudulent.

The destructive processes which form one strand of his activity are a response to the events which marked his personal and political life. Born in 1926 as the son of Polish Jews in Nuremberg and exiled with his elder brother to England in 1939, Metzger's

student years were ravaged by a war in which his parents were immolated and the art of retaliatory mass destruction was first practised at Hiroshima. In life, as in art, he has fermented rebellion. In company with Bertrand Russell and fellow anti-nuclear protesters, he was one of those imprisoned in 1961.

Science—and this is where he qualifies for inclusion in our present context—has been a constant preoccupation in his art. Science is neither automatically demonized nor gratuitously exploited. On one hand, he has savaged the way that scientific technologies have ruthlessly extended man's destructive potential, forcing the old concept of 'nature', ideally inclusive of man, to become the 'environment', which is to be managed from 'outside' by mighty human agencies. And he bears witness, metaphorically in his auto-destructive acts, to the awesome 'tearing apart' and 'annihilation' practised by nuclear physics in its dismembering of the atom.

Gustav Metzger, *Liquid Crystal Slide Projection*, in the Museum of Modern Art, Oxford, 15 October 1998– 10 January 1999

On the other hand, Metzger recognizes that 'each disintegration ... leads to the creation of a new form', a transformatory process that leads logically to the other side of his artistic and social coin—'auto-creative art'. Setting up physico-chemical reactions to produce growth and metamorphosis, 'auto-creative' works exploit the potential of such physical wonders as liquid crystals and new technologies, most notably computing, to forge art forms that serve as theatres of natural process. A central ideal is non-predictability, resulting in 'a limitless change of images without image duplication'.

His most prominent creations in this 'auto-creative' mode are his liquid crystal projections, invented in 1965 and first manifested on a huge scale at concerts by 'The Cream', 'The Who', and 'The Move' at the Roundhouse in London at the end of the following year. For a series of exhibitions in 1999, the ponderous 1966 programme of 12 apparatuses operated by a dozen assistants (and less than smoothly) were replaced by a computerized system. Six automated projectors, equipped with devices for the heating and cooling of slides of liquid crystals, worked according to a non-repetitive programme to cast images through rotating polarized filters on to the walls of the gallery. The endless sequence of infinitely varied configurations and colours pulsed with similitudes of organic processes, orchestrated according to different timetables. They simultaneously suggested micro-biological metabolisms, geophysical phenomena, chemical reactions, physical processes, and the artificial beauty of the kind of abstract art that rose to prominence in the 1950s and 1960s with the Abstract Expressionists. During a sustained viewing in the Museum of Modern Art in Oxford, there were recurrent though non-identical resonances with the floating veils of colour on the canvases of Mark Rothko.

On one side of his coin Metzger displays our potential to become the agents of irreversible destruction; on the other he rejoices in our creative integration with the life-giving properties of nature. His mission fuses art and political meaning. He tells us that the choice of on which side the coin falls is too vital to be left to the short-term expediencies of commercial gain. ❧

Cornelia Parker, *Cold Dark Matter: An Exploded View*. Frith Street Gallery, London

Parker's pieces

What's this bollocks doing in *Nature*?' The question, more rhetorical than inquisitive or grammatical, was loudly posed in the biology department's tearoom at Leicester University by a postgraduate faced with the enigmatic insertion of Cornelia Parker's photographs of 'Navel Fluff' from a 'sailor (while at sea)', a 'farmer', and an 'architect' in the 'News and Views' section of *Nature* in the issue of 16 October 1997. In truth, none of her magnified photographs of delicate residues insinuated by the editor, Philip Campbell, in that or in the three preceding issues looked visually out of place. They could well have been microscopic images of something scientifically significant. The problem was one of the context and the readers' resulting expectations.

Parker's pieces do not rely on fixed meaning. They do not communicate to the viewer or reader with the studiedly unambiguous parades of hypothesis, evidence, analysis, and demonstration that is the aspiration of the illustrators and authors contributing elsewhere in *Nature* or in other periodicals of serious science. Rather they exploit a resonant series of visual and verbal associations to provide invitingly open fields for our imaginative exploration.

Residues of memory are central to Parker's associative processes. She is concerned to arouse our contemplation of the acts and processes that have deposited what we now see. She also exploits the pedigree of an item's ownership, relying, for example, upon the way that an object acquires significance through being in the hands of a famous or notorious owner. Such significance cannot be certified by any material change in the object; we just need assurance of its provenance.

The scored furrows in micro-photographs of a record of the 'Nutcracker Suite' owned by Hitler and the lacquer residue etched from a master recording at the Beatles' Abbey Road Studios exploit the familiar frisson of fame by association and also strike deeper. The record of the Tchaikovsky work, the grooves of which sounded their sugary tune in Hitler's ears, invites us to think about the paradox of sweet music for an evil listener. The lacquer residue is precisely that which is taken out to allow us to hear the sound of the musicians playing in the North London studio. The excavated strips are, by logical implication, 'negatives of sound' (to use Parker's own term).

Cornelia Parker, micro-photographs of a record of the 'Nutcracker Suite' owned by Hitler, 1996. Frith Street Gallery, London

Cold Dark Matter: An Exploded View, probably her best-known work, exemplifies the voraciously encyclopaedic reach of the associations she wishes to invoke, a reach that extends from childish play to the cosmos of science. To begin with, an inoffensive garden shed, illuminated from within and stuffed with acquired clutter, stood in an otherwise empty gallery. Then, courtesy of the British Army, the shed was blown apart in a centrifugal cascade of fractured planks and material possessions—a blasted plastic dinosaur, a boot rent asunder, a savaged hot-water bottle, a euphonium wrenched out of tune. Systematically harvested, the debris has been reassembled as a galaxy of fragments hanging on wires. Lit by an inner bright star, its shadows collide with the confining walls, roof, and floor.

Parker is not *illustrating* the scientific concept in her title. Rather she is realizing the metaphorical poetry inherent in science's calculated but often suggestive acts of naming. The moment of catastrophic expansion is frozen in a state of uncertainty, its 'implicate order' (to adapt the telling phrase of the physicist, David Bohm) but dimly discernible. We cannot tell if it is undergoing endless dispersion or coming back together to be reconstituted as a shed and contents. The 'exploded view' plays on the convention of technical illustration, virtually invented by Leonardo da Vinci, in which a mechanism is visually dismembered to allow the discerning and naming of the parts in due spatial order.

Cold Dark Matter orbits around opposites: gathering and dispersal, expansion and contraction, explosion and implosion, inhaling and exhaling, falling and suspension, transformation and stasis, peace and violence, making and breaking, playful and sinister. These alternative states by implication exist simultaneously within a kind of photographic 'still' from a dynamic phenomenon.

The ambiguities, in which the spectator is invited to participate, seem the very antithesis of the science that appeared with her images in *Nature*. Yet we have seen repeatedly that science involves acts of creative looking at images that hover on the edge of illegibility. This is true not least of those who gaze into the most distant realms of the cosmos. Parker, as an artist, exploits conditions of visual and psychological indeterminacy. The modern astrophysicist is determined to master the uncertainty through mathematical formulation, even when indeterminacy itself is at the centre of the system. ❧

Jonathan Callan, *Dust Landscape*, 1998, view from a raking angle. Courtesy of the artist and the Hales Gallery, London

Callan's canyons

Artists have always relied upon physico-chemical processes in the making of their works. The processes have ranged from the technological complexities of bronze casting to the suspension of pigments in various kinds of binding agents. Traditionally, the behaviour of materials has needed to be understood and controlled, so that the potentialities of the various media might be exploited and their technical limits duly respected. Sometimes, as with watercolour washes, creative 'accidents' in the behaviour of the medium were openly welcomed, but always within set parameters.

Since the 1950s, when Metzger began working, an increasing number of artists have been prepared to endow process with a more dynamic and determining role, setting up situations in which the physical behaviour or chemical action of the medium is given its head. In effect, the parameters for the programme are established, but it is then left to run with results that are not subject to subsequent control and are not precisely predictable.

The London artist, Jonathan Callan, has been exploring a range of processes, from the controlled modelling of phenomena in sculptural form to what may be described as 'freestyle evolution of morphology'. He has undertaken a series of works which rely upon the properties of viscosity and flow in various semi-solid and granular materials. He is undertaking what he calls 'material conversations'. As he says, 'to have a conversation with a nail you need a hammer'.

In one series, of which the work illustrated here is part, he begins with surfaces punctured by circular holes at irregular intervals. Granular material, in this case powdered plaster, is then shaken evenly over the surface through a sieve. The piles that accumulate on the unperforated portions of the aluminum 'stencil' are subject to a succession of avalanches. The result, viewed laterally, is an extraordinary landscape of jagged peaks,

hanging ridges, clustered summits, and deep canyons. Seen from above, a cellular structure emerges, with a network of dividing walls surrounding the central spaces. The configuration obeys what he terms 'a de-natured geological principle, of sedimentary deposits, the silting of a river estuary … a geography that seems … both eminently 'natural' and highly 'artificial', the Alps brand new'.

Repeating the process with the same materials and surface configuration results in 'landscapes' that are similar with respect to some general rules—e.g. the highest 'mountains' correspond to the largest areas of unperforated surface—but not perfect duplicates. The avalanches occur when the critical angle of the slope is exceeded, but the exact behaviour of successive landslides and their interaction with adjoining systems is not forecastable. The same configuration of holes results in what we may describe as fraternal physiognomies rather than absolutely identical features.

For anyone concerned with developments in the sciences of complexity, Callan's dust piles will irresistibly recall the sandpile phenomenon that provided Per Bak, Chao Tang, and Kurt Weisenfeld with their initial model of self-organized criticality. Callan's 'experiments' are undertaken with no knowledge of the scientific theory, yet they serve as elegant illustrations of what Bak has characterized as a 'poised, critical state' of great delicacy in which tiny disturbances lead to catastrophic events. The artist is not overtly concerned with the analysis of the process in the manner of a physicist, but has sensed artistically how such processes can result in topographies of timeless beauty.

Callan was as surprised and delighted as the author when Adrian Webster of the Royal Observatory in Edinburgh responded to the original article in *Nature* by pointing out in a subsequent issue that the configurations viewed from above shared characteristics with 'Voronoï cells', in the tesselation described by the Russian nineteenth-century mathematician, Georgii Voronoï. Webster's response was in turn developed by the mathematician, Ian Stewart, in his popular feature on 'Mathematical Recreations' in *Scientific American*. Rather than cannabalize the way they have brought science to bear on 'Callan's canyons', the main body of Stewart's article follows, with his kind permission. ∾

Jonathan Callan, *Dust Landscape*, 1998, view from above. Courtesy of the artist and the Hales Gallery, London

Cementing relationships

Ian Stewart

Civil engineers have long been familiar with how granular materials—such as sand, soil, or cement powder—pile up. The simplest and most important feature is the existence of a 'critical angle'. Depending on the nature of the granular material, there is a steepest slope that it can sustain without collapsing. This slope runs at a constant angle with the ground—the critical angle. If you keep piling sand higher and higher (say, by pouring it in a thin stream) the slope of the sandpile will steepen until it reaches the critical angle. Any extra sand will then trickle down the pile, causing either a tiny avalanche or a big one, to restore the constant slope. The resulting 'steady-state' shape, in this simplest model, is a cone whose sides slope at exactly the critical angle.

Complexity theorists study the process by which the slope attains this shape, and the nature of the avalanches, big or small, that accompany its growth. Danish physicist Per Bak coined the term 'self-organised criticality' for such processes, and he has suggested that they model many important features of the natural world, especially evolution (where the avalanches involve not grains of sand, but entire species, and the piles are in an imaginary space of potential organisms.)

In Callan's artworks, the structure of cement powder around each hole is an inversion of the civil engineer's conical sandpile. Consider a horizontal board with just one hole. Away from the hole, cement rises in every direction at the critical angle, creating a conical depression whose tip points downwards and rests at the centre of the hole. These inverted cones are the craters that form Callan's striking landscapes.

But what of the geometry when there are several holes? The key point now is that any cascading cement powder that trickles through the board will fall out through the hole that is nearest to its initial point of impact. It is therefore possible to predict where the boundaries between the conical craters will occur. Divide the board into regions surrounding the holes, in such a manner that each region consists of those points that are closer to the chosen hole than they are to any other hole. The region is the hole's 'sphere of influence', so to speak, except that it is not a sphere but a polygon. Provided the board is horizontal, the boundaries between these regions are directly underneath the common boundaries of adjacent craters.

A way to sketch one of these regions is to choose any hole and draw lines from its centre to the centres of all the other holes (see the illustration shown here). Cut each line in half and

Adrian Webster's computer model from *Nature*, 29 January 1998

from that point draw another line at right angles to it (that is, draw the perpendicular bisector). The result will be a criss-crossing network of bisectors. Find the smallest convex region that is bounded by segments of this network and contains the chosen hole. This region is known as a Voronoï cell. Each hole is surrounded by a unique Voronoï cell, and all the Voronoï cells together tile the plane. Georgii F. Voronoï (1868–1908) was a Russian mathematician who worked on number theory and multidimensional tilings. Voronoï cells go by a few other names—Dirichlet domains and Wigner–Seitz cells, for example —because they have been rediscovered in many contexts.

Callan's craters, then, rise in inverted cones at the same criticial angle, and meet above the edges of the Voronoï cells defined by his system of drilled holes. One comfortable consequence of this geometry is that when two slopes meet, they do so at the same height above the board—there is no sharp discontinuity. Another feature, less obvious, can also be deduced: the shape of the ridge where one crater merges into its neighbour. In the abstract, what we have are two inverted cones rising at identical angles. They meet above the perpendicular bisector of the line that joins their vertices—above the Voronoï boundary. Consequently their intersection lies in the vertical plane through that boundary line. What curve do you get if you cut a cone with a vertical plane? The ancient Greeks knew the answer: a hyperbola. This fact helps to explain the rather jagged nature of Callan's landscapes.

What of the connection with astronomy? Instead of holes in a plane, imagine points in three-dimensional space. In the plane, the perpendicular bisector of a pair of points is a line, but in space it is a plane. Draw these bisecting planes for the lines between a given point and all the other points. Let the Voronoï cell of a given point be the smallest convex region that surrounds it and is bounded by parts of these planes. Now the Voronoï cell is a polyhedron. Astronomers have recently discovered that the large-scale distribution of matter in the universe resembles a network of such polyhedra. Most galactic clusters seem to be located on the boundaries of neighbouring Voronoï cells. This pattern has been called the Voronoï foam model of the universe because it looks somewhat like a giant bubble bath.

There is an analogy—imperfect but still illuminating—with the distribution of cement powder in Callan's landscapes. In his sculptures, the cement piles up highest along the Voronoï boundaries. The analogous property in three-dimensional space would be that, as the universe expands, matter concentrates along the same boundaries. So this one simple idea encapsulates some arresting art, elegant mathematics, and deep physics about the structure of the universe. ꙮ

The sides of each crater slope at the same angle as the sides of a conical pile of cement powder

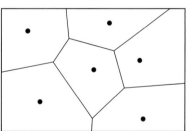

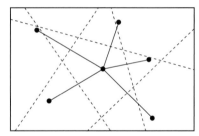

Voronoï cells can be sketched by drawing the perpendicular bisectors of the lines between the holes

Susan Derges, *River Taw 22 May 1997.*
Courtesy of the artist and Michael
Hue-Williams Fine Art, London

Susan Derges, *River Taw 16 July 1997.*
Courtesy of the artist and Michael
Hue-Williams Fine Art, London

Derges' designs

Nature is an alarmingly tough competitor for any artist, parading an endless succession of beguiling and elusive effects which exhibit a subtlety and vitality that present an enduring challenge to the inert media used by the painter and sculptor. In particular, the capturing of the transitory beauties of light and motion in water has presented perpetual problems, to be faced by the Renaissance painter of the *Baptism of Christ* or *Birth of Venus* no less than by an Impressionist seeking to evoke a seascape saturated with sunlight and fractured by scattered reflections of rocks and trees. One type of solution to the problem of entrapping such natural effects, brilliantly realized by the Devon artist, Susan Derges, is to collaborate directly with the natural phenomena themselves, in such a way that nature inscribes its own order and disorder on the designated surfaces of the works of art.

Derges is internationally admired for her photoworks in which nature imprints patterns and rhythms of motion, growth, and form directly on the light-sensitive surface of

the photographic emulsion. She has collaborated intensively with such phenomena as powder on vibrating plates (in the manner of Chladni), arcs of water droplets (inspired by Boys), the populations of busy honeycombs, and vessels of germinating toads' eggs, making us look again—look really hard—in keeping with a historical succession that runs through Leonardo, Dürer, Goethe, and Ruskin. Her most recent work tackles the motion of water, that hell of the predictive sciences.

In one series she treats the surface of a river, the Taw in Devon, as a photographic transparency, searching out flow patterns which remain relatively stable. Sheets of photographic paper in a large slide (about 6 feet × 2 feet) are immersed just below the surface at night and illuminated by a brilliant but diffuse flash lasting a microsecond. The colour images register the peaks of the wavelets as white lines and the troughs as tinted by moonlight or other ambient lighting. Sometimes dark silhouettes of reflected vegetation enhance the effect as though we are looking at Japanese screens. Black-and-white photographs are also made with a negative process which inverts the tonality. The crests accordingly describe a rippling cellular network of dark membranous filaments.

Detail from *River Taw 22 May 1997*

In a technical sense, a student of hydraulics might scrutinize her large prints as lucid illustrations of wave trains, capillary waves, and so on. But they are more than technical illustrations. They suggestively evoke the pattern-forming propensities of related phenomena, not only those exhibited dynamically by fluids but also those discernible in the growth of cells, the wrinkling of tissues, and so on—across a wide range of scales. At one level, the images are life-size representations of very specific events (and they are unusually large for photographs, immersing us in their flow). Yet at another, they aspire to reveal scaleless commonalities in nature.

The designs that Derges' discerns in natural phenomena are sensed both intuitively and in a knowing dialogue with a number of authors who are concerned with the recurrent topic of pattern formation in nature and the new sciences of complexity. When we learn that she owns books by Charles Vernon Boys (*Soap Bubbles*), James Gleick (*Chaos*), Hans Jenny (*Cymatics*), Theodore Schwenk (*Sensitive Chaos*), and Danah Zohar (*The Quantum Self*), as well as having studied Japanese art and gardens in situ, we can gain some insight into the rich conversations she undertakes with what Leonardo termed the 'marvellous works of man and nature'. ∾

Glen Onwin, Nigredo—
Laid to Waste, 1991,
installation in the Square
Chapel, Halifax

Onwin's holistics

Early in the 1970s the Edinburgh artist, Glen Onwin, discovered the extensive salt-marsh near Dunbar. Its strange topography—shaped by tidal flooding, the ebb and flow of subterranean waters, erosion and consolidation, precipitation and evaporation, the crystallizing and dissolving of salt, and the tenacious grip of specialized vegetation—embodied through natural processes those cyclical qualities of life and death that he had already been seeking through artistic creation.

Onwin works with a wide range of media: photographs, not only of features visible to the naked eye but also structures discernible with an electron microscope; printed images, including a large, square, white-on-black recitation of Mendeleev's periodic table; semi-abstract pictures 'painted' with wax, minerals, and organic materials, composed at least in

part by chance; and a range of installations which typically use concentrated solutions of chemicals to create ever-evolving panoramas of seas, lakes, continents, and islands.

His 1991 installation in the partly derelict Square Chapel in Halifax centred upon a vat of black brine, a square sea in which clusters of crystals congealed around barren lands of floating wax, each different in their aggregated morphologies yet essentially similar in the underlying mechanisms of aggregation.

Glen Onwin's photograph of the Saltmarsh, Dunbar, 1974

The processes behind such formations stand within the province of the science of chemistry. And there is much in Onwin's response to the phenomena that is consistent with modern science, in particular the search for the constants that decree that salt ideally seeks to crystallize in cubes, or that determine those common morphologies transcending scale, from the cosmic to the microscopic:

> I want to work in a microcosmic, macrocosmic way, to get as much information from the larger image of the work as … from the detail. It is important that you know the detail is there, but you should stand back … and view the whole work with that knowledge.

However, he is also delving into realms of symbolism that share more with alchemy, particularly in its psychological interpretation by Carl Jung, than with the prevailing tenor of modern science. Such formations as a cube of salt, and a circular ring of vegetation growing from its dying centre in the saltmarsh, echo the ancient symbols which express the mystical quest to explain age-old perceptions.

His fascination with the emergence of shape from chaos marries the *massa confusa* of alchemy with the modern speculations on the origins of matter. If this seems a strange marriage, it is appropriate to recall that Newton was an alchemist. The title of the Halifax installation, *Nigredo*, is openly alchemical in its reference to the primitive and sometimes recurrent stage of black putrefaction in the transmutation of substances, while its subtitle, 'Laid to Waste', alludes to his long-standing concern for the fragile ecology of our planet menaced by technology.

He senses that the saltmarsh, in which a precarious balance determines that the same substances can either give life or decree death, stands as both a physical model and imaginative metaphor for the holistic processes, small and grand, in which we intervene at our peril. ❧

Herman de Vries, *from earth; nepal and india,* (earth on paper), 1992.
Bruno Schneyer/Royal Botanic Garden, Edinburgh

De Vries' varieties

The history of natural history revolves around acts of naming and classification. This
has most obviously been the case in the Linnaean and Darwinian eras, in which the
concept of the species assumed such centrality. But it is equally true of those eras in which
the name of something served to inscribe it in the book of nature and declared its sym-
bolic significance within God's treasury of wonders.

Naming and taxonomy are tools, functionally apposite according to the demands of the
users and, as we saw with Mendeleev, capable of creative reshaping of our understanding.
The systems vary across different cultures, by place and time, though less radically than
has been claimed by cultural relativists. Herman de Vries, the Dutch artist, philosopher,
and poet, is a collector of natural things—things of a kind. But his 'kinds' stand in a com-
plex and often challenging relationship to standard taxonomic categories, such as those in
the herbaria and aboreta in which he has worked.

Since 1970 he has been exhibiting collections—shells, flowers, leaves, branches, herbs,
and varieties of earth—which can sometimes be packaged intellectually in the standard
fashion but which often resist the process of separation which denomination entails. Thus
his montages of earths alert us to a multitudinous variety which far outstrips our leaden
vocabulary.

De Vries has a collection of more than 2400 samples of earth, including no less than 300

Herman de Vries, *forms from the botanic garden*, (leaves on paper), 1991–2

from Gröningen in Holland and 350 from the volcanic island of Gomera in the Canaries. They are laid out according to criteria of similarity and difference, but not within rigid categories. The visual differences in the 'element' (in the ancient sense), which is the basis of so much life, speak by implication of the manifold variations in the lives themselves and of the wonderful attuning of plant physiologies to minute variations in the compositions of soils.

His art involves the quiet contemplation of nuances. But it is also quietly subversive. When he exhibits collections of herbal substances, rich in odour, he plays to sensory perceptions even more resistant to exact naming than objects of sight. When he records the sounds of the world he alerts us to a natural music which does not lend itself to conventional notation—even by the French composer Olivier Messien, who drew such inspiration from birdsong. When de Vries writes without capital letters, as he has done for 20 years, he intends to signal:

a kind of anti-hierarchic expression. it's the same in nature; every part has its own function, so why should a tree be more important than a diatom? ... language is 'you and me', 'we and them', 'here and there', whereas in effect, it is all part of the same, it's one. Language ... gives us a grip on reality and great social power, but we also pay for it in the loss of unity.

His book of nature has no rigidly prescribed lists of flora and fauna. He invites us to sense anew, so that we can sense affinities across boundaries. He also alerts us to pages torn out—as in his book 'in memory of scottish forests'—forests still named on some maps but whose absence testifies to the perils of collective insensitivity. Like Mendeleev, he is in the business of creative regrouping, but he does not want us to draw a fixed conclusion. ❧

Cornelia Hesse–Honegger, *Harlequin Bug* (*Pentatomidae*), with deformed scutellum and asymmetrical patches, 1991, found near Three Mile Island plant, USA. © Hesse–Honegger/www.locusplus.org.uk

Hesse–Honegger's handwork

The hand-drawn image continues to cling obstinately to its roles in the art of scientific illustration. It is less obviously central now than in the eras when it was the only way to originate representations, but it still does jobs that technologically generated images cannot. The unique, directed interplay that occurs in the acts of seeing, controlled representation in line, tone, and colour, and communication retains a human potency that cannot be equalled by any other means.

Yet is this potency 'subjective'—like a work of art is supposed to be—and, therefore, 'unscientific'? The charge of subjectivity has been made of the amazing watercolours of deformed insects made by the Swiss painter, Cornelia Hesse–Honneger. They may be very striking, and even 'accurate' on their own terms, but can they be 'taken and used in evidence'? Are they, in short, works of art or scientific illustrations?

Cornelia Hesse–Honegger, *Leaf Bugs* (*Miridae*), part of wing and scutellum (undeformed), 1979, found in Gockhausen, Switzerland. © Hesse–Honegger/www.locusplus.org.uk

Hesse–Honneger was trained as a zoological illustrator in Zurich, where she drew for publication, amongst other specimens, induced mutations in the *Drosphilidae*. After the arrival of her children, she worked increasingly on her own visual agenda, concentrating upon the local population of leaf bugs in their adult (*imago*) stage 'because of their beautiful patterns and colours'.

The direction and purpose of her work was redefined in 1986, the year of the Chernobyl disaster. Already aware of the sensitivity of insects as bioindicators of the environment, and unconvinced by reassurances about the lack of danger posed by radiation levels below 5 rem per year, she undertook studies of leaf bug and *Drosphila* populations along the cloud trail in Sweden and Switzerland, and subsequently around Chernobyl itself.

Visually attuned by her scrupulous earlier depictions of the patterned beauty of such features as the leaf bug's scutellum, she exploits her perceptual and representational skills to draw our eyes into the miniature world of deformations she is uncovering—not only in zones affected by such major incidents but also downwind of normally operating plants such as Sellafield.

The legacy of her scientific training is apparent in her systematic mapping and counting of the occurrence of deformed specimens. At Three Mile Island in the USA she concluded that 'the worst deformations were only located in the E and ESE direction of the plant in an area within one mile of the … plant. No other studies were available.'

It is not my intention here to offer a judgement on her subsequent disputes with the majority scientific view that what she is recording is statistically insignificant and without correlation to low levels of ionizing radiation, lacking proper reference to control populations, statistical analysis, and alternative causes. Rather, it is to affirm the right of the obsessional enquirer to probe uncomfortably into visual corners where dark questions lurk—using the most powerful visual tools available. Her probing is highly personal in motivation and aesthetic means. I would resist any attempt to classify it rigidly as 'good science' or 'bad science'—or even as 'good art' or 'bad art'. It is, like all 'good imagery', designed to enhance our ability to look and think.

She speculates that her mutated flies 'are perhaps closer to today's reality of nature or, maybe, are prototypes for a future aesthetics of nature'. Such aesthetics are subjective in the true sense, but every one of her watercolours carries deep implications for issues of objective observation and the frameworks of explanantion. ❧

Andy Goldsworthy, *Blades of Grass, Creased and Arched, Secured with Thorns*, 1988, Penpont, Dumfrieshire. Courtesy of the artist and Michael Hue-Williams Fine Art, London

Goldsworthy's genera

Round holes, often of a tangible blackness, are fringed by miraculous aureoles of glowing autumn leaves. Sometimes the dark apertures are bounded by pebbles, graded in size and colour, while at other times they are hedged in by nests of bleached sticks. Long, thin fissures run jaggedly across layered carpets of leaves and through apparently random arrays of stones. Craters and snaking ridges of sand and soil speak of an organic geometry that blends the rectilinear and curvilinear without dissonance.

Low, vertiginous arches are engineered from raw plates of slate or irregular paving stones of ice, each discrete unit, courtesy of gravity, mutually squeezing its companions into stable unity in the absence of adhesive. A sharp star of shining silvery icicles tiptoes on needle-thin points across abrasive rocks. Cut slits transform a wall of frozen snow into an arctic Stonehenge.

Oval stones and angular rocks balance miraculously over single points. Twigs and thin sticks are woven into spiral bowers or giant cobwebs, as unexpected in pattern as they are paradoxical in their stability. A curved, tapering cornucopia, freshly green, is composed

Andy Goldsworthy, *Japanese Maple Leaves, Supported by a Woven Briar Ring*, 1987, Ouchiyama, Japan. Courtesy of the artist and Michael Hue-Williams Fine Art, London

from a continuous spiral of sweet chestnut leaves, its seams stitched with thorns. Goldsworthy is a visual poet of natural form.

In the illustrations included here, Japanese maple leaves, startlingly carrot in hue, metamorphose from a floating chain one day to become, the next, a fringed hole supported by a woven briar ring. And blades of grass, creased and arched into a snake of expanding girth, are pinioned to the soil by ranks of thorn rivets.

The British 'sculptor', Andy Goldsworthy, is unrivalled in range and skill as a 'nature artist'. He works as a collaborator with natural phenomena during the passing seasons, feeling deep into the essence of soil, stone, water, ice, flower, leaf, stem, stick, and trunk. He is a maker in the manner of the bower-bird, spider, swallow, bee, shellfish—or, in human terms, the Eskimo, dry-stone waller, oriental master of Zen gardens. Tensile strength is conjured from fragile delicacy, and stable unity is compounded from inchoate members.

He creates genera of forms—spheres, rings, holes, arches, spires, snakes, and fissures—which cut across (sometimes literally) the conventional taxonomies of genus and species. Through sight, touch, and motion he searches out, like a latter-day D'Arcy Thompson, morphological commonalities which arise from the material and processes of nature. For example:

> Some works have the qualities of snaking but are not snakes … The snake has evolved through a need to move close to the ground, sometimes below and sometimes above, an expression of the space it occupies. This is a potent recurring form in nature which I have explored through working in bracken, snow, sand, leaves, grass, trees, earth. It is the ridge of a mountain, the root of a tree, a river finding its way down a valley.

Across diversity, Goldsworthy sees commonalities, and in complexities he intuits shared shaping. An instinctive dialogue with the age-old perceptions of order and disorder continues—in his creations no less than in the new sciences of complexity and the revived interest in pattern formation. ∾

William Latham, *Evolving Form*, computer generated using 'Mutator'. Courtesy of the artist and Computer Artworks Ltd.

Latham's life-forms

It seems to me that there is a real problem with computer art. The problem does not reside in getting the new tool to perform old artistic tricks but rather with a more profound identification of what new territories computers and art might inhabit in terms of the inherent nature of computational procedures.

One approach, pioneered by Benoit Mandlebrot in his famous 'set'—with its profusion of rococo curves and gratuitous 'technicolour'—has been to use iteration to model algebraic procedures in visual terms. Fractal processes of repeated division according to the principle of self-similarity (resemblances across scales) have produced sublime mountainscapes for science fiction films. Such results may be seen as 'art'—just as Renaissance drawings of the Platonic solids or Poincaré's geometrical models can be accorded aesthetic status—but they only inhabit a limited domain in the wide territories already colonized by the visual arts. And they rarely stray into a domain that could be described as aesthetically subtle.

Standard computer design programs and the kinds of software 'palettes' aimed specifically at artists, are best seen as providing ingenious extensions to hand-driven techniques—or at worst as providing lazy operatives with the opportunity to exploit methods

they do not understand. A few artists are conducting a more searching exploration of art forms that can only be generated with computers.

The most promising approach, exemplified by the British sculptor, William Latham, is to set up programs on the basis of aesthetic choices in such a way that the parameters of style and content in the images are established but the final form is not predetermined. Indeed, a fixed 'final form' may not be the end in view. Rather, the evolutionary programme gives rise to a new type of kinetic sculpture.

Latham, who spent six years as research fellow in the IBM Scientific Centre at Winchester, has developed his programs in collaboration with Stephen Todd—most notably a powerful and wide-ranging design tool called 'Mutator'—in which sculptural forms are endowed with genetic properties which shape their growth. The programme also provides rules through which the 'life-forms' are subject to processes of natural selection. The results of such 'Darwinian evolution driven by human aesthetics' are fantastical organisms whose morphologies metamorphose in a sequence of animated images.

The still images show the kinds of form he generates, working 'like a "gardener" or "farmer", repeatedly picking, marrying and breeding, starting from a simple structure to evolve thousands of complex genetic variations'. They are intricately wondrous in their compulsive convolutions, marrying a strange beauty with an air of predatory menace.

William Latham, *Array of Evolving Forms*, computer generated using 'Mutator'. Courtesy of the artist and Computer Artworks Ltd.

Where Latham's images are typical of those generated by computer is that they seem irredeemably to have a computerized 'look' about them. The visual feel of the rendering exhibits very characteristic qualities—just as the look of an oil painting is reliant on the properties of that particular medium. Latham himself openly exploits these qualities, not least in relation to a certain kind of 'sci-fi' aesthetic that owes more than a little to the imaginative visions of the best draftsmen in children's comics and the designers of Hollywood films. It is one of the characteristic visual modes of our age. But for the 'art world', such images still provoke general unease and meet with limited acceptance. Whether this is because of the art establishment's conservatism or the lack of aesthetic longevity in computer art remains to be seen. I suspect the former to be the case. ❧

Tom Mullin and Anne Skeldon, *Attractors for Coupled pendulum in Chaotic Motion*, with the dimension of speed given by red = fast and blue = slow, 1990

Attractive attractors

For those of us who can best cope (or can only cope adequately) when mathematical procedures can be envisaged as processes in space, the graphic plotting of chaotic systems comes as something of a relief, reclaiming visual territory lost to the logicians of symbolic computation since the era of Descartes. The algebra of chaos bears fruit graphically in the illusory space behind the computer screen, yielding the strangely beautiful secrets of its attractors and fractal self-similarities to new virtuosi of the electronic palette.

Yet there is a paradox here. The spatial and colouristic magic of the graphics of chaos, to which we respond with senses attuned to plastic forms in our own experiential world, is a product of a quite different realm of conceptual space in which the co-ordinates of 'normal' three-dimensionality stand incompletely and symbolically for multidimensional co-ordinates of which the three standard directions of space provide only one set.

A conscious search for an effective mode for the rendering of a chaotic system was undertaken in 1990 by Anne Skeldon and Tom Mullin of the Non-Linear Systems Group, then at the Clarendon Laboratory in Oxford. They chose the coupled pendulum, a now classic exemplar of how simple deterministic means can, under particular conditions, result in surprising unpredictability.

From the end of a pendulum which can swing in one plane is hung a second pendulum that swings at right angles to it. The pivot of the upper pendulum is driven up and down at a regular frequency. There are five co-ordinates chosen for plotting: the velocity of the top pendulum; its angle; the velocity of the drive; the velocity of the lower pendulum; and its angle. As the frequency of the drive changes, complex, chaotic assemblies of periodic motions are generated. Three of the five co-ordinates are selected: the angle of one pen-

Tom Mullin and Anne Skeldon, *Attractors for Coupled Pendulum in Regular Motion*, 1990

dulum; the angle of the other; and the amplitude of the drive. Plotting the trajectories in the phase space—the 3D space resulting from the 3 co-ordinates—as a three-dimensional graph, two characteristic attractors emerge, each in the now familiar form of a torus. Within the conventions of the mapping, which displays the torus (ring-shaped) bands as intersecting and assigns different colours to differentiate them, they merge progressively at lower frequencies.

It is possible to vary the colour within the torus bands to map a selected fourth dimension—in this instance speed of motion—so that an additional co-ordinate for the behaviour of the system can be graphically represented. The colours are in a sense arbitrary, yet the encoding red as fast and blue as slow is no less contrived than our automatic registering of various frequencies of light as different colours.

The attractors exhibit undeniable appeal as plastic artefacts, yet the true space they occupy can only be seen by what Feynman called 'the eye of analysis', rather than the sensory eye. They are not, as they might readily be taken to be, graphic plots of the motion in 'our' experiential space. They exist only in the more abstract realm of 'phase space'. Yet evolution has equipped us with sensory eyes for the mastery of the space in which we exist as physical entities. It is these 'material eyes' that are powerfully satisfied by the translation of multidimensional variables into a pleasurable, visual realm. ◌

People, places and publications

Orren Turner, *Albert Einstein, c.* 1947,
US Library of Congress. Science
Photo Library

Icons of intellect

What a scientist (or artist, author, composer ...) looks like should not matter to us. It would make no difference to the theories of relativity if Einstein was clean-shaven, or even if he had a retroussé nose. Yet we harbour an apparently irresistible urge to scrutinize the appearance of famous and infamous persons—above all their faces—as if we might use outer signs to understand exceptional inner attributes.

Certain images of famous persons have come to serve as more than physiognomic records. They have assumed iconic status, standing for something more archetypal than the traces of individual appearance. The fame of the subject is crucial, but the nature of the portrayal must exhibit the potential to work with popular archetypes. Good examples are Yousoff Karsh's photograph of Winston Churchill as the British 'bulldog' and Andy Warhol's schematic Marilyn Monroes as the all-American blonde bombshell. Few images of scientists have achieved this status.

No face of Newton readily looms into public view when his name in mentioned. Yet Einstein has come to be instantly recognizable in caricatured form—wild halo of white hair, hooded eyes, characterful nose, bushy moustache, and exaggeratedly large 'brain-box'—as seen on T-shirts and orchestrating word processing 'help' programs. The theatrically lit image by Orren Turner, photographed at Princeton around 1947, plays as potently on the notion of the venerable sage as any of the of the older Einstein.

The general ancestry of Einstein as magus is clear, and more specifically it stands in line of descent from Mrs Cameron's Victorian photographs of the great astronomer and pioneer of photographic processes, Sir John Herschel. So concerned was she to capture the qualities she recognized in the friend whom she called her 'teacher and High Priest', that she cajoled him into washing his hair so that it would encircle his head like an aura of cerebral light.

Julia Margaret Cameron, *Sir John Herschel*, 1867

It would be difficult today to envisage the staging of a portrait of a great scientist in quite the same way, but this does not exclude the possibility of new icons. The most likely candidate is Stephen Hawking, Newton's latest successor at Cambridge as Lucasian Professor of Mathematics. His prominence as a public persona, through his authorship of the improbable bestseller, *A Brief History of Time*, and his unembarrassed willingness to disclose the effects of his motor neurone disease, have meant that his appearance has become widely familiar. The contrast between the clear signs of Hawking's physical infirmity and the public perception of him as a genius of modern science, points up the traditional mind–body duality.

Whereas the portraits of Herschel and Einstein radiated deep wisdom through their external aura, Hawking is, by implication, pure mind trapped in a physical integument whose incapacity mocks the depth and reach of his intellect. James King–Holmes' 1997 photograph shows how a portrait of Hawking may portray not just individual appearance but may also embody the kind of general concepts that are necessary for an image to achieve iconic status. ∾

James King–Holmes, *Stephen Hawking*, 1997. Science Photo Library

Arnold Mitchell, entrance to the School of Agriculture (now the genetics department), 1909–10, Downing site, Cambridge University

Laudable labs?

W̶e are all too familiar, across the world, with the messy clutter of disparate laboratory buildings squeezed into congested science sites. The lab is a major building type, yet we have come to expect little of it—other than as providing functional spaces which almost invariably prove to be inadequate as soon as they are occupied. It would be better if we cared more about their appearance.

All the larger structures have assumed their external appearance and internal configurations as the result of intense efforts by intelligent patrons and ranked architects, and the older sites embody in microcosm the histories of nineteenth- and twentieth-century architecture. Two telling examples, cheek by jowl on the Downing site at Cambridge University, are the School of Agriculture of 1909–10 (now housing the genetics department) and the Wellcome Wing built for the biochemistry department as an extension to the Sir William Dunn Building in 1961–3.

The School of Agriculture, designed by Arnold Mitchell, proudly proclaims its status through Edwardian rhetoric, above all in the two protruding bays topped by curved

pediments, one of which once provided the main entrance. The sculptural adornment parades heraldic shields (including the royal arms) and interlaced initials, whose significance has long since faded. In carved swags on either side of the upper windows, a series of agricultural tools—all romantic hand tools and no machinery—are suspended from a sheaf of corn and a ram's head. The motto above the door tells us that 'Unto God Only Be the Honour and the Glory'. The effort and expense devoted to such iconographical display was unthinkable only 50 years later.

The biochemistry wing exudes 1960s functionalism of mass production. Envisaged in principle in 1920, the plans moved towards reality in 1955 when the Wellcome Trust offered £120 000, supplemented by £200 000 from the University Grants Committee in 1957, when Roger Norton was appointed as architect. Beset with the planning difficulties, delays, and arguments which are endemic in committee-run projects, building work finally commenced in 1961.

C.A. Roger Norton (for Hammet and Norton), the Wellcome Wing (housing the biochemistry department), 1962–3, Downing site, Cambridge (in the foreground of the picture, with the School of Agriculture in the background)

It was a pioneering structure for the site. Constructed with precast concrete frames, hammered concrete columns, and clad in precast concrete slabs faced with granite aggregate, it belonged very much to the brave new world. Its rhetoric spoke of function, structural integrity, delight in concrete and glass, and industrialized production—nicely in tune with biochemistry as the study of the engineering of organisms. Even the prominent bicycle shed speaks of utility, while the entrance modestly punctuates the end bay with no more fuss than the windows above. It was well received. Niklaus Pevsner, writing in his canonical *Buildings of England* in 1951 , hailed it as 'clear, precise and well detailed … probably the best building on the whole site'. Author of *Pioneers of the Modern Movement*, Pevsner was committed to the promotion of modernism in his adopted country.

Almost 40 years later, distance has not lent enchantment to Norton's construction. The School of Agriculture has mellowed nicely; the biochemistry wing has simply aged. The latter's precast materials have weathered gracelessly. Or is it simply that inadequate distance lends unjustified disenchantment? ❧

Entrance to the Wellcome Wing

Noticing *Nature*

The first issue of *Nature* on Thursday 4 November 1869 announced itself as 'A Weekly Illustrated Journal of Science'. A letter touting for new personal subscriptions in 1998 extolled '*Nature*'s beautiful presentation' and state-of-the-art visuals: 'the "new-look" *Nature* now fully exploits modern graphics and typography'. The emphasis upon the centrality of illustration has remained constant, but little else is the same. The few constants—most obviously the use of line diagrams—are greatly outweighed by conspicuous changes.

The huge visual evolution of *Nature*, like other leading and long-lived journals of science, serves to show not only how notions of 'illustration' have been transformed over more than a century, but also how visual styles for the conduct and broadcasting of the sciences have undergone fundamental change. It is easy, at a distance of historical remove, to discern the visual rhetoric appropriate to 1869. We are less alert to our own period style.

The masthead of the newly emergent *Nature* in 1869 appeared atop two columns of advertisements (including such delights as 'Kemble's Shakespeare Readings', as well as the expected books of science). It displayed planet earth rising—presumably not sinking—through celestial clouds against a firmament of twinkling stars, across which sped a comet. 'NATURE' is spelt out in the twiggy calligraphy of a rustic gazebo and, nestling in the crook of the 'U', Britain is accorded a comfortably secure position in the cosmos of scientific nations. The volume would have looked thoroughly at home with the solid wooden joinery of the library shelves in one of the great Gothic 'palaces' built around 1850 for the conduct of science in Britain's older universities.

Nature, as it enters a new millennium, rejoices in a computerized, full-colour cover. A typical example, from 7 May 1998, sets pale type against the out-of-focus background of a very pretty photograph of two hermit crabs in an 'agonistic encounter'. The lettering is seemingly pushed forward on to an ambiguously positioned 'window' in front of the photographic picture, giving a sense of transparent depth to the flat surface of the cover.

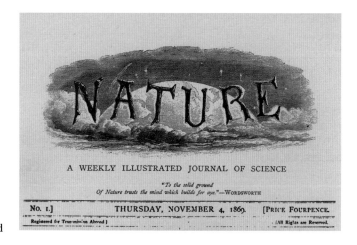

Original 1869 masthead

The image is brisk, up-to-date, and snappy, exuding a sense of high-tech mastery without making it all too blatant and obvious. As the potential reader's first encounter with that particular issue, one of the cover's main jobs is to induce a sense of wonder which will encourage us to explore within—though it is not always easy to locate the specific contribution to which the cover picture refers. The necessary bar code is manoeuvred to do least visual damage to the aesthetics of the graphic design. Vivid contemporary styling is

Front cover, 7 May 1998

clearly intended to make the journal look the part (not least as a prestigious unit in the publisher's stable of periodicals), and ensure that it can compete for notice in an age when every published product shouts for visual attention.

The design now in use is not the first 'new look' *Nature*. A 'tidied-up' version of the global masthead—with a cleaner Roman typeface and more clearly delineated globe which located Britain in an even more central position—surprisingly survived into the later 1950s. As always, there must have been a tension between updating the image and losing 'product identification'. For a long time, the familiar image hung on. By contrast, *Nature* prepared to enter the 1960s with a radical redesign, lead by a punchier two-colour masthead, hugely simplified in keeping with a more modern image. The only non-verbal elements were two purposeful arrows, seemingly denoting progress and pointing by implication into the optimistic future. The Wordsworth quote in the original design survived the immediate revolution, repositioned on the title page, only to slip into quiet retirement in 1963. In 1968, even the arrows went. 'NATURE, INTERNATIONAL JOURNAL OF SCIENCE' was printed in the starkest possible typeface and forced itself loudly against the margins of its coloured band.

By 1974, the present, more friendly Garamond typeface in democratically trendy lower case was in place, printed in white, generally against the familiar orange, and the persistent advertisements had been replaced by a striking photographic image. The present glamorously integrated cover of words and images was initiated in 1993, not least in response to advances in computer design programs.

The visual styles over the years are very much of a piece with the tone of the texts. The capital 'N' accorded to nature in the Wordsworthian homily—'To the solid ground of Nature trust the mind that builds for eye'—is much in keeping with the opening essay

Modern masthead,
January 1958

Ultra-modern masthead,
June 1968

commissioned from Thomas Huxley, which was largely given over to his translation of 'Aphorisms by Goethe'. Written around 1780, Goethe's paradoxes of ecstatic wonder are full of what the German author later admitted was 'a sort of Pantheism, to the conception of an unfathomable, unconditional, humorously self-contradictory Being, underlying the phenomena of Nature'. Although the first article by Alfred Bennett, 'On the Fertilisation of Winter-Flowering Plants' eschews Goetherian rapture in favour of Darwinian sobriety, it is written in the first person (a style which seems to have gone out in the 1950s) and unabashedly uses the epithet 'beautiful'.

By contrast, the tone of the technical contributions to recent issues is doggedly impersonal. Many years of collective effort have gone into the honing of a scientific prose in which an occasional 'we' is sanctioned (to refer to a team effort) but in which any personal or collectively enthusiastic voice is systematically repressed. Typical in tone are such phrases as 'the evidence suggests', 'it is impossible to assess', 'there are only two plausible interpretations', and 'according to the models discussed here'. The graphic vehicle is correspondingly clean and business-like, favouring sans serif typefaces for headers, titles, and captions. Its natural visual habitat is the top of a metal desk, beside a VDU, or on a modular shelving unit in a modern laboratory.

Picking up a recent issue, it clearly has a very different tactile and visual feel from its first predecessor. It is bigger, glossier, thicker, and heavier and the range of visual images, as we might expect in the wake of the technical revolutions in magazine production and scientific imagery, is far wider. Colour now plays a key role, both decoratively and as a conveyer of information, as in the 'false colour images' in various types of scanned image.

All the illustrations in the meagre ration of 11 in 1869 were engraved, two from photographs and one from a spectrometer. The diagram predominated as a conveyer of visual information. The dominant vehicle in present-day issues remains the authoritative graph, in its various forms. A few images rely on 'drawings' in the traditional handmade sense, and 'normal' photographs are largely restricted to the news sections, book reviews, and 'new on the market'. Eye-catching 3D graphics of complex molecules, using standard graphics programs such as MolScript or locally devised systems, generally help to ensure a decent quotient of sexy visuals. No science volunteers to look out-of-date in its modes of illustration and colour plays a crucial role in this respect, often beyond the strict requirements of context.

The great majority of non-diagrammatic images are generated through the use of devices to detect (and sometimes also to generate) non-visible emissions. 'Perceptual' analysis is undertaken using computers, and the final representations are made with computer graphics. Even some optical records, hovering on the edge of legibility through their distant or otherwise problematic origin, would be unintelligible without computational

intervention of a radical kind. It is good practice to credit the software package, such as 'Image Reduction and Analysis Facility' which is widely used by astronomers and is distributed by the National Optical Astronomy Observatories. Inevitably the name is compressed to IRAF, in the acronymic mode that is now *de rigeur* in any profession which wishes to exude an air of efficiency and professional exclusivity.

The setting up of machines to perform—in a highly selective way—acts that were formerly the province of human visual perception and hand representation has provided the dominant visual tenor of *Nature* in the last decade, and perhaps even earlier. Such images breathe an air of non-human objectivity, since our intervention can be minimized during the course of the acts of seeing and showing, but the choices of how the

Molscript image of Ras p21 protein

device is designed, set up, and operated are no less matters of human judgement than with the hand-drawn image. The key choices now reside at different points in the system and are often less easy to unravel for the non-specialist—and even for some specialists who use standard software much as a motorist drives a car.

Looking at the overall format of the journal, it would be easy to guess that advertisements now play an ever greater visual role. However, this guess would be wrong. Not only did the first issue establish the long-term presence of adverts on the cover, but it also contained 18 pages of adverts for 20 of text—to set against a typical recent proportion of 36 pages of main adverts, 31 of classified, and 99 of text.

The currently fashionable rhetorics of scientific imagery appear in conveniently exaggerated form in the advertisements. Polished photographs of equipment and eager operatives feature prominently, with a lacing of more technical images, such as graphs and the double helix (which must hold the advertisers' record for graphic popularity in this decade). The regular Eppendorf page is particularly telling. Whereas a half-page advert a few years earlier showed the pipette with descriptive text, the new Multipette Plus takes second place to an advertising agency's image of thrusting modernity in the form of an ultra-high-speed train, the streamlined profile of which literally outfaces its steam-driven predecessor. Promising to 'streamline work in your lab', the Multipette aspires to 'work as reliably and precisely as you yourself'—an oddly inverted compliment, since presumably it will be acquired by the laboratory scientist to achieve more precision than is possible with more hand-driven procedures.

Eppendorf advertisement, 7 May 1998

The array of advertisements and their disposition reflects a complex series of decisions, based on such factors as historical precedent, willingness (and ability) to pay premium rates for prime positions (such as inside the front cover or opposite important text), status and leverage, international sensibilities, and keeping obvious competitors apart. Taken with the news sections and 'new on the market', each issue of *Nature* can be seen to embody complex measures of the relative commercial, individual, institutional, and national weights that need to be balanced by the editorial and other staff of any international journal of science. Perhaps the only major factors in the world of science that do not find commensurate visual expression are the huge edifices of the research councils and academic institutions. They tend to feature only through photographs of persons and views of buildings—though, in theory, it should be irrelevant what a major scientist looks like or whether a piece of research originates from an ancient 'palace' or a 1960s greenhouse of glass and steel.

Nature in its present guise ensures through its news features that the visual and verbal cultures of human scientists play more overt roles than in most specialist journals, yet the dominant feel is of the supra-personal 'great machine' of science and technology. More traditionally 'subjective' dimensions of the sciences of the natural world—inspirational, passionate, intuitive, poetic, artistic, spiritual, social, and political—resurface only as matters of conscious editorial intent, as in the essays collected in this book, rather than as part of the integral expression of the substratum of the scientists' mental and material landscapes. Yet looking at current editions of *Nature*, even set beside some of the glossier periodicals of art, we are regularly presented with a visual feast which seems to speak incontrovertibly of an undimished aesthetic excitement with acts of observation, analysis, visualizing, modelling, and representation. But you would never know from the texts in which the scientists announce their discoveries. ∾

Concluding remarks

To begin these remarks with a caution, even a strong qualification, might seem to be offering an unnecessarily substantial hostage to fortune. However, in the belief that what I have been trying to do gains from being recognized for what it is in relation to what it is not, it will I think be helpful to put my enterprise in its due place.

Entering the territories of art and science through the gateways of the case studies presented here could lead to a misleading perspective on their respective histories. In art, for instance, Vermeer and Saenredam stand far more chance in this context of representing seventeenth-century Holland than Rembrandt. It might well be possible to write about Rembrandt in relation to Dutch science of his day, but he is a less obvious and immediately instructive 'candidate' than Vermeer, particularly in the brief compass of the individual studies. I would find it hard to argue that Saenredam is a more rewarding painter than Rembrandt, in spite of the delight I take in the former's mastery of space, light, line, and spiritual suggestion. Vermeer, on the other hand, is competition for anyone in my personal pantheon (and I do believe in *quality*)—Rembrandt included. But that is not the point. I have not been writing a history of art as such.

Nor, to an even greater extent, have I been writing a history of science. I have been looking at visual imagery in science. It seems clear to me that visualization (in the literal sense) and modes of representation have played a central role in Western science from the Renaissance onwards. One reviewer of a companion book I hope to publish dismissed the whole enterprise on the basis that 'there is no evidence that scientists ever think visually' —something that would surprise Sir Harry Kroto and his fellow visual modellers of the twentieth century, no less than their predecessors in earlier eras.

However, I do not subscribe to the view that the 'Scientific Revolution' was caused or driven by the revolution in representational techniques wrought by Renaissance artists. The role of abstract computation—above all through the rise of algebra, trigonometry, and calculus—is clearly as central to the physical and mathematical sciences as spatial geometry, and more significant than naturalistic portrayal. The relative role of the visual depends on the science and upon how that science is operating in particular places at particular times. Pictures of animals were, to put it at its simplest, more important in early natural history than representations of falling bodies in the determination of Galilean and Newtonian mechanics. In all sciences, there have been practitioners who have lent towards 'picturing' (mental and actual) at every stage of their activity, while others rely predominantly on a tool kit of symbolic and logical formulae. As Feynman shows, the same field can embrace the two types at the same time, and no science can depend exclusively on one or the other.

In the final analysis, I do not think that the visual versus non-visual polarization should

be taken too far. My intuition is that there is a type of thought, most readily recognizable at the very outset when ideas begin to stir but actually operative throughout, which is neither visual nor verbal—nor abstract or symbolic. Such a type of thinking embodies aspects of the visual and non-visual in a preverbalization and previsualization shuffle of such speed as to be effectively instantaneous.

In any event, we can say with confidence that there are no pictures within science, or within art for that matter, that operate outside an implicit or explicit dialogue with words, any more than there are theories about how things work that can ultimately resist our apparently irresistible desire to picture phenomena. There may be aspects of pure mathematics which produce gratification without this visual need, and much theoretical physics aspires to this condition, but for most of us ordinary mortals a theory that purports to explain how something works acquires a different status when it can be visualized as a working model—regardless of however schematic the representation may be with respect to reality of the phenomenon.

Entering via our present gateways also highlights certain features about how we relate to the world around us. Other ways of ordering my material might well produce other insights, and the reader is invited to do just that. In my own 'shuffle' the main themes seem to be:

1. echoes of comparable orders across very different scales, from cosmological to atomic;

2. the role of analogy in explanatory thinking and articulate seeing;

3. optical orders as discerned via our visual apparatus and perceptual processing;

4. the extraction of some kind of order from dynamic systems of such complexity as to appear chaotic (in the lay use of that term);

5. the necessity of model building as an essential aspect of the process of understanding, in which the remaking of nature conducts a vital dialogue with what is seen;

6. the desire to bring the unseen and the unseeable into visual form;

7. the key role of representational 'modes', not least the styles and vehicles through which communication becomes effective;

8. the role of human interest, both instinctual and socially conditioned, in the production and broadcasting of imagery.

These eight points sound as if they are designed for the history of science but, if we think about them, each is applicable almost without modification to the making of the kind of art with which we have been concerned.

Generally speaking, the imagery at which we have been looking emphasizes modes of art and to a lesser degree of science that tend towards holistic attitudes and the positing of ubiquitous 'implicate orders' (in the sense of the physicist David Bohm) rather than to the 'reductionism' which (in current shorthand) has come to be seen as the dominant mode of institutionalized science in the twentieth century. By 'reductionism' we mean the dissection of natural phenomena into their smallest component parts or operational units through empirical investigation, and the construction of explanatory strategies on the basis of the action of those units.

Against this approach (to draw the polarities sharply) stand those scientific thinkers who emphasize the wholeness and complexity of things, searching for orders and explanations

that penetrate all levels of a system. Until recently, it seemed that the 'hard' sciences—those which aspire to explanations that pertain to mathematics or mathematical-style logic—provided the model for all science, and that any science must necessarily strive to operate in a reductionist manner if it was to be seen as genuinely 'scientific'. This requirement no longer looks so clear-cut. As the new mathematics of complexity (especially chaos theory) have penetrated with varying degrees of success and depth into those sciences that are particularly involved in complex contexts (most notably the environmental sciences), so it seems that the 'hardness' of mathematical modelling or theoretical rigour is not the sole prerogative of the 'reductionists'.

This issue of holism and reductionism has such vital implications for the role of visual imagery in science that it is worth looking at it in more detail. A good example for this purpose is the case of the 'selfish gene', as memorably characterized by Richard Dawkins. He provides his own definition.

> What is the selfish gene? It is not just one single physical bit of DNA. Just as in the primeval soup, it is all *replicas* of a particular bit of DNA distributed throughout the world … 'it' is a distributed agency, existing in many individuals at once.

The key characteristic of the fundamental unit is that it is a 'replicator', demonstrating the properties of 'longevity, fecundity and copying-fidelity'. 'Success' is defined as the long-term survival of the replicator, or more accurately as the persistence of the template as replicated across generations of the same or various species. This persistence is independent of the survival of any physical entities, whether the organism or individual pieces of DNA. As Dawkins says,

> The life of any one physical DNA molecule is quite short—perhaps a matter of months, certainly not more than one lifetime. But a DNA molecule could theoretically live on in the form of *copies* of itself for a hundred million years.

The level of conceptual abstraction behind Dawkins' 'selfish gene'—signalled by his 'could theoretically live'—has not been adequately recognized as the phrase has entered popular consciousness. Indeed, Dawkins' language of communication has not encouraged such a recognition. A characteristic passage in which he argues for the gene and against the organism as the fundamental unit will serve to give an idea of his rhetoric:

> The genes are the immortals, or rather, they are defined as genetic entities that come close to deserving the title. We, the individual survival machines in the world, can expect to live a few more decades. But the genes in the world have an expectation of life that must be measured not in decades but in thousands and millions of years …
>
> The genes are master programmers, and they are programming for their lives. They are judged according to the success of their programs in coping with the hazards that life throws at their survival machines, and the judge is the ruthless judge of the court of survival.

It is characteristic of such conceptual 'hardness' in biology that it relies very little upon picturing, either in the process of visualization or in the broadcasting of the ideas. Indeed, the theories of Darwinian evolution and Mendelian genetics have depended little on visual representation, beyond the metaphorical evolutionary trees in which Haeckel specialized.

However, the actual operation of the gene and natural selection does not exhibit the predictability that a hard explanation should ideally possess. What happens in nature

concerns incredibly complex, intersecting fields of change, action, and interaction involving multiple agents which are not necessarily stable entities in themselves. The system is 'chaotic'—both in the lay sense of the term and according to the specific tenets of the mathematics of chaos. Modelling even the apparently simple case of one population of predators and another of prey takes us into the mathematics of complexity, in which precise predictability is not the rule. Rather it is possible to map the probabilities in phase space to produce visible attractors of the kind which Mullin and Skeldon produced for the coupled pendulum. (The reader who would like to follow up these questions is referred to the writings of Ian Stewart, in particular *The Collapse of Chaos*, co-authored with Jack Cohen.) What is particularly interesting in our present context is that such mathematical modelling has reinstated the act of picturing as a central tool of analysis and visualization, albeit with a very different role from the direct depiction of natural phenomena predominant in earlier science.

It is apparent that the visual approach inherent in this book predisposes its arguments towards Stewart's kind of enterprise rather than Dawkins' style of science. It plays towards the kinds of pattern-forming propensities in natural forms and phenomena recently brought together in Philip Ball's nice compilation, *The Self-Made Tapestry*. This leaning, particularly in the artworks, towards patterns that are suggestive of holistic principles of self-organization does not mean that I am trying to demonstrate that Stewart is more 'right' than Dawkins—or that the holists are striving towards a better truth than the reductionists.

It seems to me to be a philosophical and ethical question, not a scientific one, as to which level of organization we choose as our gateway into the system. In biology, to continue with our present example, we can potentially choose to define the 'significant unit of natural selection' as the gene, DNA, the cell, the individual organism, the species or larger taxonomic entity, those collective sectors of the orbiting environment directly affected by what Dawkins calls the 'long reach' of the phenotypes (the expressions of the genes in proteins and beyond), the whole of the local environment inhabited by the species, the broader environmental system of which the local environment is part, the ecosystem of the world as an entity, or larger universal entities which can be described as undergoing cosmic evolution.

Even from the limited perspective of the 'gene's-eye view', we can see that DNA can only replicate itself in the context of a complex system of enzymes and catalytic reactions within cells. Adopting a far wider perspective, James Lovelock proposed in 1982 that the fundamental level of address should become that of the whole earth as an organism—developing what he called the 'Gaia hypothesis', after the Greek goddess for the earth. In this sense, the whole earth may be considered as an organism in the same way that we might think of a coral reef as 'the organism' for coral, though it is actually the product of an extended colony of individual organisms. Or, just as the body has its cells, so the earth supports its component units of life (animals, plants, etc.), all of which collectively go to make up the total organism, which is characterized as a dynamic, self-regulating biosphere. More recently, Lee Smolin has proposed an even larger evolutionary unit—the universe; each universe serving as a replicatory agent via black holes. A scale of scales: DNA, the organism, the earth, the universe. The insight behind the microcosm and macrocosm seems to live again, albeit within a different philosophical context.

I do not believe that it is possible to demonstrate that any one of the alternative levels is 'right', most 'significant', or even preferable. Each level of scrutiny is potentially able to reveal non-arbitrary and operative aspects of the system as a whole. The different levels each lead to a different mode of explanation—each with its own insights and short comings. Each mode can do a distinct and valuable job in making sense, albeit incomplete sense, of what is happening. The kind of explanation operative at each level is inevitably locked into our conception of what kind of causes we believe to lie behind the wonderful intricacies that we see in nature.

My intuition is that the kind of mathematics that is appropriate for complex, evolutionary systems will remain distinctly different from the 'bottom-up' logicalities that characterize the theories of standard physics and chemistry at the microscopic and submicroscopic levels. I have a sense that we will never be able to merge the levels of chaotic and self-organized systems with the 'standard' kinds of physics and chemistry with which we have become familiar. A new conceptual framework is required.

What we have seen in this book is that visual insights, the building of visual models, and modes of visual communication stand in positions of incredible richness with respect to these considerations of levels of order and modes of explanation. Sometimes, not infrequently in fact, we have seen intuitions which play to the micro/macrocosmic echoes of pattern formation that speak of self-organizing principles in the organic and inorganic worlds. At others, we have seen the building of models that represent the mechanical units through which the engineering of nature is conducted, whether at the level of the levers and strings of Vesalian anatomy or the engineered models of big molecules. In other instances, most strikingly with Mendeleev's table of the elements, we have seen how the kind of theoretical modelling that posits holistic order is set in creative and indissoluble dialogue with the smallest operational units under consideration (i.e. the elements).

The art of someone like Mario Merz stands in a comparable position. His units are tables (of the four-legged kind) and mathematically growing populations (à la Fibonacci), but his view is of the holistic implications of mathematical series as expressed through its realization in art. The operative product in this case has been designed according to instinctual principles and is presented as an open field for intuitive interpretation.

The repeated visual echoes across cultures speak of continuities and constancies in structural intuition, to set against the standard historical picture of cultural difference and change. I did not contrive that the first piece, on Leonardo da Vinci, should deal with perception of curvaceous order in the 'chaotic' flow of fluids, while the last image in Part IX should illustrate a contemporary means to extract beautiful order from a chaotic system. However, the resonance seems to me to be deeply indicative of what can happen when we let the human enterprises of art and science speak to each other. Not least, the Leonardo drawing of water and the computer graphic of the coupled pendulum give to me, as all the images have, a sheer sense of pleasure in the visual—a pleasure that plays a vital role in keeping us going in the world we inhabit. ௸

Bibliography

Note: a full bibliography for essays covering the present range of topics would be unmanageably vast. I have therefore provided guidance to some general reading on the main issues (including books by authors advocating stances very different from mine), and some references for particular topics chosen to introduce the reader to the sources and the more specialist literature.

General

Brian Baigrie, *Picturing Knowledge. Historical and Philosophical Problems Concerning the Use of Art in Science*, University of Toronto Press, 1996.

Per Bak, *How Nature Works. The Science of Self-Organised Criticality*, Springer, New York, 1996.

Philip Ball, *The Self-Made Tapestry. Pattern Formation in Nature*, Oxford University Press, 1999.

Margaret Boden, *The Creative Mind: Myths and Mechanisms,* Cardinal, London, 1992.

Horst Bredekamp, *The Lure of Antiquity and the Cult of the Machine. The Kunstkammer and the Evolution of Nature, Art and Technology*, translated by Allison Brown, Markus Wiener Publishers, Princeton, 1995.

Enrico Coen, *The Art of Genes. How Organisms Make Themselves*, Oxford University Press, Oxford, 1999.

I. Bernard Cohen, *Album of Science. From Leonardo to Lavoisier 1450–1800*, Charles Scribner's Sons, New York, 1980.

Jack Cohen and Ian Stewart, *The Collapse of Chaos. Discovering Simplicity in a Complex World*, Viking, London, 1994.

Paul Crowther, *The Language of Twentieth-Century Art. A Conceptual History*, Yale University Press, New Haven and London, 1997.

Richard Dawkins, *The Selfish Gene*, Oxford University Press, 1976 (revised edn. 1989).

Samuel Y. Edgerton Jr., *The Heritage of Giotto's Geometry. Art and Science on the Eve of the Scientific Revolution*, Cornell University Press, New York and London, 1991.

Michele Emmer, *The Visual Mind: Art and Mathematics*, MIT Press, Cambridge (Mass.) and London, 1993.

Richard Feynman, *QED: The Strange Story of Light and Matter*, Princeton University Press, 1985.

Richard Feynman, *The Character of Physical Law*, Penguin, London and New York, 1992.

J. V. Field, *The Invention of Infinity. Mathematics and Art in the Renaissance*, Oxford University Press, 1997.

Brian Ford, *Images of Science. A History of Scientific Illustration*, British Library, London, 1992.

Guy Freeland and Anthony Corones (eds.), *1543 and All That. Image and Word, Change and Continuity in the Proto-Scientific Revolution*, Kluwer Academic, Dordrecht, 2000.

John Gage, *Colour in Culture*, Thames & Hudson, London, 1993.

Peter Louis Galison and Emily Ann Thompson, *The Architecture of Science*, M.I.T. Press,, Cambridge (Mass.) and London, 1999.

Ernst Gombrich, *Art and Illusion*, Phaidon, London, 1977.

Ernst Gombrich, *A Sense of Order, a Study in the Psychology of the Decorative Arts*, Phaidon, Oxford, 1984.

Brian Goodwin, *How the Leopard Changed its Spots*, Weidenfeld & Nicolson, London, 1994.

Stephen Jay Gould, *Ontogeny and Phylogeny*, Belknap Press of Harvard University, Cambridge (Mass.), 1977.

Stephen Jay Gould, *The Mismeasure of Man*, Norton, London and New York, 1981.

Stephen Jay Gould, *Hen's Teeth and Horse's Toes*, Norton, London and New York, 1983.

Stephen Jay Gould, *Eight Little Piggies: Reflections on Natural History*, Norton, New York, 1993.

Nina Hall (ed.), *The New Scientist Guide to Chaos*, Penguin, London, 1991.

Stephen S. Hall, *Mapping the Next Millennium: The Discovery of New Geographies*, Random House, New York, 1992.

Linda D. Henderson, *The Fourth Dimension and Non-Euclidean Geometry in Modern Art*, Princeton University Press, 1983.

Nicholas Jardine, James Secord, and Emma Spary, *Cultures of Natural History*, Cambridge University Press, 1995.

Caroline Jones and Peter Galison, *Picturing Science, Producing Art*, Routledge, New York and London, 1998.

Michio Kaku, *Hyperspace. A Scientific Odyssey Through Parallel Universes, Time Warps and the Tenth Dimension*, Oxford University Press, 1994.

Stuart Kauffman, *At Home in the Universe. The Search for Laws of Self-Organisation and Complexity*, Oxford University Press, New York, 1995.

Martin Kemp, *The Science of Art. Optical Themes in Western Art from Brunelleschi to Seurat*, Yale University Press, London and New Haven, 1992.

Martin Kemp, *From a Different Perspective. Visual Angles on Art and Science*, New York, forthcoming.

Martin Kemp, Us and Them, This and That, Here and There, Now and Then: Collecting, Classifying, Creating. In Siân Ede (ed.), *Strange and Charmed*, pp. 84–103, Calouste Gulbenkian Foundation, London, 2000.

David Knight, *Zoological Illustration; an Essay towards a History of Printed Zoological Pictures*, Dawson, Folkestone, 1977.

John Krige and Dominique Pestre (eds.), *Science in the Twentieth Century*, Harwood Academic, Amsterdam, 1997.

James Lovelock, *The Ages of Gaia. A Biography of our Living Earth*, Oxford University Press, 1988.

Benoit Mandelbrot, *The Fractal Geometry of Nature*, Freeman, Oxford, 1982.

Renato Mazzolini (ed.), *Non-Verbal Communication in Science Prior to 1900*, Leo S. Olschki, Florence, 1993.

Arthur Miller, *Imagery in Scientific Thought. Creating 20th-Century Physics*, Birkhäuser, Boston, 1984.

Arthur Miller, *Insights of Genius. Imagery and Creativity in Science and Art*, Copernicus, New York, 1996.

William Mitchell, *The Reconfigured Eye. Visual Truth in the Post-Photographic Era*, MIT Press, Cambridge (Mass.), 1992.

Ilya Prigogine and Isabelle Stengers, *Order Out of Chaos: Man's New Dialogue with Nature*, Heinemann, London, 1984.

Frank Popper, *Art of the Electronic Age*, Thames & Hudson, London, 1993.

Eliot Porter and James Gleick, *Nature's Chaos*, (ed. Janet Russek), Cardinal, London, 1990.

Robert Root-Bernstein, The Visual Arts and Sciences, *American Philosophical Society*, vol. 75/6, 1895, pp. 50–68.

Betty and Theodore Roszak, Deep Form in Art and Nature, *Resurgence*, 176, 1996, 20–22.

Lee Smolin, *The Life of the Cosmos*, Oxford University Press, Oxford and New York, 1997.

Barbara Stafford, *Body Criticism. Imaging the Unseen in Enlightenment Art and Medicine*, MIT Press, Cambridge (Mass.), 1991.

Barbara Stafford, *Artful Science. Enlightenment, Entertainment and the Eclipse of Visual Education*, MIT Press, Cambridge (Mass.), 1994.

Barbara Stafford, *Visual Analogy. Consciousness and the Art of Connecting*, MIT Press, London, 1999.

Philip Steadman, *The Evolution of Designs*: Biological Analogy in Architecture and the Applied Arts, Cambridge University Press, 1979.

Ian Stewart, *Does God Play Dice? The New Mathematics of Chaos*, Penguin, London, 1990.

Ian Stewart and Martin Golubitsky, *Fearful Symmetry: Is God a Geometer?*, Blackwell, London and New York, 1992.

Elaine Strosberg, *Art and Science*, UNESCO, Paris, 1999.

Ann Thomas (ed.), *Beauty of Another Order. Photography in Science*, Yale University Press, London and New Haven, 1997.

Conrad H. Waddington, *Behind Appearance, a Study in the Relations between Painting and the Natural Sciences this Century*, Edinburgh University Press, 1969.

Lewis Wolpert, *The Unnatural Nature of Science*, Faber and Faber, 1992.

Semir Zeki, *Inner Vision: An Exploration of Art and the Brain*, Oxford University Press, 1999.

Topics

Lisa's laws

Martin Kemp, *Leonardo da Vinci: the Marvellous Works of Nature and Man*, Dent, London, 1981.

Martin Kemp, *The Science of Art. Optical Themes in Western Art from Brunelleschi to Seurat*, Yale University Press, London and New Haven, 1992.

Jean Paul Richter (ed.), *The Literary Works of Leonardo da Vinci*, 2 vols., Phaidon, London, 1970.

Dürer's diagnoses

William Martin Conway (ed.), *Literary Remains of Albrecht Dürer*, Cambridge University Press, Cambridge, 1889.

Jerome Kagan, Galen's Prophecy: *Temperament in Human Nature*, Basic Books, 1994.

Erwin Panosky, *The Life and Art of Albrecht Dürer*, Princeton University Press, Princeton NJ, 1975.

Cycling the cosmos

Julie Hansen and Susanne Porter (eds.), *The Physicians Art: Representations of Art and Medicine*, Duke University Press, Durham, North Carolina, 1999.

Palissy's philosophical pots

Martin Kemp, Palissy's Philosophical Pots: Ceramics, Grottos and the 'Matrice' of the Earth *Le Origini della Modernita*, ed. W. Taga, 2 vols., Florence, 1999, pp. 69–88.

Vincian velcro

Kenneth Keele and Carlo Pedretti, *Leonardo da Vinci. Corpus of Anatomical Studies at Windsor Castle*, 3 vols., Johnson Reprint Corporation, London and New York, 1979–80.

Vesalius' veracity

K. B. Roberts and J. D. W. Tomlinson, *The Fabric of the Body: European Traditions of Anatomical Illustration*, Clarendon, Oxford, 1992.

Andreas Vesalius, *Humani Corporis Fabrica Libri Septem*, Oporinus, Basel, 1543.

Babes in bottles

Julie Hansen, 'Resurrecting Death: Anatomical Art in the Cabinet of Dr Frederiik Ruysch, *Art Bulletin* LXXVIII (1996) 663–679.

Frederik Ruysch, *Thesaurus Anatomicus*, Amsterdam, 1724.

Basically Brunelleschian

Leon Battista Alberti (1404–72) , *On Painting*, translated by Cecil Grayson, with an introduction and notes by Martin Kemp, Penguin, London, 1991.

Piero della Francesca, *De Prospectiva Pingendi*, edited by G. Nicco Fasola, Florence, 1942.

Martin Kemp, *The Science of Art. Optical Themes in Western Art from Brunelleschi to Seurat*, Yale University Press, London and New Haven, 1992.

Antonio Manetti, *The Life of Brunelleschi, translation of Vita di Filippo di Ser Brunelleschi* (c. 1470–80), (ed.) Howard Saalman and trans. Catherine Enggass, Pennsylvania State University Press, University Park, 1970.

Piero's perspective

J. V. Field, *The Invention of Infinity: Mathematics and Art in the Renaissance*, Oxford University Press, 1997.

Piero della Francesca, *De Prospectiva Pingendi*, edited by G. Nicco Fasola, Florence 1942.

Marilyn Aronberg Lavin, *Piero della Francesca: The Flagellation*, Chicago University Press, Chicago 1990 [repr. from Viking, New York 1972]

Vermeer's vision

Philip Steadman, *Vermeer's Camera*, Oxford University Press, Oxford 2000 (forthcoming).

Saenredam's shapes

Robert Ruurs, *Saenredam: the Art of Perspective*, Benjamins, Amsterdam, 1987.

Simon Stevin, *De Deusrichtige*, Leiden, 1605.

Kepler's cosmos

Jean Bodin, *Les Six Livres de la Republique*, edited by Christiane Frémont, Fayard, Paris, 1986.

Nicolaus Copernicus, *De Revolutionibus orbium coelestium*, (1543), translated by E. Rosen, Warsaw, Polish Scientific Publishers, 1978.

J. V. Field, *Kepler's Geometrical Cosmology*, Athlone, London, 1988.

Johannes Kepler, *Mysterium Cosmographicum*, Tübingen, 1596.

Luca Pacioli, *De Divina Proportione* , Venice, 1509.

Cartesian contrivances

Brian Baigrie, Descartes's Scientific Illustrations and La Grande Mécanique de la Nature. In *Picturing Science* (ed. Baigrie), pp. 86–134, University of Toronto Press, 1996.

Claude-Nicolas Cat, *A Physical Essay on the Senses*, 1750.

René Descartes, *Principia Philosophiae*, Amsterdam, 1644.

Maculate moons

Samuel Y. Edgerton, *The Heritage of Giotto's Geometry: Art and Science on the Eve of Scientific Revolution*, Cornell University Press, London and New York, 1991.

Galileo Galilei, *Sidereus Nucius*, Venice, 1620.

Galileo Galilei, *Sidereus Nucius or the Sidereal Messenger*, translated and notes by A. van Helden, University of Chicago Press, Chicago and London, 1989.

Martin Kemp, *The Science of Art. Optical Themes in Western Art from Brunelleschi to Seurat*, Yale University Press, London and New Haven, 1992.

Hooke's housefly

Robert Hooke, *Micrographia*, London, 1665.

Robert Hooke: New Studies, ed. Michael Hunter and Simon Schaffer, Woodbridge, 1989.

Merian's metamorphoses

Natalie Zemon Davis, *Women on the Margins: Three Seventeenth Century Lives*, Harvard University Press, Cambridge (Mass.) 1995.

Maria Sibylla Merian, *De Metamorphosibus Insectorum Surinanensium*, 1714.

Maria Sibylla Merian, *The Wondrous Transformation of Caterpillars and Their Remarkable Diet of Flowers*, 1679.

Maria Sibylla Merian 1647–1717: Artist and Naturalist, exhibition catalogue, Historisches Museum Frankfurt 1997–8, Verlag Gerd Hatje, Ostfilden-Ruit, 1998.

Sexy stamens and provocative pistils

Erasmus Darwin, *The Botanic Garden: A Poem in Two Parts with Philosophical Notes. Part 1 The Economy of Vegetation. Part 2 The Loves of Plants*, 1791.

Martin Kemp, 'The "Temple of Flora": Robert Thornton, Plant Sexuality and Romantic Science' in *Natura-Cultura*, ed. Guiseppe Olmi, Lucia di Tongiorgi Tomasi and Attilio Zanca, Mantua, 2000, pp. 15–28.

Charlotte Klonk, *Science and the Perception of Nature: British Landscape Art in the Late Eighteenth and Early Nineteenth Centuries*, Paul Mellon Center for Studies in British Art, Yale University Press, New Haven and London, 1996.

Carl Linnaeus, *Philosophica Botanica*, 1751.

Robert Thornton, *New Illustration of the Sexual System of Linnaeus*, London, 1804.

Robert Thornton, *The Temple of Flora*, London 1812.

Jean Jacques Rousseau, *Lettres élémentaires sur la botanique*, 2 vols., Paris, 1789.

Stubbs' seeing

Judy Edgerton, *George Stubbs 1724–1806*, exhibition catalogue, Tate Gallery, London, 1984.

George Stubbs, *The Anatomy of the Horse*, London, 1766.

George Stubbs, *A Comparative Anatomical Exposition of the Structure of the Human Body with that of a Tiger and a Common Fowl*, London, 1817.

Audubon in action

John James Audubon, *Birds of America*, 4 vols., London, Edinburgh, 1827–1838.

John James Audubon, *Ornithological Biography*, 5 vols., Edinburgh, 1831–1839.

Maria R. Audubon, *Audubon and his Journals*, London, 1898.

Wright's ruptions

Judy Edgerton, *Wright of Derby*, exhibition catalogue, Tate Gallery, London, 1990.

Sir William Hamilton, *Observations on Mount Vesuvius, Mount Etna and Other Volcanoes*, London, 1772.

Sir William Hamilton, *Campi Phlegraei*, Naples, 1776.

Turner's trinity

John Gage, *Colour in Turner. Poetry and Truth*, Studio Vista, London, 1969.

Wolfgang Goethe, *Zur Farbenlehre*, Tübingen, 1810.

Monge's maths; Hummel's highlights

Jonathan Miller, *On Reflection* (exhibition catalogue), National Gallery, London, 1998.

Gaspard Monge, *Geométrie Descriptive*, Paris, 1811.

Modelled moons

James Nasmyth and Edward Carpenter, *The Moon Considered as a Planet, a World and a Satellite*, London, 1874.

Ann Thomas, in *Beauty of Another Order. Photography in Science*, Yale University Press, London and New Haven, 1997.

Lucid looking

John Hammond and Jill Austin, *The Camera Lucida in Art and Science*, IOP, Bristol, 1987.

Cornelius Varley, *A Treatise on Optical Drawing Instruments*, London, 1845.

Wheatstone's waves

Brian Bowers, *Sir Charles Wheatstone*, HMSO, London, 1975.

Mendeleev's matrix or 'Telling tables'

E. G. Mazurs, *Graphical Representations of the Periodic System during One Hundred Years*, University of Alabama Press, 1974.

Dmitry Mendeleev, The Periodic Table of Chemical Elements (Faraday Lecture) *Journal of the Chemical Society LV* (1889) 637–656.

J. W. van Spronsen, *The Periodic System of the Elements: a history of the first hundred years*, Elsevier, Amsterdam, 1969.

Gray's greyness

Henry Gray, *Anatomy, Descriptive and Surgical*, 1858.

Paolo Mascagni, *Vasorum Lymphaticorum Corporis Humani Historia et Ichnographia*, Senis, 1787.

K. B. Roberts and J. D. W. Tomlinson, *The Fabric of the Body: European Traditions of Anatomical Illustration*, Clarendon, Oxford, 1992.

Graphic gropings

W. Bernard Carlson, Innovation and the Modern Corporation: From Heroic Invention to Industrial Science in John Krige and Dominique Pestre, *Science in the Twentieth Century,* Harwood Academic Publishers, Amsterdam, 1997.

Thomas A. Edison, *The Papers of Thomas A. Edison*, 4 vols., ed. Reese Jenkins, Johns Hopkins University Press, Baltimore, 1989.

Jules Henri Poincaré, *Science and Hypothesis*, translated by W. J. G., Walter Scott Publishing Co., London and Newcastle-upon-Tyne, 1905.

Edouard Toulouse, *Henri Poincaré*, 1910.

Röntgen's rays

Nature 23 January 1896: article on X-rays

Alan R. Bleich, *The Story of X-Rays from Röntgen to Isotopes*, Dover, New York, 1996.

Josef Maria Eder, *History of Photography*, translated by Edward Epstean, Dover Publications, London and New York, 1978.

Josef Maria Eder and Eduard Valenta, *Versuche über photographie mittlest der Röntgenschen Strahlen*, Vienna, 1896.

Alan G. Michette and Slawka Pfautsch, *X-Rays: The First Hundred Years*, Wiley, New York, 1996.

Boys' bubbles

F. Algarotti, *Sir Isaac Newton's Philosophy explain'd for the use of Ladies*, translated by Elizabeth Carter, E. Cave, London, 1739.

Sir Charles Vernon Boys, *Soap Bubbles and the Forces that Mould Them* (Lectures 1889–1890), The Society for Promoting Christian Knowledge, 1902. (Reproduced in the *Science Study Series*, 1959.)

Sir David Brewster, *Letter on Natural Magic, addressed to Sir Walter Scott, bart*, John Murray, London, 1834.

Stilled splashes

Seeing the Unseen: Dr Harold E. Edgerton and the Wonders of Strobe Alley, exhibition catalogue, Publishing Trust of George Eastman House, Rochester N.Y., 1994.

Sir D'A. W. Thompson, *On Growth and Form*, Cambridge University Press, 1917 (revised 1942).

Arthur Worthington, *A Study of Splashes*, Longmans and Co., London, 1908.

Shelley's shocks

J. V. Field and Frank James, Frankenstein and the Spark of Being: The Influence of Regency Period Ideas on Mary Shelley's Tale of an Infamous Creation' *History Today* 44.9 (September 1994) 47–53.

Frankenstein. Creation and Monstrosity, (ed.) Stephen Bann, Reaktion, London, 1994.

Mary Shelley, *Frankenstein or the Modern Prometheus*, Lackington, Hughes, Harding etc., London, 1818.

Frémiet's frenzy

Eric A. Buffetant, *Short History of Vertebrate Palaeontology*, Croom Helm, London, 1987.

Charles Darwin, *On the Origin of the Species*, John Murray, London, 1859.

G. Louis Figuier, *Primitive Man*, translated by Edward Burnet Taylor, London, 1870.

Albert Gaudry, *Les ancetres de nos animaux dans les temps géologiques*, Bailliere, Paris, 1888.

Paul Antoine Gratacap, *Le Musee d'histoire naturelle*, Paris, 1854.

Jacques Perret, *Le Jardin des Plantes*, Julliard, Paris, 1984.

Martin Rudwick, *Scenes from Deep Time: Early Pictorial Representations of the Prehistoric World*, University of Chicago Press, Chicago and London, 1992.

Hyde's horrors

Charles Darwin, *The Expression of the Emotions in Man and Animals*, John Murray, London, 1872.

Martin Kemp, 'A Perfect and Faithful Record": Mind and Body in Medical Photography before 1900', in Ann Thomas (ed.), *Beauty of Another Order. Photography in Science*, Yale University Press, London and New Haven, 1997.

Robert Louis Stevenson, *The Strange Case of Dr Jekyll and Mr Hyde*, Edinburgh, 1885.

Haeckel's hierarchies

Louis Agassiz, *Recherches sur les poissons fossiles*, Neuchâtel, 1833–43.

Stephen Jay Gould, A Tale of Three Pictures' in *Eight Little Piggies: Reflections in Natural History*, Norton, New York, 1993.

Ernst Haeckel, *General Morphology of Organisms*, 1866,

Ernst Haeckel, *The History of Creation*, translated by E. R. Lankester, London, 1876.

Akeley's Africa

Karen Wonders, *Habitat Dioramas*, Uppsala University Press, Uppsala, 1993.

Ernst's ego

Max Ernst: A Retrospective, Tate Gallery, in association with Prestel. London, 1991.

Sigmund Freud, *Leonardo da Vinci and a Memory of his Childhood*, translated by A. Tyson with an introduction by Brian Farrell, Penguin Books, Harmondsworth, 1963.

Ian Turpin, *Ernst*, Phaidon, London, 1993.

Boccioni's ballistics

Reyner Banham, *Theory and Design in the First Machine Age*, Butterworth Architecture, Oxford, 1992.

Umberto Boccioni, Futurist Painting: Technical Manifesto (1910) *Futurist Painting*, exhibition catalogue, Sackville Gallery, London, 1912.

Filippo Tommaso Marinetti, Foundation and Manifesto of Futurism (1909) in *Marinetti's Selected Writings*, ed. R. W. Flint, Secker & Warburg, London, 1971.

Feynman's figurations

Richard Feynman, Space-Time Approach to Quantum Electrodynamics, *Physical Review*, 9 May 1949.

Richard Feynman, *The Character of Physical Law*, Penguin, London and New York, 1992.

Christopher Sykes (ed.), *No Ordinary Genius: The Illustrated Richard Feynman*, Weidenfeld & Nicolson, London, 1994.

Dali's dimensions

Thomas Banchoff, *Beyond the Third Dimension*, Scientific American Library, New York, 1990.

Charles Howard Hinton, *The Fourth Dimension: Geometry, Computer Graphics and Higher Dimensions*, Swan Sonnenschein & Co, London, 1906.

Salvador Dali, Retrospective 1920–1980, exhibition catalogue, Centre Georges Pompidou, Musée National d'Art Moderne, Paris, 1980.

Bill's bands

Max Bill, in M. Emmer (ed.), *The Visual Mind: Art and Mathematics*, MIT Press, Cambridge (Mass.), 1993.

Abbott's absolutes

Berenice Abbott, *The World of Atget*, Horizon Press, New York, 1964.

William Henry Fox Talbot, *The Pencil of Nature* (London 1844), facsimile edition, ed. Larry J. Schaaf, Hans P. Kraus, New York, 1989.

Ann Thomas (ed.), *Beauty of Another Order. Photography and Science*, Yale University Press, London and New Haven, 1997.

Alfred North Whitehead, *Science and the Modern World (Lovell Lectures, 1925)*, Cambridge University Press, USA, 1926.

Alfred North Whitehead, *Process and Reality: An Essay in Cosmology (Gifford Lectures, 1927–8)*, Cambridge University Press, 1929.

Merz's maths

Mario Merz, exhibition catalogue, Museum Volkwang Essen, Essen, 1979.

Mario Merz, exhibition catalogue, Moderna Museet, Stockholm, 1983.

Leonardo Fibonacci da Pisa, *Scritti*, ed. Baldassare Boncampagni, 2 vols., Rome, 1857–1862.

Albers' abstracts

Joseph Albers, *Interaction of Color*, Yale University Press, London and New Haven, 1963.

Wilhelm Ostwald, *The Color Primer*, edited and with a foreword and evaluation by Faber Birren, Van Nostrand Reinhold Co., New York, 1916.

John Gage, *Colour in Culture: Practice and Meaning from Antiquity to Abstraction*, Thames & Hudson, London, 1993.

Gabo's geometry

Naum Gabo and Antoine Pevsner, *The Realist Manifesto*, 1920.

Martin Hammer and Christina Lodder, *Gabo's Stones*, Centre for the Study of Sculpture, Leeds City Art Gallery, Leeds, 1995.

Ernst Haeckel, *Kunstformen der Natur* (2 vols), 1899–1904.

Sir D'A. W. Thompson, *On Growth and Form*, Cambridge University Press, 1917 (revised 1942).

Kendrew constructs; Geis gazes

John Kendrew, The Three-Dimensional Structure of a Protein Molecule, *Scientific American*, vol. 205, no. 6, December 1961.

The Molecular Art of Irving Geis, exhibition catalogue, MIT, Cambridge (Mass.), 1993.

Max's modelling

Linus Pauling and Roger Hayward, *The Architecture of Molecules*, W. H. Freeman & Co., San Francisco and London, 1964.

Max Perutz, *Proteins and Nucleid Acids: Nature and Function*, 1962.

James D. Watson and Francis Crick, A Structure for Deoxyribose Nucleid Acid, *Nature*, 171 (2 April 1953) 737.

James D. Watson, *The Double Helix*, New American Library, New York, 1969.

Visible viruses

Francis Crick and James Watson, The Structure of Small Viruses, *Nature*, 177, 1966, 473–475.

H. E. Huxley in F. S. Sjøstrand and J. Rhodin (eds.). *Proceedings of the Stockholm Conference on Electroon Microscopy*, Stockholm 1956, pp. 260–1.

P. Wildy, W. Russell, and R. Horne, article in *Virology*, vol. 12 (1960).

The Biological Laboratory, Cold Spring Harbor, N.Y., *Basic Mechanisms in Animal Virus Biology*, Cold Spring Harbour Symposia on Quantitative Biology 27 (1963).

Kroto and charisma

T. Kamaseki and K. Kadota, 'The Vesicle in a Basket', *The Journal of Cell Biology* 42 (1969) 202–220.

D. Koruga et al, *Fullerene C60: History, Physics, Nanobiology, Nanotechnology*, Elsevier, 1993.

Harry Kroto, 'C$_{60}$: Buckminsterfullerene' *Nature* (14 November 1985).

Julesz's joyfulness

Sir David Brewster, *Letter on Natural Magic, addressed to Sir Walter Scott, bart*, John Murray, London, 1834.

B. Julesz, *Foundations of Cyclopean Perception*, University of Chicago Press, Chicago and London, 1971.

David Marr, *Vision*, Freeman, New York, 1982.

Mammary models

Ralph Highnam and Michael J. Brady, *Mammographic Image Analysis*, in Computational Imaging and Vision Series, vol. 14, Kluwer Academic Publishers, Dordrecht and London, 1999.

Heezen's highlands

Bruce C. Heezen and Marie Tharp, *The Floors of the Oceans*, vol. 1, *The North Atlantic*, Geological Society of America Special Papers, vol. 65, New York, 1959.

The Ocean Floor: Bruce Heezen Commemorative Volume, ed. R. A. Scrutton and M. Talwani, Wiley, New York, 1982.

Bruce Heezen and Charles Hollister, *The Face of the Deep*, Oxford University Press, Oxford and New York, 1971.

Henry William Menard, *The Ocean of Truth*, Princeton University Press, Princeton, 1986.

Turrell's tunnelling

James Turrell, *Air Mass*, exhibition catalogue, South Bank Centre, London, 1993.

Craig E. Adcock, *James Turrell: The Art of Light and Space*, University of California Press, Berkeley, 1990.

Venus' voyeurs

Peter Cattermole and Patrick Moore, *Atlas of Venus*, Cambridge University Press, London, 1997.

David Grinspoon, *Venus Revealed*, Perseus, Boulder, Colorado, 1997.

Lane's landscapes

N. J. Lane and L. S. Swales, Intercellular junctions and the development of the blood–brain barrier in *Manduca sexta. Brain Research* 168 (1979) 227–245.

N. J. Lane and H. J. Chandler, Definitive evidence for the existence of tight junctions in Invertebrates, *Journal of Cell Biology* 86 (1980) 765–774.

Lelio Orci and Alain Perrelet, *Freeze-Etch Histology: a Comparison between Thin Sections and Freeze-Etch Replicas*, Springer, Berlin, 1975.

Metzger's mission

Gustav Metzger, *Damaged Nature, Auto-Destructive Art*, Coracle, London, 1996.

Gustav Metzger, exhibition catalogue, Museum of Modern Art, Oxford, 1998.

Gustav Metzger: Retrospectives, Museum of Modern Art Papers, vol. 3, Museum of Modern Art, Oxford, 1999.

Parker's pieces

Cornelia Parker, *Avoided Object*, exhibition catalogue, Cardiff, 1996.

Cornelia Parker, exhibition catalogue, Institute of Contemporary Art, Boston, 2000.

Callan's canyons

Par Bak, *How Nature Works. The Science of Self-Organised Criticality*, Copernicus, New York, 1996.

Marina Wallace, *Art and Science*, "Project 8", exhibition catalogue, Total Museum of Contemporary Art, Seoul, 1998.

Derges' designs

Sir Charles Vernon Boys, *Soap Bubbles and the Forces that Mould Them* (Lectures 1889–1890), The Society for Promoting Christian Knowledge, 1902. (Reproduced in the *Science Study Series*, 1959.)

Susan Derges, *Liquid Form*, Michael Hue-Williams, Londoon, 1999.

James Gleick *Chaos*: Making a New Science, Cardinal, London, 1988.

Hans Jenny, *Cymatics: the Structure and Dynamics of Waves and Vibrations*, Heinz Moos, Munich, 1967–74.

Theodor Schwenk, *Sensitive Chaos: the Creation of Flowing Forms in Water and Air*, Rudolf Steiner, London, 1996.

Danah Zohar, *The Quantum Self*, Flamingo, London, 1990.

Onwin's holistics

Glen Onwin, *Revenges of Nature*, exhibition catalogue, Fruitmarket Gallery, Edinburgh, 1988.

De Vries' varieties

Herman de Vries, *Documents of a Stream: The Real Works 1970–1992*, Royal Botanic Garden, Edinburgh, 1992.

Herman de Vries: gute Hoffnung, ohne Gezensätze, exhibition catalogue, Kunstverein Ruhr, Essen, 1993.

Hesse–Honegger's handwork

Cornelia Hesse-Honegger, *The Future's Work*, Locus, Newcastle-Upon-Tyne, 1997.

Cornelia Hesse-Honegger, *After Chernobyl*, Bundesamt für Kultur (Bern) im Verlag Lars Müller, Baden, 1992.

Goldsworthy's genera

Andy Goldsworthy, Viking, London, 1990.

Andy Goldsworthy, *Stone*, Viking, London, 1994.

Andy Goldsworthy, *Wood*, Viking, London, 1996.

Latham's life-forms

William Latham's website 'Computer Works Ltd' http:///www.artworks. co.uk

Benoit Mandelbrot, *The Fractal Geometry of Nature*, Freeman, Oxford, 1982.

Stephen Todd and William Latham, *Evolutionary Art and Computers*, Academic Press, London, 1992.

Laudable labs?

Nikolaus Pevsner, *Buildings of England*, Penguin Books, Harmondsworth, 1951.

Nikolaus Pevsner, *Pioneers of the Modern Movement*, Faber and Faber, London, 1936.

Tim Rawle, *Cambridge Architecture*, Deutsch, London, 1993.

Index